The New
Digital
Photography
Manual

THIS IS A CARLTON BOOK

Text and design copyright © 2000, 2002, 2005, 2010 Carlton
Books Limited

This edition published in 2010 by Carlton Books Limited
20 Mortimer Street
London
W1T 3JW

First published in 2000

A CIP catalogue for this book is
available from the British Library.

ISBN 978 1 84732 478 8

Executive Editor: Sarah Larter
Design: Diane Spender, Michael Spender, Vicky Holmes,
Jim Lockwood
Cover Design: Sooky Choi
Picture Research: Philip Andrews
Production: Janette Burgin

Printed in Dubai

Author's Acknowledgments
My thanks go to the hardware and software manu-
facturers whose help is an essential part of writing
any book of this nature. In particular I wish to thank
technical and marketing staff at Adobe, MGI, Ulead,
Corel, Wacom, Kodak, Fuji, Canon, Epson, Iomega,
AMD, Imation, FreeDrive, Minolta and Umax.

I would also like to acknowledge and thank the
editors of the journals where my freelance articles are
featured. It is through the support and encouragement
of *Amateur Photographer* (UK), the *British Journal of
Photography* (UK), *Digital Photo and Design* (Aus) and
Commercial Photography (Aus) magazines that I have
been able to collate my thoughts into the volume you
now hold in your hands. Some of the ideas that graced
your pages first now find a permanent home here.

Finally I want to thank my wife, family, friends
and students for putting up with the pixel-laden
rantings of this digital photography author over the
last few months as the writing of this handbook
dominated our lives.

The New
Digital
Photography
Manual

An Introduction to the Equipment and
Creative Techniques of Digital Photography

Philip Andrews

CARLTON
BOOKS

CONTENTS

FOREWORD

FOREWORD

It wasn't long ago that my fascination with digital photography began. At that time I was impressed with the potential the new medium offered photographers though I was also awed by the learning curve it presented those that cared to take it on.

Naturally the birth of consumer digital photography created a sense of impending doom and despair among the more conservative camera clubs and photo associations. Judges and members alike cried "foul" and "unfair advantage" as a overabundance of ghastly digital collages and composites hit the exhibition stands around the country. Unfair it was, but more so to the infant medium of digital photography than to those that felt most threatened.

As with the birth of any medium, the early days are its most unstable, and in the case of digital photography this proved especially so. At that time digital cameras were little more than expensive, pixel-poor toys. The computers on which their images were manipulated performed slower than the proverbial "wet weekend" and the imaging software on offer was complex and unnecessarily expensive. I don't even want to think about the quality of the printed output on offer, it was that bad ...

But that was years ago, and even a few months is a long time in digital imaging. Now we can enjoy affordable pixel-rich digital cameras capable of producing A3plus-sized images impossible to pick from film originals. We also have access to powerful and easy-to-use computer systems as well as software manipulation programs that suit every conceivable budget and skills level. Best news of all is that we can also buy economical printers that output photo-realistic images of a quality to die for!

What does this all mean for the emerging digital photographer? Unfortunately, for such a jump in economy and quality, there's not been an equivalent shift in the level of understanding. Digital technology has not really improved the quality of our output. In fact it might have dragged it backwards a few notches as we tend to pay more attention to its bells and whistles than the creative aspects of image-making.

Even though digital photography is well out of its infancy, there's still a staggering amount of new ground to be covered across all aspects of the craft. Great technology is simply not enough any more and that's where publications like this come into their own. *The Digital Photography Manual*. A handbook such as this, with clean and no-nonsense text and simple, clear illustrations, is worth ten times its weight in software CD-ROMs or instructional video downloads. And, though the technology will undoubtedly have advanced further still by the time you read this book, it's the theory and technique that remains its greatest asset.

Read this book. Learn the principles and techniques explained between its covers and your image making will ultimately benefit, regardless of the technology you acquire.

Robin Nichols
EDITOR
Better Digital magazine
Sydney, Australia

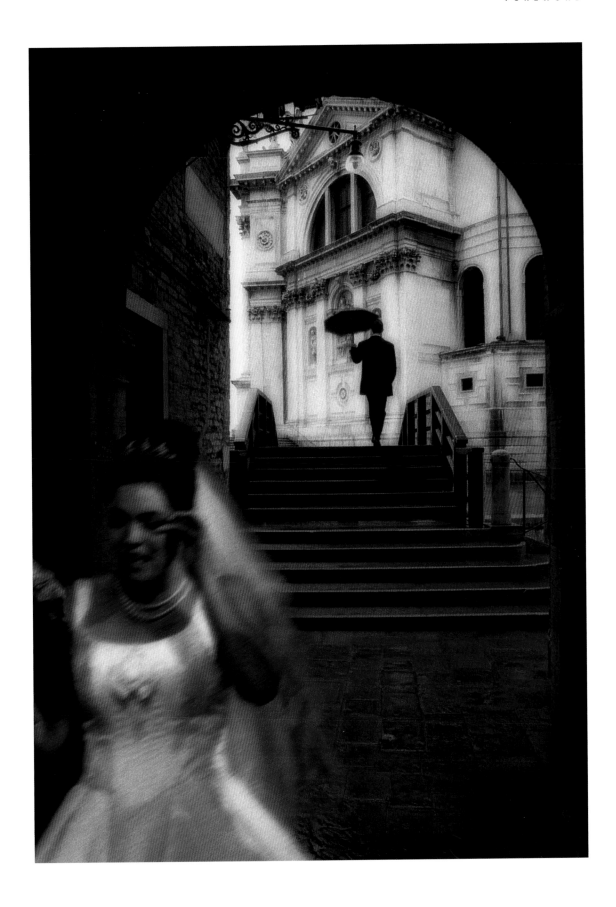

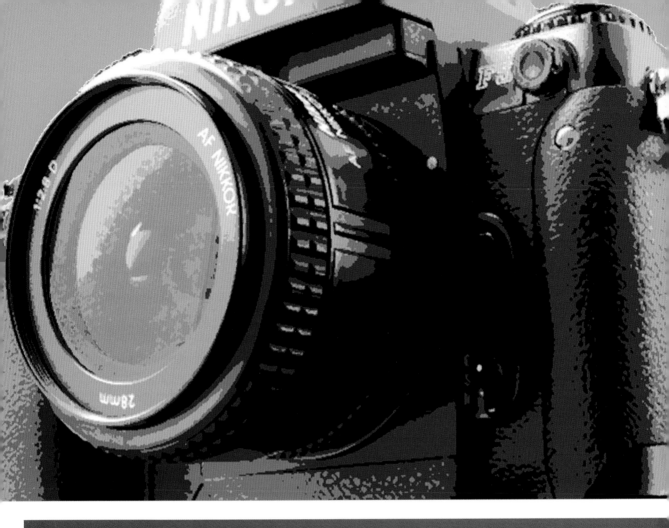

WHY DIGITAL?

WHY DIGITAL?

I believe that in the heart of all good photographers is the desire to make great images – images that communicate ideas or feelings, images that document times past or give us a glimpse of societies, people and places that we never knew existed.

Right from the very infancy of the medium, photographic image-makers have embraced whatever technology was available to them to help satisfy this desire. The history of photography is as much the story of the technological changes in the medium as it is about famous people, images and events.

In France in 1826, Joseph Nicéphore Niepce produced the first photographic image the world had

Fig 2 – I'm sure that Fox Talbot would not only have been interested in digital imaging, but would have embraced the technology wholeheartedly.

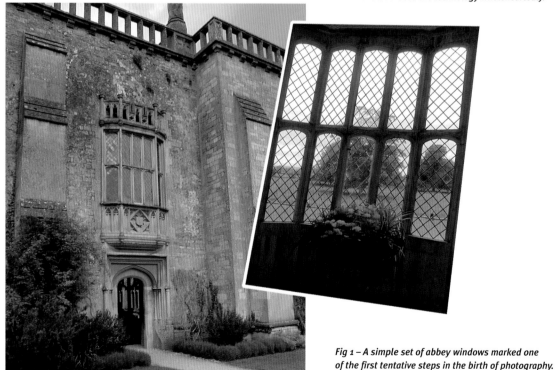

Fig 1 – A simple set of abbey windows marked one of the first tentative steps in the birth of photography. Shooting the same scene digitally around 160 years later shows the development of imaging technology.

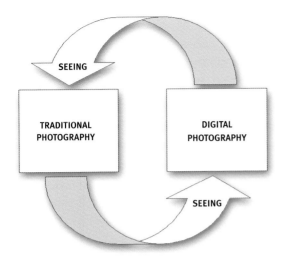

Fig 3 – Good images are made by photographers whose skills are independent of the equipment they use. The most important skills that you have will easily transfer to the digital environment.

ever seen. Over the Channel, an equally simple, small and fuzzy picture – of a set of windows from an abbey a hundred miles west of London – produced by William Henry Fox Talbot signalled a similar beginning to what has been a continual progression of technological advancements in the world of mechanical image-making. For the last 175 years, people like Niepce and Fox Talbot have been constantly striving to produce materials, processes and equipment that will allow us to capture images of our world more easily, quickly and with better quality than ever before.

On a recent trip to Lacock Abbey in Wiltshire, I wondered what Fox Talbot would have thought of me photographing the exact same window he used in his experiments with the very latest in photographic technology, a digital camera (see fig 1). I get the feeling that he would have been amazed and excited. The man was fervent, some might say zealous, in his pursuit of the ways and means to record the world around him. With this in mind, I feel that it would not be too much of a stretch of the imagination to see him striding around the grounds, digital camera in one hand and laptop in the other.

NO NEED TO BE TECHNOPHOBIC
I start this book by referring back to the past because there is still an element in the photographic community that heralds all that is digital as a rejection of the craft of our imaging heritage. I believe that in reality the advent of digital photography and the huge uptake of both the new equipment and its associated processes are entirely in line with our history (see fig 2).

Photographers have always pushed the technological boundaries of their medium. You have only to look at modern film-based camera systems to know that we will eagerly embrace changes in the way we do things if we feel that it will improve our ability to take great shots. In their latest incarnations, Sony, Canon and Nikon have produced professional 35mm systems that have a vast array of functions and computer-based controls. Such advancements are readily accepted as great aids to making better images and there are very few photographers who would be prepared to argue that these cameras deny the craft of our common heritage.

Sadly, in some quarters, digital photography still doesn't receive the same acceptance. Traditionalists fear that these new tools will render useless the skills that they have developed over years of careful practice. Nothing could be further from the truth.

REUSE YOUR SKILLS IN A NEW WAY (fig 3)
The most important assets of great photographers are not their ability to manipulate their equipment or materials, but rather the skills that are not only transferable to the digital world but are essential to all photography. To be able to "see" will never be replaced by new technology. This might seem like a strange statement to be coming from someone who is writing a book about digital technology, but it is important to understand that the ability to "see" is fundamental in all image-making endeavours.

This skill, which for most of you has probably been learnt over many years of looking at the world through a viewfinder, is the very basis of all great image-making. It is not dependent on the camera or film you use – if that were true then only those working with particular equipment and material combinations would produce successful shots. It is not something that is new – the great masters from the last century made fantastically memorable photographs because of their ability to see, not because of their place in history. And it is not a skill that will be lost in the digital world – on the contrary, digital photography is crying out for practitioners who are able to "see" and who have the skills to manipulate the tools and processes of this new area.

QUALITY (OR PRICE) IS NOT AN EXCUSE (fig 4)

OK, I admit that when I first saw the new digital technology in all its glory, 19 or 20 years ago, I was not all that impressed. The equipment was big, bulky and heavy. The images didn't appear sharp and for me to change to digital would have required me to sell not only my house but possibly several members of my family as well.

But even in those early days there was a hint of the revolution that was to come. The following years have seen the advancement of camera and printer technology to such an extent that now entry-level equipment can produce, or exceed, photographic quality images with comparative ease. The quality of image that even the cheapest digital cameras of today produce rivals that of the first professional models of the early nineties.

With such quality readily available, the last few years have seen a change in the way in which digital work is viewed. Before this period, most photographers played the "I can see pixels" game when confronted by a digital print. Along with this comment came the argument that as long as you could tell that the image's origin was digital then it should not be regarded as truly photographic. Now even the most basic digital kit can produce images that look and feel like traditional prints. This fact alone should encourage those of you who are still sceptical to give digital a try.

JUST ANOTHER TOOL IN YOUR KITBAG (fig 5)

In my photographic training I was taught to use a range of different cameras, film formats and stock types. No one combination was emphasized as more important or essentially any better than any other. Each camera type or film format had a purpose, advantages and disadvantages. When we were given a photographic task to complete, we would discuss which system would be appropriate for the job. Some days I would use 5 x 4 inch sheet film cameras, other days 35mm SLR (single-lens reflex) equipment. After graduation I took this way of working into my professional life.

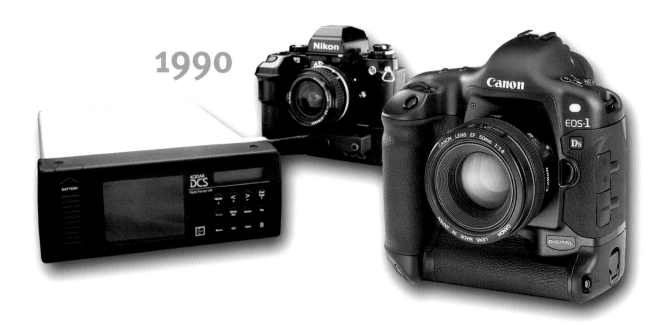

Fig 4 – The last two decades have seen a massive change in technology and digital image quality. Now cameras are lighter and don't need to be tethered to cumbersome backpacks and the average picture resolution has increased ten-fold.

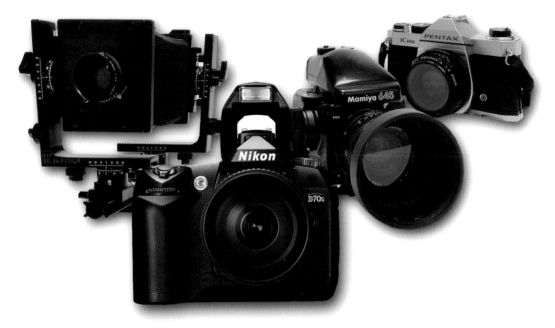

Fig 5 – Digital is yet one more choice for the working photographer. Don't be fooled into thinking that the technology is suitable for all shooting scenarios. Understanding the limitations and the advantages of the system is the key to knowing when, and for what jobs, you should choose pixel-based imaging over silver.

When digital came along I saw it as no different to any other system. It became another tool in my kitbag. Now, when asked to shoot images, I not only have to make decisions about format and film stock but I also have to choose whether to shoot film at all. Seeing digital in this way frees it from being the "new messiah" for all that is photographic. It allows the technology to be used for those tasks for which it is best suited and not used in areas where film is a better choice.

THE PROFESSIONALS ARE USING IT (fig 6)

As the technology increases in sophistication and quality, digital photography is being used for more and more shooting scenarios. Initially two groups of photographers saw the potential for digital in their spheres of image-making. Press photographers realized that not having to process or scan their images would see a faster turnaround time. Commercial shooters, on the other hand, used digital photography techniques to manufacture high-quality advertising images, replacing manual retouching and splicing techniques with faster digital versions.

A quick look at any photographic association's yearly show will demonstrate just how many

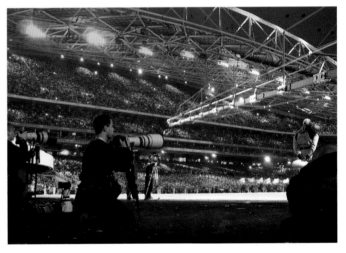

SHOOTING IN THE
OLYMPIC STADIUM

WIRELESS
TRANSMISSION

Fig 6 – Press and sports photographers were two of the first sectors of the industry to take up the digital challenge.

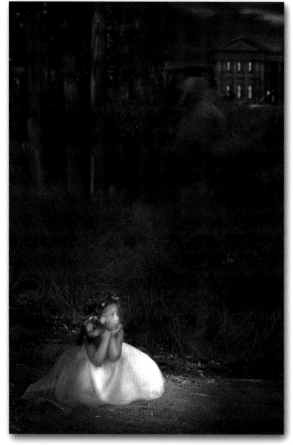

Fig 7 – Not to be outdone, wedding and portrait photographers are now diving headlong into the new technology.

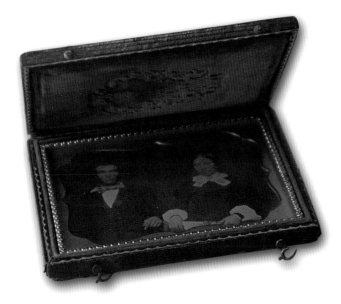

Fig 8 – The daguerreotype is an enduring reminder of photography's beginnings.

of the hundreds of images displayed owe part, if not all, of their existence to the new technology. Now professionals almost exclusively use digital for all their work. As a result the inner workings of the industry has changed forever (see fig 7).

The Sydney Olympics was the first in modern history where major press agencies chose to shoot no film. Of the 1200 professional press photographers present, at least 85 per cent chose to shoot pixel-based images. With this kind of statistic, it's easy to see why newspaper and magazine photographers see digital not as a passing fad but as their current reality. Round-the-clock processing facilities at big papers or major sporting events no longer exist. No sooner are the images shot and saved to disk inside the camera than they are being transported by modem or mobile phone to picture desks or press centres all over the world.

SOME THINGS ARE BETTER DONE DIGITALLY

Where speed is a major consideration, digital is now firmly entrenched as the only way to stay ahead of the game. In areas like current events and sports, more and more photographers, and their agencies, are working exclusively with pixel-based images. Tight deadlines mean that digital is the only viable option, especially if the photographer is working on the other side of the world.

In other sectors of the industry, such as editorial or illustrative photography, all retouching and montage work is now being completed digitally. A few years ago, images that were made up of two or three photographs combined together would have taken four or five days of careful masking and airbrushing to produce. Today such a montage can be completed digitally in minutes rather than days.

In fact, not only can digital work methods produce results more quickly than traditional ones, they are also capable of effects

and fine-tuning that were never possible before. Sophisticated colour correction is one such case. Using an image editor like Photoshop it is possible to alter the colour casts of the midtones, shadows or highlights independently within an image. This level of control was never a practical reality with traditional photographic printing.

IT WON'T GO AWAY, SO BE TRUE TO YOUR HERITAGE
So just as Niepce and Fox Talbot embraced the very latest in technology to help them in their drive to record the images that surrounded them, you too can take up the challenge of digital photography and move boldly into the modern era of image-making.

This book will help you get started with guidance on equipment, software and techniques, but always keep in mind that these things are only part of the story. Great photography is always a combination of technique, materials, processes and "seeing".

**A HISTORICAL PERSPECTIVE –
HOW PHOTOGRAPHY HAS EMBRACED
TECHNOLOGY THROUGHOUT HISTORY**

1826: Heliograph – The first photographic image ever created. The process was invented by Joseph Nicéphore Niepce and used a special type of bitumen that hardened when it was exposed to light. The plate was then washed with lavender oil to remove the areas of soft bitumen.

1838: Daguerreotype – Invented by Louis Jacques Mande Daguerre, the process used a highly polished surface of silver that was sensitized over the vapours of iodine crystals. After exposure the plate was developed using the fumes from heated mercury and fixed ready for viewing in light (see fig 8).

Fig 9 – Fox Talbot's process was the first to introduce a positive/negative system to the photographic equation.

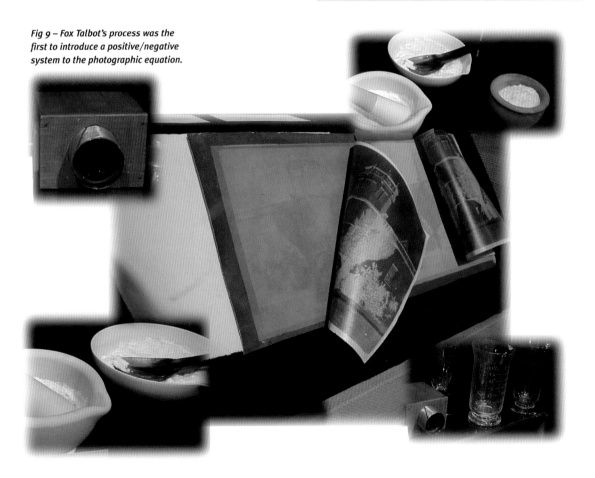

Fig 10 – The glass plate produced images of wonderful clarity and detail as most prints were made from contacting the negative rather than enlarging it.

1839: Calotype – William Henry Fox Talbot announced a process based on a negative/positive system that is the forerunner of modern film-based photography. A paper negative was made of sensitized paper that was exposed, developed and fixed. This image was then placed in contact with another piece of sensitized paper, exposed and processed for the positive print (see fig 9).

1851: Collodion Wet-Plate – Combined the detail of the daguerreotype with the reproducibility of the calotype process. The system involved the use of glass plates which had been coated with a sensitizing emulsion and then exposed and developed while still wet (see fig 10).

1880s: Roll Film – George Eastman is credited as the man responsible for popularizing photography by providing a roll film and simple camera system that did away with the heavy plates of the collodion process (see fig 11).

1935: Kodachrome and Agfacolour – The introduction of these two films made it possible to produce high-quality colour images easily and comparatively quickly.

1963: First Basic Digital Camera – David Gregg from Stanford University invented a videodisk type digital camera which was capable of capturing and storing images for a few minutes.

1986: Megapixel CCD Sensor – Kodak designed and created a sensor that contained 1.4 million pixels.

1990s: First Commercial Digital Cameras – Starting with black-and-white only and then moving into full-colour, Kodak provided digital solutions for the working professional (see fig 12).

2000: Mass Production of Digital Cameras – Consumer and professional level cameras capable of extremely good image quality produced and sold in great numbers.

2005: Affordable Digital SLR Cameras – After previously releasing professional level "full frame" digital SLR cameras Canon makes the technology more affordable with the introduction the EOS 5D.

2009: Full frame and video SLR Cameras – Price continues to fall as features and functions increase. Full frame DSLR cameras become even more affordable and HD video and sound finds its way onto many models.

"STARE. IT IS THE WAY TO EDUCATE YOUR EYE"

Walker Evans (1903–1975)

Fig 11 – Roll film made photography affordable for the masses.

DIGITAL COMMANDMENTS

Seven things **not** to believe when it comes to digital imaging:

1. *A bad photograph can be saved using the digital process.* The best way to ensure good images is to take them in the first place.

2. *The digital way of working is suitable for all image-making.* This line of thinking is only purported by salesmen and the ill-informed.

3. *You have to be rich to get into digital photography.* Entry-level equipment is a lot more affordable than it used to be.

4. *Digital imaging can never achieve the quality of traditional photography.* This is definitely not true. In fact some high-end digital systems are able to record a far broader range of brightness than was ever possible with traditional films.

5. *Digital will mean the death of traditional photographic skills.* Sure you will need to learn about some new equipment and processes to take full advantage of the new technology, but your composition and "seeing" skills will always be invaluable and more importantly, transferable.

6. *You will have to be a computer technician to be able to get involved in digital photography.* This is no more true than saying that you will need to be a mechanic to drive a car. It is true that you will need to familiarize yourself with a new way of working, but your job is to concentrate on making the images not the technology.

7. *Because digital photography makes it so easy to manipulate images convincingly no one will be able to believe that photographs are true any more.* Photographs have always been manipulated and changed so that they no longer resemble reality. It's only with the advent of mass-appeal image-editing programs that the general population now realizes just how easy it is to change images.

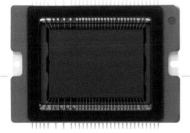

Fig 12 – The continued development of electronic sensors is the cornerstone of the modern digital system.

::::DIGITA

DIGITAL VERSUS TRADITIONAL PHOTOGRAPHY

DIGITAL VERSUS TRADITIONAL PHOTOGRAPHY

Agood way to start looking at the new technology is to compare it with what most of us already know and understand. In this section I will introduce the concepts of digital photography using ideas that will be familiar to anyone who has used an ordinary film camera.

THE CAMERA

Look at most modern digital cameras and you will see little difference from their film-based counterparts. Sure, most models have a tell-tale viewing screen on the back of the body but, apart from this, most look and feel very familiar. If you describe a camera in its simplest terms it is a box with a lens, viewfinder, shutter, aperture and a place to hold the film (see fig 1).

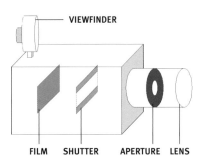

Fig 1 – All cameras are basically a light-tight box with a lens, viewfinder, shutter, aperture and a place to put the film.

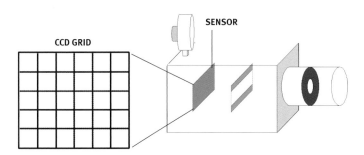

Fig 2 – Digital cameras are very similar to film cameras in most areas except that the film is replaced by an electronic sensor.

All cameras, no matter how basic or sophisticated, follow this simple design. The photographer frames the image using the viewfinder. When the composition is judged to be just right, the shutter is released. Light passes through the lens and the aperture and is focused on to the film. The shutter is closed at the point when enough light has reached the film to form an image.

The digital camera adheres to this basic design in most ways except that the image is recorded on to a digital sensor rather than film (see fig 2). All the other elements of the camera work in much the same fashion for both traditional and digital image capture. If you are proficient with your film camera then you will be able to transfer a lot of your skills to new digital equipment.

DIGITAL FILM

The heart of a digital camera is the sensor. This usually takes the form of a grid of Charge Coupled Devices, or CCDs, each designed to measure the amount of light hitting it. When coloured filters are placed over the top of each CCD, each sensor can determine the colour of the light as well as the quantity. The filters are set in a pattern across the grid alternating between red (R), green (G) and blue (B) (see fig 3). Using just these three colours it is possible to make up the majority of the hues present in a typical scene.

Colour film and filtered sensors

The idea that all the colours that we see can be made up of three basic or primary colours might seem a little strange, but this system has been used in colour photography from the time that it was first invented. In fact the modern colour film has more in common with its digital sensor counterpart than you might first realize.

Almost ninety years ago it was discovered that you could capture the colour detail of a scene by shooting

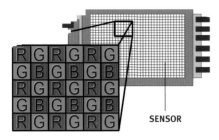

Fig 3 – A pattern of filters on a grid or matrix of CCD cells forms the heart of most digital cameras.

it on black-and-white film through red, blue and green filters. If these images were then projected together through the same filters, the colour scene could be recreated. Since those early days colour film has developed in sophistication but this basic separation idea remains the same – the colours of a scene are separated and recorded individually and then recombined as a print or transparency (see fig 4).

Once it was found that CCDs could only record black and white (the brightness of a scene), it was a comparatively small jump to impose a similar separation idea on to a grid of CCDs. The result is that the majority of sensors in cameras now use this system. The files they produce are called RGB as they contain the colour information for the scene in three separate black-and-white channels relating to each colour, red, green and blue. When we view the file on screen or print it the three separations are recombined to form a full-colour image (see fig 5).

The new grain

With traditional film the details of a scene are recorded via an intricate structure of light-sensitive grains. Each grain changes in response to the light that hits it. These grains can be visible on the final print or transparency, most noticeably in large prints, or if you have been using a fast film designed for low-light photography.

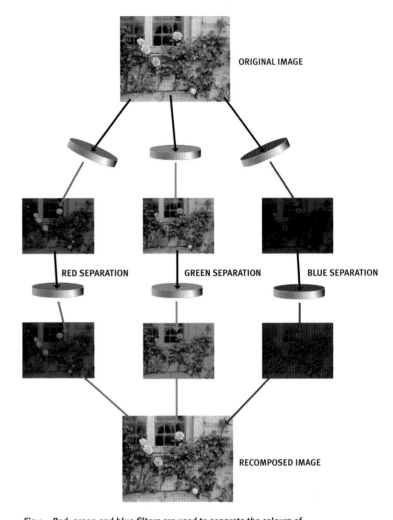

ORIGINAL IMAGE

RED SEPARATION GREEN SEPARATION BLUE SEPARATION

RECOMPOSED IMAGE

Fig 4 – Red, green and blue filters are used to separate the colours of a typical scene into three greyscale images. These pictures are then tinted and recombined to form a colour version of the original scene.

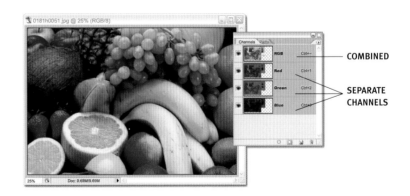

COMBINED

SEPARATE CHANNELS

Fig 5 – Colour digital files are made up of red, green and blue channels which are stored separately and are then recombined when printed or viewed on screen.

Fig 6 – Pixel grids seen from a
distance appear as though they
are a continuous tone photograph.

The digital equivalent of grain is a picture element, or pixel as it is usually called. Your digital photograph is made up of a grid of pixels. When seen at a distance these rectangles of colour blend together to give the appearance of a continuous tone photograph (see fig 6). Each pixel is the result of a CCD sensor recording the colour and brightness of a part of a scene. The more sensors you have on your camera chip the more pixels will result in your digital file. Just as the grain from traditional negatives is more noticeable as you make larger prints, pixels also become more apparent as you make bigger pictures.

THE DIGITAL PROCESS

The process used for capturing images the traditional way is so familiar for most of us that it is almost second nature. Shoot your images onto film, have the film processed and your negatives enlarged and then sit back and enjoy your images. When it comes to the digital equivalent it can be a little more confusing (see fig 7).

Essentially we still have three main stages – a shooting (capturing) phase, a processing (manipulation) phase, and a printing (outputting) phase. However what happens in each stage is a little different (see fig 8).

SHOOTING

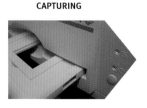

PROCESSING

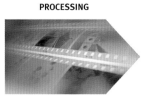

PRINTING

Fig 7 – The traditional
photographic production
cycle with its three
basic stages.

CAPTURING

MANIPULATION

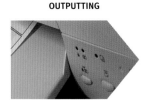

OUTPUTTING

Fig 8 – The digital
production cycle still
has three distinct
phases but after the
familiar shooting
phase the way the
content is processed
is quite different.

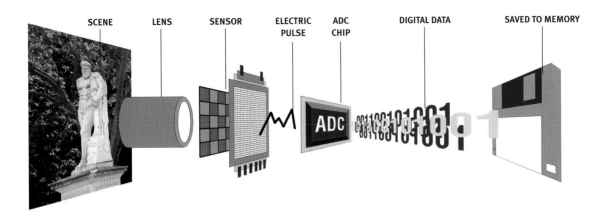

SCENE LENS SENSOR ELECTRIC PULSE ADC CHIP DIGITAL DATA SAVED TO MEMORY

Fig 9 – Shooting skills are very similar with film and digital cameras. The difference is that the digital camera captures the image using a grid of electronic sensors rather than a piece of film.

Shooting (capturing) (fig 9)

1. The image is composed and focused and the shutter is released. Here the concerns are the same whether you are shooting on film or with a digital camera.
2. Light hits the sensors. Varying amounts of light are reflected from the scene focused by the lens onto the sensor. Each sensor receives a slightly different amount of light.
3. In response to the light, each CCD cell produces an electrical charge. The more light, the greater the charge. Keep in mind that each sensor is filtered red, green or blue so the charge reflects the colour of the light as well as the amount.
4. All the electrical pulses are collated, converted to digital information and stored according to their position within the CCD grid or matrix. This process is sometimes called quantization and uses a special chip called an analog to digital converter or ADC.
5. The digital information is stored in the camera as picture files. The information which now represents a single digital image made up of pixels, each of which has a position within the grid, a colour and a brightness, is saved to memory within the camera. The camera is now ready to take another shot.

Processing (manipulation) (fig 10)

6. The digital files are transferred to a computer. The space within the camera is limited so at some stage it is necessary to download or transfer the image files. This is usually achieved by connecting a cable from the camera to a PC.
7. Once the image is on the computer an editing program like Photoshop can be used to enhance the image.
8. The enhanced picture is saved in the computer, usually on the hard disk.

Printing (outputting) (fig 11)

9. At this point the image is ready for outputting. Most times this means making a print using an inkjet or similar colour printer, but the digital file can also be used for web publishing or even printed (written) back to film as a slide or negative.

MORE SENSORS = HIGHER RESOLUTION = BETTER-QUALITY PICTURES

In traditional photography, the film is separate from the camera so it is possible for a photographer to select the film that is suitable for a particular job. If you are shooting sport under floodlights at night you can use a fast film that is particularly sensitive to low light. If, on the other hand, you are shooting under controlled lighting conditions within a studio, you can use a slow film with fine grain and saturated colours.

The digital photographer doesn't have the luxury of being able to swap recording stock. The sensitivity and "grain" or resolution of the sensor is fixed. For this reason manufacturers continue to try to develop digital cameras with higher resolution chips that can handle a greater range of lighting conditions.

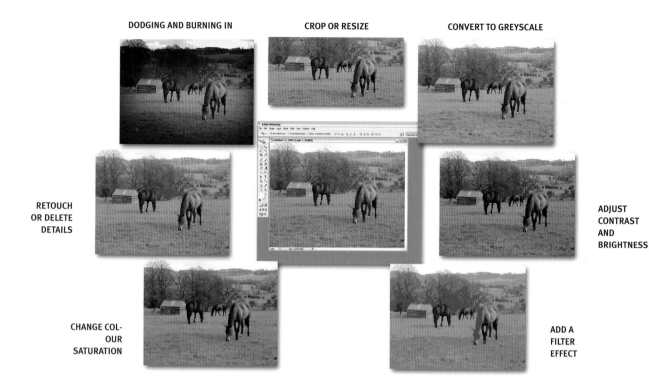

DODGING AND BURNING IN

CROP OR RESIZE

CONVERT TO GREYSCALE

RETOUCH OR DELETE DETAILS

ADJUST CONTRAST AND BRIGHTNESS

CHANGE COLOUR SATURATION

ADD A FILTER EFFECT

Fig 10 – It is during the manipulation stage of the process that we can see the power of digital photography. Here images are enhanced or changed according to the photographer's design or fancy.

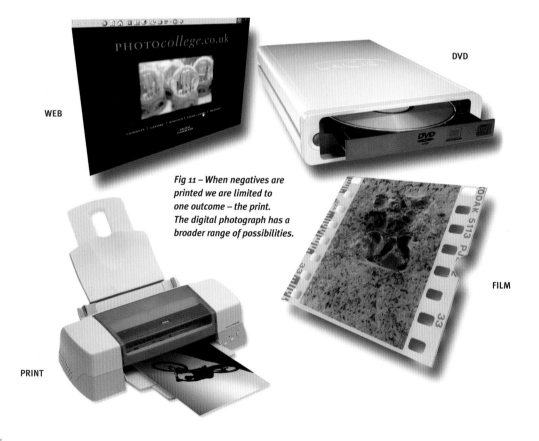

WEB

DVD

PRINT

FILM

Fig 11 – When negatives are printed we are limited to one outcome – the print. The digital photograph has a broader range of possibilities.

Over the last few years we have seen digital camera resolution increase from the early days where it was measured in hundreds of thousands of pixels to today when chips are capable of upwards of 20 million pixels. Some specialist studio models are capable of 50-million-pixel images but these are not your average point-and-shoot cameras. To put these figures into perspective the average 100 ISO film is estimated to have 60 million light-sensitive grains within one 35mm frame. This means that the best digital SLR camera's sensors are capable of recording similar amounts of detail to that possible when using film.

In terms of sensitivity, a few years ago the average digital camera chip had an equivalent ISO rating of between 100 and 200. Now professional-level press models like the Nikon D2Hs can shoot up to a sensitivity of 6400 ISO (see fig 12). This effectively enables the digital press photographer the opportunity to shoot under a much wider range of lighting conditions than ever before.

THE BASICS
Lens
The function of the lens is to focus the image in front of the camera onto the film or sensor. Lenses for digital cameras are essentially the same as those for film-based cameras. In fact with some professional-level cameras the same lenses can be used on both film and digital camera backs.

Viewfinder
The viewfinder is the photographer's frame around the world. It is here that the image is composed and a moment selected for the shutter to be released. Most digital cameras have a viewfinder that is separate from the lens as well as a small colour screen that, in some modes, can act as a preview of what you are photographing.

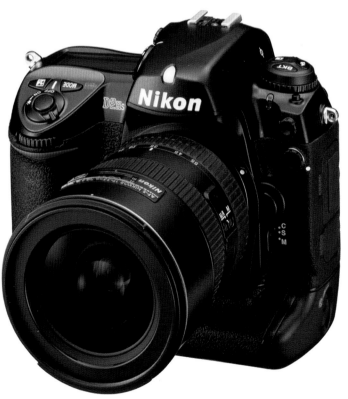

Fig 12 – The Nikon D2Hs is capable of shooting under a much wider range of lighting conditions than ever before.

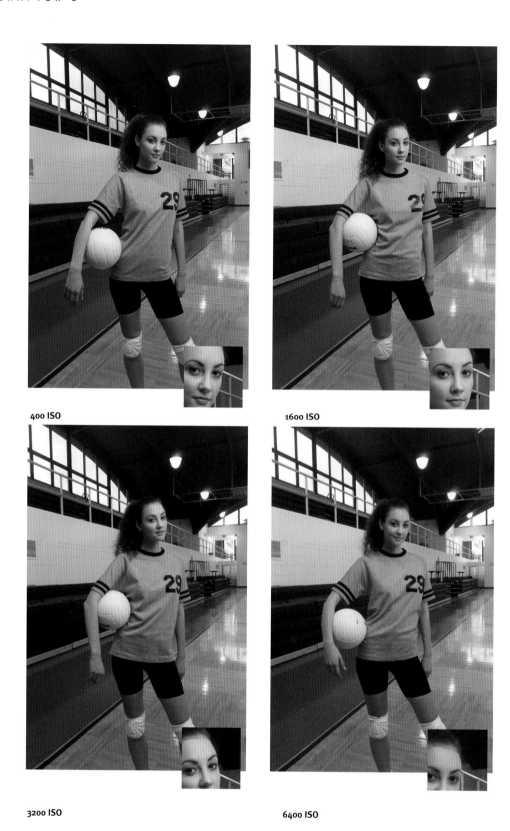

400 ISO

1600 ISO

3200 ISO

6400 ISO

Fig 13 – Unlike other cameras before it, the DCS620x and DCS720x use cyan, magenta and yellow filters to separate scenes into three greyscale channels. In doing so it has gained a full stop more sensitivity.

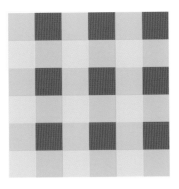

Fig 14 – The CCD chip Kodak uses in its DCS620x and DCS720x is based on cyan, magenta, yellow separation of the light rather than red, green, blue.

STANDARD RGB FILTER PATTERN

NEW CMYK FILTER PATTERN

Shutter

The shutter helps controls the amount of light falling on the film or sensor. In film-based cameras the shutter is usually a thin metal curtain that is raised to allow light into the camera for a specific amount of time and then lowered. Some digital cameras work in a similar manner, but others just turn the sensor on and then off again.

Aperture

The aperture is the second mechanism that controls the amount of light entering the camera. It works in a similar way to the irises in our eyes. When light levels are high the hole is made small to restrict the amount of light hitting the film. When levels are low the diameter is increased to allow more light to enter the camera.

The film

Instead of the traditional film, the digital camera captures its images using a sensor. Areas of light and dark together with information about the colour of the scene are all recorded within a fraction of a second.

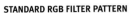

EXCEPTIONS TO THE RULES
Non RGB filtered cameras (fig 13)

Not all cameras use RGB sensors. For instance a few years ago Kodak released a different version of

its press camera. The DCS720x was a major change from previous models. Instead of using a CCD matrix that is filtered red, green and blue, Kodak changed the separation filters of the sensor to cyan (C), magenta (M), and yellow (Y) (see fig 14).

In doing this Kodak gained an extra stop of usable sensitivity as the new filters allow more light to pass to the sensor than before. This means that the camera can be used with an ISO film sensitivity setting equivalent to 6400.

For anyone familiar with colour printing techniques the step probably appears to be a fairly simple one. For years we have known that CMY colours work in a balancing act with their opposite RGB

Fig 15 – The colour diamond familiar to all you colour printers out there clearly shows the relationship between the two separation systems.

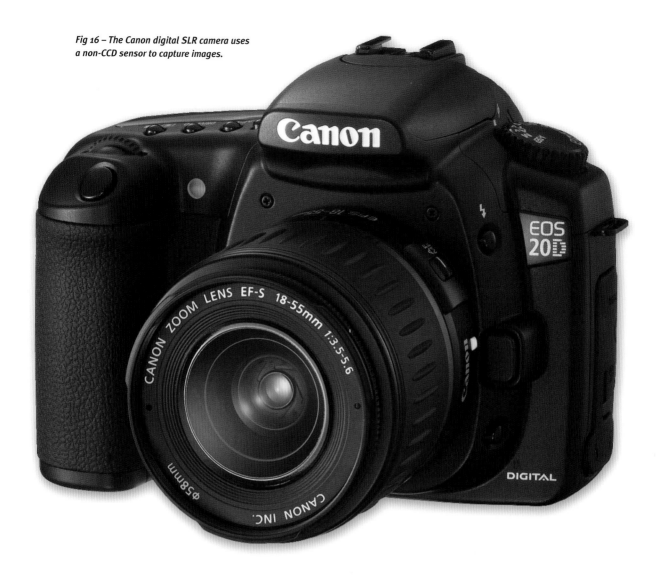

Fig 16 – The Canon digital SLR camera uses a non-CCD sensor to capture images.

colours to form white light. So it seems completely logical to swap separation filters and gain the advantage of more light hitting the sensor (see fig 15).

Non-CCD sensor cameras (fig 16)

While CCDs are the main image sensor technology in town, some manufacturers are successfully pioneering image capture using other techniques. Early in 2002, Canon introduced a six-megapixel digital SLR camera based on the highly acclaimed EOS 1-N film camera. The camera makes use of a CMOS chip rather than the usual CCD matrix (see fig 17).

As well as the CMOS sensor used in Canon cameras Foveon produces a three-layer sensor called the X3 which is used in Sigma digital SLR cameras. The unusual design embeds the pixel sensors in silicon and then uses its ability to absorb red, green and blue at different depths to separate and record the colour in a picture.

HOW IS A SENSOR'S RESOLUTION MEASURED ANYWAY?

A digital image is measured not in inches or centimetres but in pixels. Each pixel relates to a sample that was taken by a CCD sensor during the capturing process. Digital cameras have a set number of sensors and so the resultant file's pixel dimensions can be directly related to the chip it was made with.

The sensor's resolution is measured by quoting the number of pixels widthways by the number in height. Take a resolution of 1200 x 1600 pixels. When these dimensions are multiplied you will have a sensor with approximately two million pixels. This is called a two-megapixel sensor.

When digital pictures are printed the pixels are spread over the paper at a specific rate per inch (or centimetre). This gives us the printing term dots per inch (DPI).

Fig 17 – Canon has successfully enlarged the CMOS sensor technology that it has been using in its scanner products to suit capture in its cameras.

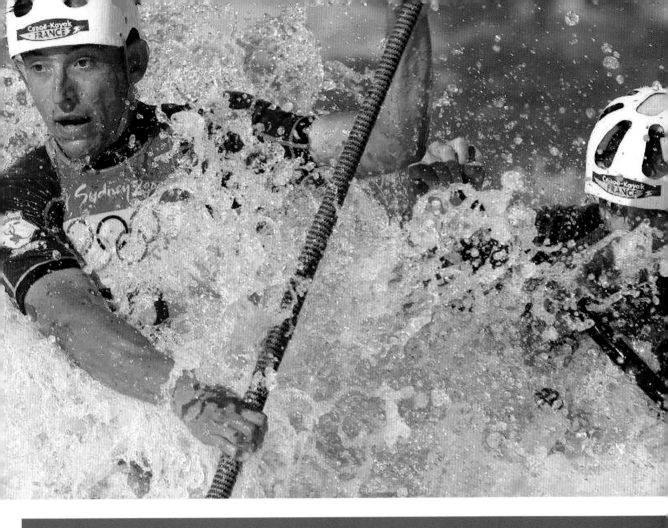

CAPTURING THE IMAGE

CAPTURING THE IMAGE

CAPTURING THE IMAGE

Most photographers start on their life-long image-making journey because they enjoy taking pictures. Those of us who are actively involved in using digital technology are no different.

I believe that the technology is secondary to making great images. This might seem like a funny thing for the author of this book to say, but I feel that making the images is the main job of the photographer and the technology, be it traditional or digital, plays a supporting rather than leading role in this task. Don't get me wrong, knowing your medium is a sure way to guarantee good results. But in getting to understand the characteristics of equipment and software, never lose sight of the technology's role in your photographic life. It is there to underpin your image-making, not overtake it.

For this reason, I will take the first part of this chapter to outline some basic imaging principles that could easily be used by traditional film shooters as well as their digital counterparts.

STARTING TO SHOOT (fig 1)

Photography can be a hard taskmaster. A lot of people find the whole thing a bit overwhelming when they first start taking pictures. So let's simplify things a little. I believe that when it gets down to it there are only really three things you need to understand to make great images from day one.

I call them the holy trinity of photography – no offence intended. The fact is, these three elements interact so much, it is as though they are one. Get to grips with these ideas and you will start your image-making career on a firm footing.
They are:
- Composition
- Focus
- Exposure

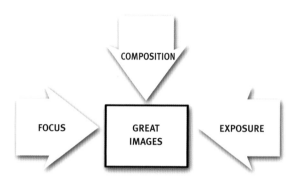

Fig 1 – Good focus, composition and exposure all combine to make great photographs.

COMPOSITION

When you look through the viewfinder of a camera you are framing the world. Just as a painter would do, you are choosing what is in the frame and how each of these elements will fit together.

Some of you might say that this is overstating the activity, "All I do is point the camera at the subject and push the button". I agree, but whether you realize it consciously or not, in pushing the button, you are actually making a lot of decisions that affect the way your images look.

Making better compositions (and photos) is all about becoming actively involved in the decisions you make before exposing the film. I find it helpful to look at these choices one by one.

Filtering – What to Put In and What to Leave Out! (fig 2)

Filtering is something that a lot of people do almost without thinking. Put a camera in someone's hand and immediately they are asking you to "Move that vase", or "Stand to the right so that I can see the church steeple behind you". The fact is, we all make decisions about what should be in the picture.

Keeping it simple is a great way to get control over how your images are organized. When you are looking through the viewfinder, ask yourself this question: "Is there too much in the frame?" Often some of the best images are the ones that present a single idea,

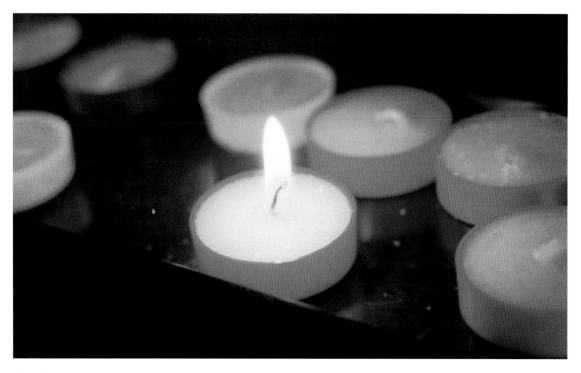

Fig 2 – Keeping the composition simple gives you a greater chance of ending up with a balanced image.

or subject, without distraction. Move objects, change backgrounds and even reorganize your subject if you have to – but make sure that distractions or unwanted elements are removed from the frame.

Get to the point! My view is that photography is about communication, and as we all know, one of the quickest and best ways to communicate is to get to the point. The same can be said of making images. Again, when you are shooting ask yourself "What am I trying to say in this shot?", or "What is the point of the photograph?". Once you have narrowed your ideas down, study the image in front of you in the viewfinder and make sure that all of what you see relates to the point you are making.

If you are taking a portrait, make sure that all the other objects in the frame relate to your sitter in some way. If they don't, remove them. If your interests lie in the area of landscape photography, be selective about what you leave in or put out of the picture. Move the camera around. Make sure that what you are viewing presents a clear and consistent idea.

Remember, filtering can make or break a shot. Don't just think about what you want in the picture, think about what you don't want as well (see fig 3).

Fig 3 – Search the viewfinder to find objects that distract from the main idea of your image. Change position or angle to eliminate these things from your picture.

Framing – Learn to See as the Camera Does

Your eye is an amazing piece of imaging equipment. When you look at an object, it's possible to concentrate your vision so much that the other things in your peripheral view almost don't exist. Unfortunately the camera is not as clever, and not nearly as selective.

When viewing a scene through a camera's viewfinder, new photographers often only look at the object on which they are focusing. After all, this is the way we see and it is also a good way to start framing your picture. But concentrating on the main subject is just the beginning. Your next step should involve actively scanning the rest of the frame to see how other picture elements interact with your main point of interest.

Fig 4 – Make sure you look at what is in front of, as well as behind, your subject at the time you press the button.

Have you ever had the experience of getting your images back from the processing outlet to find a few surprises in the foreground and background areas? I often hear new photographers say "I don't remember that being there". This is a sure sign that they haven't scanned the whole frame – fore-, mid- and background – before releasing the shutter (see fig 4).

The lesson is to learn to see as the camera sees. I know that it sounds difficult, but with a little practice it is possible to focus on the main point of interest in the frame and then quickly scan the other areas of the image to check for distractions.

Balance –The Art of Composition

Texts abound on the subject of composition and balance. Most introductory design courses contain at least one mandatory unit called "Fundamentals of Art and Design". In these classes students are presented with all sorts of rules and guidance to follow if they want to make masterpieces. I'm not about to go into depth about all these ideas but what I will do is give you some basic ideas that will get you started.

Visual weight: Composition is all about making the elements within your frame seem balanced and "at ease with themselves". To achieve this, look at the visual weight of each element in turn. Colour, texture or brightness all determine how much attention-grabbing effect, or weight, an object has. A red flower against a deep green lawn, for instance, will attract a lot of attention – it has visual weight due to the contrast of colours.

Balancing act: To produce a balanced composition the photographer has to adjust the position of objects within the frame according to their visual weight. If you place a bright white element on the edge of the frame, our eyes will be attracted to it, and then get drawn out of the frame. Generally the result is an unbalanced picture. If the photographer changes position and the bright white element is now in the centre of the frame, our eyes will be held on the image and the whole picture will feel more balanced.

Types of balance: The simplest balance is symmetrical. This is where the point of interest (and the element with the most visual weight) is in the middle of the frame. Asymmetrical balance, on the other hand, means that the interest points are off centre (see figs 5 & 6).

A good guide when positioning objects off centre is the rule of thirds. The frame is divided vertically, and horizontally, into thirds. To balance the picture, the elements are placed on these lines, or at their junction points.

Fig 5 – Placing your main point of focus in the centre of the frame is the easiest way to balance your images.

Fig 6 – Positioning objects off centre requires you to balance their visual weight with another part of the image that is equally strong.

Rules are meant to be broken: The details above are just guides. Conforming to them will increase your chances of achieving visual balance, but won't guarantee it. And great images don't always adhere to any of these rules.

The best advice I can give is look at how other image-makers handle balance in their work and then practise, practise, practise. Once you have been shooting for a while, the basics become second nature and you will be able to refine your skills and orchestrate complex compositions with more ease than you thought possible. Just as children take years to learn to read, it will take time for you to become visually literate.

Angle of View and Perspective – Getting Right Down (or Up) to It.

Too often photographers get into the habit of always shooting their images from the same height. In most cases this is eye level or the height of your tripod. By always shooting from one level, you will be missing out on a lot of great images.

Shoot high, shoot low, but just keep shooting. I can still remember as a new photographer going to see how a real professional worked. At the time he was shooting some press images for the local paper. Once he started photographing, I recall how he moved around his subject, shooting (and talking) all the time. He changed positions constantly, making sure he had covered all the possibilities available from the location and the sitter. In his words he was "working the subject".

I learnt from this man that you need to keep searching for the great images and that even people with high levels of skills are always trying to come up with a new angle on familiar subjects.

Lenses, lenses, lenses! It is amazing the kit options that the contemporary photographer has. Nowhere is this more true than when it comes to lens choice. Even those of us who have to work to strict budgets are able to purchase either a good zoom or a set of prime lenses of differing lengths.

The digital world too is changing. The first-generation cameras had either fixed focal length lenses or very short zooms. More and more of the newer models are being released with long zooms that are at least the 35mm equivalent of 28–105mm.

The availability of these types of lenses gives the photographer a whole host of compositional options. The first, and most obvious, is the ability to zoom in or out from a subject without changing position.

Fig 7 – Wide-angle lenses increase the sense of perspective in an image and give an overall feeling of foreshortening to your photographs.

The second option is the most interesting as it deals with the change in perspective that occurs when moving between wide-angle and telephoto or long lenses. Using long lenses will flatten the perspective in your images whereas wide-angle lenses will increase or steepen the effect (see figs 7 & 8).

If you don't move around your subject, or change the focal length of your lenses, you are missing opportunities and the chance to discover and shoot images that you hadn't dreamed of.

Fig 8 – Long lenses compress visual space, making objects seem a lot closer in the photograph than they were in reality.

WIDE-ANGLE AND LONG LENSES (fig 9)

In 35mm terms a standard lens (50mm) has similar perspective to our own eyes. "Long" or "telephoto" lenses see a narrower angle than our eyes and can range from 85 to 600mm or greater. They are similar in effect to a telescope, allowing the photographer to get in close to a distant scene or action.

Lenses with a smaller focal length than standard are consider wide-angle. These lenses see a larger angle of view than our eyes and have a focal length of 20 to 40mm. They are often referred to as "short" or "wide" lenses. They are great for shooting landscapes, or the interiors of small spaces.

Most digital sensors are smaller than the 35mm film frame. This difference affects the perspective of different lens lengths. As the way we classify lenses as wide, standard or long is related to the frame size, a "standard" digital lens is likely to have a focal length of only 10mm. To give you some reference point, always look for the 35mm equivalent lens length. This will help guide your lens choice (see fig 10).

Most modern film and digital cameras are supplied with a zoom lens. This enables the photographer to adjust their lens length freely between two set limits. Popular zooms range from the wide (film camera 28mm) through standard (50mm) to short telephoto (105mm) (see fig 11).

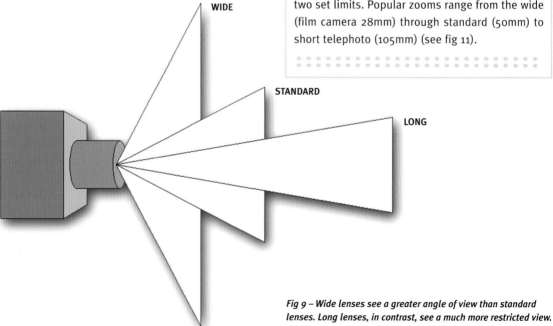

Fig 9 – Wide lenses see a greater angle of view than standard lenses. Long lenses, in contrast, see a much more restricted view.

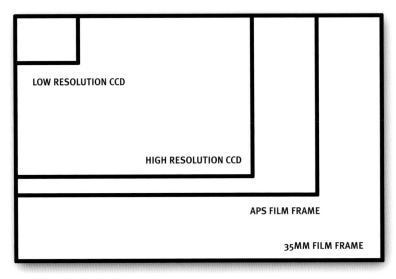

LOW RESOLUTION CCD

HIGH RESOLUTION CCD

APS FILM FRAME

35MM FILM FRAME

Fig 10 – Despite the increase in digital sensor size and resolution, the majority of cameras still have a capture area less than a 35mm frame.

Fig 11 – Zoom lenses give the user the chance to move in to a subject or widen the view to shoot interiors or landscapes. The images above are (left to right) 35mm, 50mm, and 86mm lens lengths.

FOCUS

The majority of digital cameras sold today are supplied with an auto focus (AF) lens system. In the viewfinder you will see at least one, but sometimes more than one, focusing area. For the camera to focus, the subject must be in this area. Light pressure on the shutter button activates the camera and sets the focusing on the subject that is positioned here.

In most cameras the focus area is positioned in the centre of the frame (see fig 12). In professional models though, you will not only find multiple focusing areas, but you will also notice that they are distributed across the viewfinder. With the aid of a dial, or a thumb toggle, the photographer can choose which area will be used for primary focus. This enables the focusing of subjects that are off centre.

For those readers who have systems with a single central focusing zone it is still possible to focus on subjects that are off centre in the frame. Most cameras allow the user to lock focus by pressing the shutter but-ton halfway whilst positioning the focusing area. With the focus set and without releasing the button, you can now move the camera so that the subject is off centre. Pressing the button further will release the shutter.

Fig 12 – In the centre of the viewfinder of most auto focus cameras is the focal area. The subject you want sharp must be in this area when you focus the camera.

EXTENDED SHOOTING SKILL – ZONE FOCUSING

There are a range of activities that allow the photographer the chance to predict where a moving subject will be with reasonable accuracy. In swimming for instance, the lanes and the end points of the pool are well defined. Using the zone focusing technique, the photographer would pre-focus on one point in the pool and wait for the subject to pass into this zone before pressing the shutter.

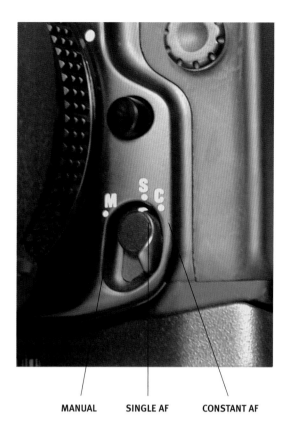

MANUAL SINGLE AF CONSTANT AF

Fig 13 – Different focusing modes give photographers the flexibility to match the subject with the focusing method that suits it.

SINGLE AND CONSTANT AUTO FOCUS (fig 13)

In AF terms, two modes determine the way in which the auto focus system works on your camera. In single mode, when the button is held halfway the lens focuses on the main subject. If the user wishes to change the point of focus then they need to remove their finger and repress the button. In this mode, if the subject moves, you must refocus.

The constant or continuous focusing mode focuses on the subject when the shutter button is half pressed, but unlike the single mode, when the subject moves, the camera will adjust the focusing in order to keep the subject sharp. This is sometimes called focus tracking. Some AF SLR systems have taken this idea so far that they have "pre-emptive focusing" features that not only track the subject but analyze its movement across the frame and try to predict where it will move.

Each mode has its uses. Single focusing is handy if you wish to focus on a zone into which the subject will appear. Constant is more useful for subjects that move more randomly.

Depth of Field

What you focus on in the frame is not the only factor that determines what appears sharp in the final image. Some images, though focused on a small part of the overall picture, have sharpness from the foreground right through to the background. In other photographs one small section of the image is sharp and the rest is blurred. This area of sharpness within an image is called the "depth of field of appreciable sharpness", but most photographers refer to it as "depth of field" or "DOF" (see figs 14 & 15).

Images that display sharpness from the foreground into the background are said to have large DOF. Photographs with only one area or object sharp have shallow DOF. Experienced film-based photographers are able to control not only where their images are focused but also how large the DOF effect is within their images.

Digital shooters can use similar techniques to those employed traditionally, but the small size of most sensors means that the majority of digitally sourced images will contain large depth of field characteristics. This said, careful control of aperture, focal length and subject distance will still enable photographers with pixel-based equipment to make images with a variety of sharpness ranges.

Fig 14 – In shallow depth of field images only one part of the image is sharp.

Fig 15 – Large depth of field images have sharpness from the foreground right into the distance.

DEPTH OF FIELD CONTROL TECHNIQUES (fig 16)

The area of sharpness within your photograph is controlled by three distinct factors:

Aperture: Changing the aperture, or F-stop number, is the most popular technique for controlling depth of field. When a high aperture number like F32 or F22 is used, the picture will contain a large depth of field – this means that objects in the foreground, middle ground and background of the image all appear sharp. If, instead, a low aperture number is selected (F1.8 or F2), then only a small section of the image will appear focused, producing a shallow DOF effect.

Focal Length: The focal length of the lens that you photograph with also determines the extent of the depth of field in an image. The longer the focal length (more than 50mm on a 35mm camera) the smaller the depth of field will be, the shorter the focal length (less than 50mm on a 35mm camera) the greater DOF effect.

Distance from the subject: The distance the camera is from the subject is also an important depth of field factor. Close up or macro photos have very shallow DOF, whereas landscape shots, where the main parts of the image are further away, have a greater DOF. In other words, the closer you are to the subject, despite the aperture or lens you select, the shallower the DOF will be in the photographs you take.

EXPOSURE

Contrary to popular belief, good exposure is just as critical in digital photography as traditional shooting. Bad exposure cannot be "fixed in Photoshop". Under- or overexposure of the sensor leads to images in which the critical picture detail is lost forever. The creation of good-quality images always starts with the capture of as much of the image detail as possible, and the capturing process is governed by good exposure (see fig 17).

The theory is simple. To capture good images you must adjust the amount of light entering the camera so that it suits the sensitivity of the sensor. Too much light and delicate highlights are converted to white and lost, too little and shadow details become solid areas of black. The photographer alters the level of the light with two camera controls – the shutter and the aperture.

The shutter determines the length of time that the sensor is exposed to the image. The length of the period that the shutter remains open is indicated by shutter speeds. The longer the time, the more light hits the sensor and the greater the overall exposure will be. With this in mind, photographers can increase exposure by selecting long shutter speeds, or decrease exposure by using shorter ones.

Shutter speeds are represented in terms of fractions of a second, 1/125th being 1/125th of a second. The range of speeds available on most cameras is broken up into a series of numbers, each one the double, or half, of the one before (see fig 18).

Coupled with the shutter is the aperture control. Working something like the iris of our own eyes, this mechanism changes the size of the opening in the lens through which the light travels. Making the aperture, or hole, larger lets in more light giving a greater exposure; reducing the size restricts the light and produces less exposure overall.

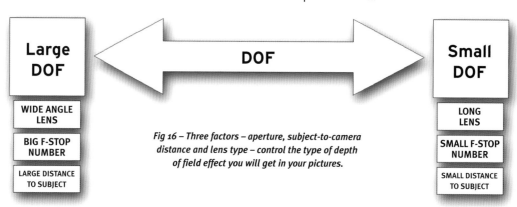

Fig 16 – Three factors – aperture, subject-to-camera distance and lens type – control the type of depth of field effect you will get in your pictures.

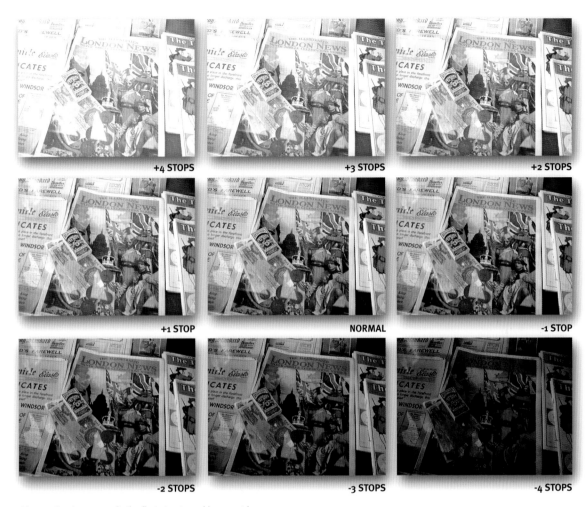

Fig 17 – Good exposure is the first step to making great images.

HALF THE EXPOSURE

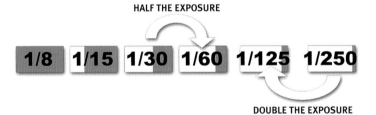

DOUBLE THE EXPOSURE

Fig 18 – Shutter speeds are arranged in a series in which each
step either doubles or halves the amount of light reaching the sensor.

HALF THE EXPOSURE

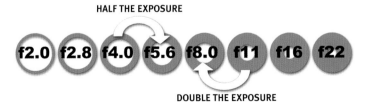

DOUBLE THE EXPOSURE

Fig 19 – The aperture series is organized in terms of F-stop numbers, each
allowing half or double the amount of light into the camera than the one before.

Again, the range of possible aperture opening sizes is represented by a number series. These are called F-stops. The numbers are organized in a halving or doubling sequence, each higher F-stop number reducing the amount of light entering the lens by half (see fig 19).

Metering (fig 20)

"All very interesting," you say, "but how do I know what F-stop and shutter settings to use to guarantee the right amount of light hits the sensor?" Good question. All digital cameras contain a metering system designed to measure the amount of light enter-

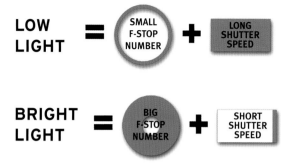

Fig 20 – In low light conditions, you will generally need to use a wide aperture and a slow shutter speed. With bright conditions you will typically use fast shutter speeds and smaller apertures.

ing the camera. In most cases the meter is linked with an auto-exposure mechanism that alters the aperture and shutter to suit the light that is available.

In low light scenarios a long shutter speed and a wide aperture would be selected to allow enough light for the sensor to record the image. In situations where light abounds, faster speeds and smaller holes would restrict the level of light to the amount required by the sensor.

In most scenarios the auto-exposure system works well, but in about five to ten per cent of all shooting occasions the meter in the camera can be fooled into providing an F-stop and shutter speed combination which produces images too dark or light to be usable. For these occasions you will need to help your camera out by intervening in the exposure process.

There are three ways to compensate for these difficult exposure circumstances:

If the camera allows the manual override of automatic settings, you can change the shutter speed (or aperture) up or down to suit the lighting.

Systems with no manual functions usually allow the locking of exposure settings. With the camera pointed at a part of the image that most reflects the exposure needed for the photograph, you can half press the shutter button to lock exposure. With your finger still on the button it is possible to recompose the image and take the picture using the stored settings.

The last method is to compensate for the exposure problem by setting the camera to purposely over or underexpose the image by one, two or even three stops worth of exposure. If you use this technique, be sure to change back to the standard settings before recommencing shooting.

HOW SENSITIVE IS MY CHIP?

The sensitivity of film to light is expressed as an ISO number. Films with a low number like 50 need a lot of light to make an exposure. Higher-numbered films require less light and are usually used for night shooting or taking pictures under artificial light.

Chips don't have ISO ratings. Instead manufacturers allocate "ISO equivalent" ratings so that we all have a reference point to compare the performance of sensors and their film counterparts.

Unlike film, most chips are capable of being used with a range of ISO settings. The smallest number usually produces the best-quality image. At higher settings the resultant images are usually a little more noisy and not quite as sharp.

OCCASIONS WHEN YOUR METER MIGHT BE FOOLED
Backlit subjects (fig 21)

Problem: When your subject is backlit, for instance if they are sitting against an open window, the meter is likely to adjust the exposure settings for the light around the subject. This can lead to a silhouette effect, where, in the window example, the subject is black but the window is well exposed.

Solution 1: Move the subject so that they are being illuminated by the light.

Solution 2: Use the camera's flash system to add some more light to the subject.

Solution 3: Move close to the subject until it fills the frame. Take an exposure reading here and then reposition yourself to make the exposure using the saved settings.

At night (fig 22)

Problem: This problem is the reverse of the example above. This time the subject is surrounded by

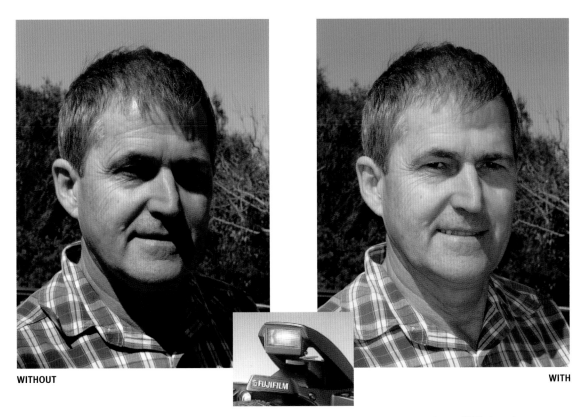

WITHOUT

WITH

Fig 21 – Strong back or side lighting can be alleviated by using some fill flash. A lot of digital cameras have a fill flash mode that uses the built-in flash to lighten dark shadow areas.

darkness. The meter sees large dark areas within the frame and overcompensates for it. As a result the main subject is "blown out" or overexposed.

Solution 1: Manually compensate for the overexposure by adjusting the camera's exposure compensation mechanism so that the sensor is receiving one, two or three stops less light.

Solution 2: Move close to the subject until it fills the frame. Take an exposure reading here and then reposition yourself to take the picture using the saved settings.

Controlling Motion in Your Images

As well as providing the means to control the amount of light hitting the sensor, the shutter can also affect the way in which motion is captured in your images.

Fig 22 – Overexposed subjects can be the result of the camera's meter trying to compensate for large areas of dark background.

Most photographers are familiar with the idea that fast shutter speeds freeze the action. Sports and action publications especially show images on every page taken with high shutter speeds. They are clear and sharp, with the main subject jumping out from the background. If this is the type of image you want, there are essentially three techniques to use:

Shoot with a high shutter speed: Sounds simple enough, select a high shutter speed and fire away. However, as you know by now, there is a direct link between aperture, shutter speed, film speed and the available light. Put simply, to be able to use speeds that will freeze motion, you need a fast lens, a good sensor and good light.

Shoot with the lens wide open: That is, with the aperture set to maximum, usually F2.8 or F4 on pro lenses or F5.6 for standard zooms. This has the added bonus of giving a shallow depth of field, making the background blurry whilst the main subject remains sharp. If the action is taking place indoors, you will need to change the sensitivity of your sensor to the highest ISO possible.

Shoot with a fast light source: The alternative to shooting with a fast shutter speed is exposing with a light source that has a very short duration. In a lot of instances, the most suitable source will be a portable flash. The majority of on-camera flash systems output light for durations of between 1/800th and 1/30,000th of a second. It is this brief flash that freezes the motion. Don't be confused with the shutter speed that your camera uses to sync with the flash – usually between 1/125th and 1/250th of a second – the length of time that is used to expose your frame is very short and is based on the flash's duration.

Blurred Motion Techniques (fig 23)

In some instances, images where the motion is frozen don't carry the emotion or atmosphere of the original event. They seem sterile and even though we know that they are a slice of real time, something seems missing. In an attempt to solve this problem, photographers through history have played with using slower shutter speeds to capture events. The results, though

Fig 23 – Sometimes freezing the motion takes away from the feeling of the activity. Here a slow shutter speed was used whilst panning the camera to try to capture the movement of the cars.

blurry, do communicate more of the feeling of the motion present in the original activity.

There is no secret formula for using this technique. The shutter speed, the direction of the motion through the frame, the lens length and the speed of the subject are all factors that govern the amount of blur that will be visible in the final image. Try a range of speeds with the same subject, making notes as you go. Too fast and the motion will be frozen, too slow and the subject will be unrecognizably blurred, or worse still, not apparent at all. The results of your tests will give you a starting point that you can use next time you are shooting a similar subject.

EXTENDED MOTION TECHNIQUES

The following two techniques are an extension on those detailed above. Both require practice to perfect.

Panning: An extension of the slow shutter technique involves the photographer moving with the motion of the subject. The aim is for the photographer to keep the subject in the frame during the

exposure. When this technique is coupled with a slow shutter speed, it's possible to produce shots that have sharp subjects and blurred backgrounds. Try starting with speeds of 1/30th of a second.

Flash Blur: To achieve this effect you need to set your camera on a slower than normal sync shutter speed. The short flash duration will freeze part of the action and the long shutter will provide a sense of motion. The results combine stillness and movement. Remember to make sure that the light is balanced between the flash exposure and the ambient light exposure. If you are not using a dedicated flash system this will mean ensuring that the F-stop needed for the flash exposure is the same as that suggested for the shutter speed by the camera's metering system.

SHOOTING DIGITAL AT THE OLYMPICS (fig 24)

Patrick Hamilton, a press and sports photographer based in Australia, has seen the way that he shoots change radically over the last decade. Film cameras are a thing of the past – now he shoots digital for every press job. Nowhere was the change more evident than when he was employed to photograph the kayaking and rowing events at the Sydney Olympics. For the first time in the history of the games, the majority of stills photographers present shot no film.

He says, "For circumstances where speed is important there is no alternative for the press photographer than to use digital. Film still has the edge in the overall quality stakes, but the demands of the modern publishing world do not allow for the extra time needed to process and scan your negatives."

On using pixel-based cameras, he says, "Despite the fact that you can transfer a lot of your film skills to digital, the new cameras do require you to change the way that you would normally shoot."

The following are some of Patrick's tips for shooting digital action:

Exposure is critical. You have very little latitude for over- or underexposure. Use a hand-held meter if you want to double-check the exact amount of light falling on your subject.

Keep in mind that all lenses are longer on digital. Because digital sensors are smaller than the 35mm

Fig 24 – The Olympics in Sydney was the first time in the history of the games that the majority of professional stills photographers shot digital rather than film.

45

frame, lenses used on these cameras have a comparatively longer focal length than stated. For instance, the Kodak DCS cameras have a focal length conversion factor of 1.6. This means that a 20–40mm wide-angle zoom becomes a 32–64mm standard on these digital cameras.

Fill the frame. The file from a press-level digital camera is between 6 and 10MB. This, though much better than previous cameras, gives a file that has little room for cropping in. Enlarging a section of this type of file will produce pixelated results so photographers must fill the frame.

Edit in-camera. The majority of digital cameras have the facility to view the images you have taken on a small in-built screen. This gives the photographer the opportunity to review, edit, keep or discard images while still on the job.

Anticipate the action. Some digital cameras have a slight time delay between the shutter button being pressed and the picture being taken. With press cameras this is a comparatively short period of time, but experienced photographers still find that they have to allow for the time lag. They do this by releasing the button to coincide with the critical point of the action (see fig 25).

SHOOTING PROBLEMS AND SOLUTIONS
Problem: Main subject is not in focus (see fig 26).

Solution: This is usually caused by not having the auto focus area on the main subject at the time of shooting. If your subject is off to one side of the frame, make sure that you lock focus on this point before recomposing and releasing the button.

Fig 25 – Digital sports photography requires an approach in which the action point is anticipated and captured rather than seen. By the time you see the action, it will be too late to press the button.

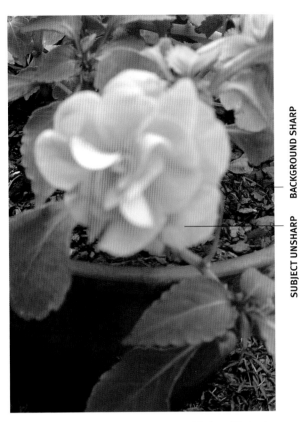

BACKGROUND SHARP

SUBJECT UNSHARP

Fig 26 – Activating the camera's AF system with the subject not in the focusing area is usually the cause of the problem when the background of an image is sharp and the subject blurry.

Problem: Underexposure (see fig 27).

Solution: This time not enough light has entered the camera. Adjust the exposure compensation control to add more light or alternatively use a flash.

Problem: Movement: images appear blurry due to the subject, or the photographer, moving during a long exposure.

Solution: Use a tripod to reduce the risk of camera-shake and if the subject is active, try taking the picture at a point in the activity when there is less movement.

Problem: Flash off glass: the light from the flash bouncing straight back from a glass surface into the lens of the camera (see fig 28).

Solution: Using available light rather than the flash is one solution. Another is to move a little to one side so that the flash angles off the glass surface away from the camera (see fig 29).

Problem: Blown highlights.

Solution: This is caused by too much light entering the camera (overexposure). You can resolve this problem by adjusting the camera's exposure compensation control so that it automatically reduces the overall exposure by one stop. Shoot again and check the exposure. If the image is still overexposed, change the compensation to two stops. Continue this process until the exposure is acceptable.

Fig 27 – Underexposed images need to be re-exposed using either manually controlled exposure settings or one of the selections from the exposure compensation options on the camera.

Fig 28 – Shooting objects behind glass from directly in front often results in the flash being seen in the final picture.

Fig 29 – Moving to one side and shooting on an angle or turning the flash off and using available light will minimize reflections.

CAMERA TYPES AND MODELS

Digital cameras come in all shapes, sizes and price ranges. What you choose to purchase will depend on how you intend to use the images and the type of pictures you want to take. Essentially all cameras can be separated into three different groups:

Consumer

This group contains entry level cameras. These are designed for the budget-conscious user who wants to start in digital photography but has a limited amount of money to spend. The film camera equivalent is definitely the point-and-shoot variety.

Most consumer cameras have base level features, 6.0–10 megapixel sensors and a short zoom lens. These cameras use technology that we all thought was terrific a few years ago but which has been overtaken by new advances.

Prices start from as little as £50/US$100 for a very basic model and rise with functionality to about £150/US$300. The products here provide a good starting point for new digital users and for those photographers who need a simple camera with modest image-output quality (see fig 30).

Prosumer

This group contains the types of cameras designed for the serious amateur or the professional with limited needs. Here you will find advanced design and technology, high-resolution sensors and good-quality optical zoom lenses.

You will pay more for the units in this group, £150–300 (US$300–600), but what you are buying is extra levels of control for both the photographic and digital parts of the camera. Image quality in a lot of these units rivals that of the more expensive pro models.

Fig 30 – Consumer level cameras provide an economical entry point into an all-digital system.

The downside is that the designs are still proprietary, which means there is little chance of changing lenses or adding accessories already purchased for a separate film-based system. The cameras here are more than capable of producing professional photographic-quality results with technology that is definitely cutting-edge (see fig 31).

Pro cameras

These cameras are generally designed on the film-based bodies of either Nikon or Canon cam eras. This means you can use the same lenses as you would on the traditional models. The target market is definitely the professional photographer and with prices that range up to £2,500 (US$5,000) you would have to be a very wealthy, or very serious, amateur to be able to afford one. Designed to look and feel

as much as possible like their film counterparts, the pro cameras are at the very forefront of digital-imaging technology. All the major companies like Kodak, Nikon, Canon and Fuji have a presence in this area of the market and, given the level of financial commitment involved in their development, this is a situation that will continue into the future (see fig 32).

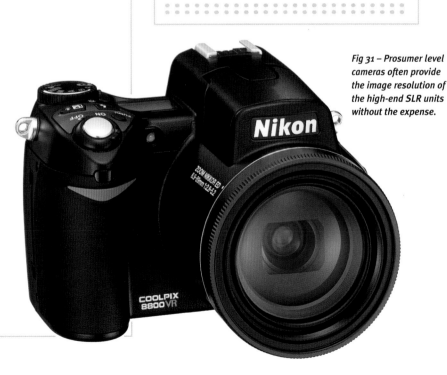

Fig 31 – Prosumer level cameras often provide the image resolution of the high-end SLR units without the expense.

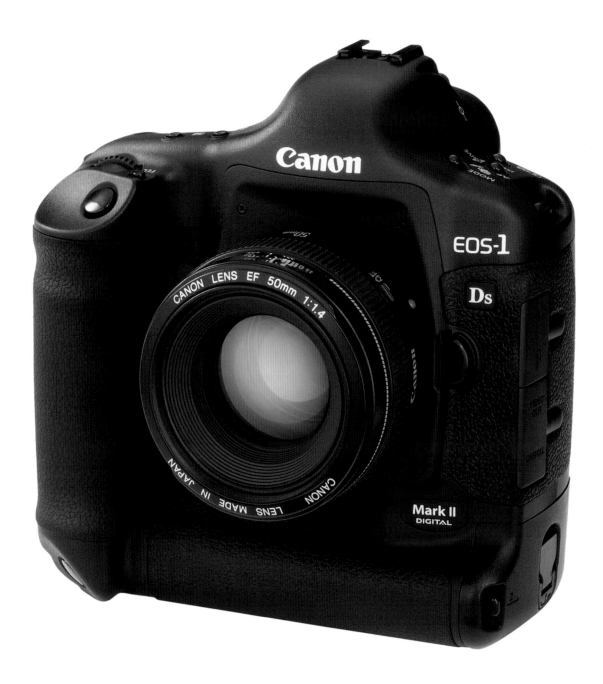

Fig 32 – Professional level cameras are designed to fit into already existing film-based systems.

BUYING YOUR FIRST DIGITAL CAMERA

With so many cameras on the market, it is important to compare features when deciding which unit to buy. Purely photographic variables like zoom length and maximum aperture are probably more familiar to you, but the digital options often cause new users more difficulties.

Below is a list of what I believe to be the most important digital features. When looking at cameras, take notes on their specifications in these areas. It will then be possible for you to compare "apples with apples" when it comes to the final choice.

Price: As a general rule of thumb, the more expensive cameras have greater resolution and a larger range of

features, both manual and automatic. This said, price can be a major deciding factor and it is important that you balance what you can afford with the limitations that come with each price bracket.

Resolution: The best cameras have chip resolutions of 20 megapixels or higher, and as you now know, the more pixels you have, the better quality the final prints will be. This said, cameras with fewer pixels are still capable of producing photographic prints of smaller sizes. The table below gives you an idea about what print sizes are possible with each resolution level.

Chip pixel dimensions	Chip resolution	Maximum photographic image size at 200dpi
640 x 480	0.30 million	3.2 x 2.4 inch (81 x 61mm)
1440 x 960	1.38 million	7.4 x 4.8 inch (188 x 122mm)
1600 x 1200	1.90 million	8 x 6 inch (203 x 152mm)
1920 x 1600	3.00 million	9 x 8 inch (229 x 203mm)
2304 x 1536	3.40 million	11.5 x 7.5 inch (292 x 190mm)
2272 x 1704	4.0 million	11.4 x 8.5 inch (289.5 x 215.9mm)
2560 x 1920	4.9 million	12.8 x 9.6 inch (325 x 243.8mm)
3008 x 2000	6.1 million	15.04 x 10 inch (382 x 250.4mm)

Focus control: Fixed-focus cameras have lenses with large depths of field but no ability to focus on particular objects. These cameras are only suitable for general purpose photography. Auto focus cameras have lenses that can focus on separate parts of the image. The number of AF steps determines how accurate the focusing will be.

Optical zoom range: Be sure to check that any information quoted on the zoom range of the camera is based on the optics of the lens rather than a digital enlargement of the picture. Enlarging the image is not a true zoom function and only serves to pixelate the image.

Aperture range: Small aperture numbers such as F2.8 mean that the camera can be used in lower light sce-narios. If you regularly shoot in low light conditions, look for a camera with a lens which includes a range of aperture settings.

ISO equivalent range: Being able to vary the sensitivity of the chip is an advantage. You won't achieve the same-quality results at higher ISO values as the base sensitivity, but having the option to shoot without a flash in low light gives you more flexibility.

Delay between shots: Cameras need time to process and store the shots you take. The size of the memory buffer will determine how much delay there will be between shots.

Flash type and functions: Most digital cameras have a built-in flash system. Check the power of the flash, which is usually quoted as a guide number. The higher the number, the more powerful the flash. Also take notice of the flash modes present in the camera. Options like red-eye reduction, fill flash and slow shutter flash sync are always useful.

Download options: Getting your images into your computer should be as easy as possible. If the camera uses a particular cable connection (USB, SCSI, serial, Firewire, Firewire 800 and USB2.0) make sure your computer has the same option.

Storage capacity: The film used by digital cameras comes in the form of flash memory cards. The storage capacity of the card is measured in megabytes. The larger the card supplied with your camera, the more images can be stored before being downloaded to the computer.

Camera size and weight: The size and weight of a camera can determine how comfortable it is to use. Make sure you handle any prospective purchase before making your final decision.

Manual features: The ability to manually override or set auto functions can be a really useful, if not essential, addition to a camera's functionality. Auto everything point-and-shoot units are designed for general shooting scenarios; trying to make images outside of these typical conditions can only be achieved with a little more user control.

THE BLACK ART OF SCANNING (fig 33)

It was not too long ago that an activity like scanning was the sole responsibility of the repro house. The photographer's job was finished the moment the images were placed on the art director's desk. But as we all know, the digital revolution has changed things, and scanning is one area which will never be the same.

Desktop scanners that are capable of high resolution colour output are now so cheap that some companies will throw them in as freebies when you purchase a complete computer system. The proliferation of these devices has led to a large proportion of the photographic community now having the means to change their prints, negatives or slides into digital files. This provides a hybrid pathway for film-based photographers to generate digital files. But as all photographers know, having the equipment is only the first step to making good images.

The following steps will help you get the best out of the machinery you have to hand.

Set Up – Know Where You Are Going Before You Start the Journey

Without realizing it, when we pick up a camera, load a film and take a photograph we have made a range of decisions that will affect the quality of the final print.

By selecting the format – 35mm, 120mm or 5 x 4 inch – we are deciding the degree that we can enlarge the image before we start to lose sharpness and see grain. The same can be said about our choice of film's sensitivity. Generally, low ISO stock will give you sharper and more grainless results than a faster emulsion. These things go almost without saying.

In a similar way, when we start to work digitally we have to be conscious of quality choices right from the beginning of the process. Essentially we are faced with two decisions when scanning – what resolution and what colour depth to scan with.

Resolution (fig 34)

Scanning resolution, as opposed to image or printing resolution, is determined by the number of times per inch that the scanner will sample your image. This figure will affect both the enlargement potential of the final scan and its file size. The general rule is, the higher the resolution, the bigger the file and the bigger the printed size possible before seeing pixel blocks, or digital grain.

For this reason, it is important to set your scanning resolution keeping in mind your required output size. Some scanning software will give an indication of resolution, file size and print size as part of the dialog panel but for those of you without this facility, here is a rough guide:

Scanning resolution	Image size to be scanned	Output size @ 300dpi	File size
4000	35mm (24mm x 36mm)	20 x 13.33 inch (508 x 339mm) 6000 x 4000 pixels	22.7 mb
2438	35mm	11.5 x 7.67 inch (292 x 195mm) 3452 x 2301 pixels	22.7 mb
1219	35mm	5.74 x 3.82 inch (146 x 97mm) 1724 x 1148 pixels	5.68 mb
610	35mm	2.87 x 1.91 inch (73 x 49mm) 862 x 574 pixels	1.42 mb
305	35mm	1.43 x 0.95 inch (36 x 24mm) 431 x 287 pixels	0.36 mb

Colour Depth (fig 35)

Colour depth refers to the numbers of possible colours that make up the digital file upon the completion of scanning. This is not as much of an issue as it used to be. Generally most modern computer systems can handle photographic-quality colour, sometimes called 24 bit, where the image is made up of a possible 16.7 million colours. So here the decision is basically whether you want to scan in colour or greyscale (8 bit or 256 levels of grey). Be aware, though, that colour files are generally three times bigger than their greyscale equivalents. Some higher-cost models have the option of working with 16 bits per colour giving a total of over 65,000 levels of grey for a monochrome image and billions of colours for RGB files.

Capture Controls – If It's Not Captured, It's Gone Forever (fig 36)

With resolution and colour depth set we can now scan the image – well almost! Just as exposure is critical to making a good photograph, careful exposure is extremely important for achieving a good scan.

All but the most basic scanners allow some adjust-

Fig 33 – For photographers with a sizeable financial commitment to film-based shooting, it is often a good idea to use a hybrid imaging system where film is shot and then scanned to provide digital files.

Fig 34 – You must have an idea about what the final use of the image will be before setting the resolution of the scanner.

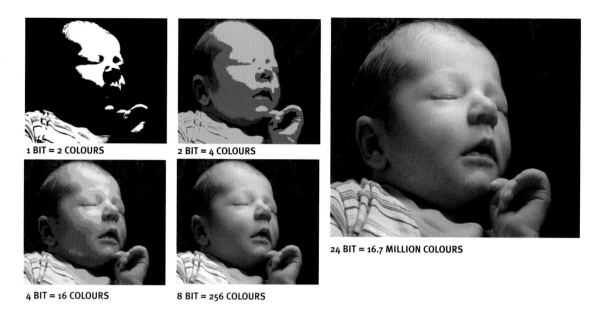

1 BIT = 2 COLOURS

2 BIT = 4 COLOURS

24 BIT = 16.7 MILLION COLOURS

4 BIT = 16 COLOURS

8 BIT = 256 COLOURS

Fig 35 – The colour depth of a file determines the numbers of colours possible in the image.

Fig 36 – Good control of exposure during the scanning stage will result in a file that contains as much of the information that was in the negative as possible.

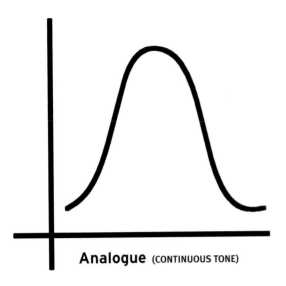

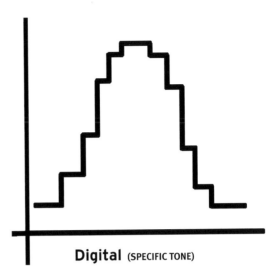

Analogue (CONTINUOUS TONE) **Digital** (SPECIFIC TONE)

Fig 37 – Scanners sample continuous tone originals at regular intervals, attributing specific numerical values for brightness, colour and position.

ment in this respect. Preview images are supplied to help judge exposure and contrast, but be wary of making all your decisions based on a visual assessment of these often small and pixelated images. If you inadvertently make an image too contrasty, you will loose shadow and highlight detail as a result. Similarly, a scan that proves to be too light or dark will have failed to capture important information from your print or film original.

It is much better to adjust the contrast, sometimes called "gamma", and exposure settings of your scan based on more objective information. For this reason, a lot of desktop scanner companies also provide a method of assessing the darkest and lightest parts of the image to be scanned. With this information you can set the black and white points of the image to ensure that no details are lost in the scanning process.

For those readers whose scanning software doesn't contain this option, try to keep in mind that it is better to make a slightly flat scan than risk losing detail by adjusting the settings so that the results are too contrasty. The contrast can then be altered later in your image-editing package.

With all the pre-scan decisions made you can now capture your image.

ANLOGUE TO DIGITAL (fig 37)

Computers can only work with digital information, so the scanning process is designed to convert continuous tone pictures such as photographs, transparencies or negatives into digital representations of these images. The machinery samples a section of the picture and attributes to it a set of numerical values. These indicate the brightness and colour of that part of the image and its position in a grid of all the other samples taken from the photograph. In this way a digital version of the image is constructed, which can then be edited in programs like Photoshop or Paint Shop Pro.

COMMON SCANNING
PROBLEMS AND SOLUTIONS

Problem: the image is too bright. The image has been scanned with settings that have resulted in an overexposed file. Highlight detail is lost and

**PIXELS
PUSHED
RIGHT**

Fig 38 – A scan that is too bright will have limited separation in highlight details.

**PIXELS
BUNCHED
TO THE
LEFT**

Fig 39 – A dark scan will lose shadow details.

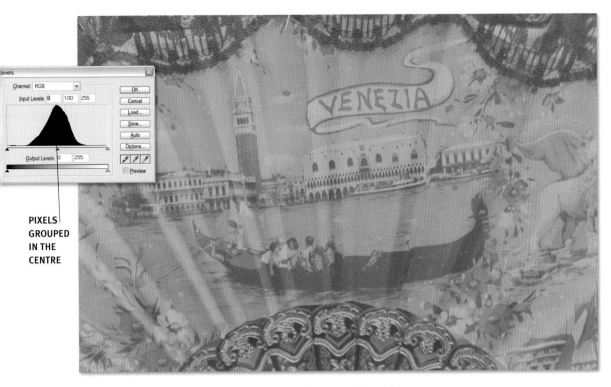

PIXELS GROUPED IN THE CENTRE

Fig 40 – A flat scan compresses all the image tones in the centre of the graph.

midtone areas are too light. In the histogram the bulk of the pixels are at the right-hand end of the graph (see fig 38).

Solution: Rescan with a lower exposure setting.

Problem: The digital file shows no shadow detail. No matter what changes are made in your image-editing package, these details will not return. The histogram shows a bunching of pixels at the shadow end of the graph (see fig 39).

Solution: Rescan the image, changing either the shadow or exposure setting so that it gives these areas more exposure.

Problem: The digital file appears flat and lacking in a good spread of tones. The histogram shows a bunching of the pixels in the centre of the graph (see fig 40).

Solution: Either rescan with a higher contrast setting or use the Contrast or Levels features in your image-editing package to spread the tones across the graph.

SCANNER AS CAMERA (figs 41 & 42)

Tim Daly, UK-based illustrative photographer and author of countless digital imaging articles, users his scanner as a large camera to produce hauntingly beautiful images of everyday objects.

He says, "There is no reason why we shouldn't use all imaging devices at our disposal as ways of making great pictures. The scanner is, in effect, a large camera capable of capturing images with extremely fine detail in high resolution. The only drawback to scanner-based images is that it is not possible to 'shoot' moving objects."

Fig 41 – It is possible to use your scanner as a high-quality digital camera.

Fig 42 – Tim's process involves the scanning of separate objects and their combining in Photoshop.

Tim's technique for making cameraless pictures:

1. Prepare your scanner. This may mean that you need to construct a small cardboard box, painted white on the inside, which fits neatly over the glass surface.
2. Select the objects you wish to include in the montage using clipping paths to keep the edges sharp.
3. Scan each of the objects in turn, creating separate image files for each.
4. Open files in Photoshop and proceed to place them into the one image as separate layers.
5. Adjust the size, colour, position and contrast/brightness of each layer to suit the other components in the image.
6. Selectively burn and dodge areas of the image to add shadows to objects and direct the viewer's attention by making some parts more apparent, others less noticeable.

TYPES OF SCANNERS (figs 43 & 44)

There are essentially two different types of scanners, those suitable for scanning prints and those used for negatives and transparencies. Both types sample the image at regular intervals to determine colour and brightness, but the flatbed or print scanner bounces light off the object onto the sensor, whereas film versions scan the image via light travelling through the film.

Companies like Microtek have been able to combine both methods into their range of hybrid scanners. With these units, the user can select reflective- or transmission-based scanning, depending on the original image type.

conversions of your images available. Files are saved in a variety of file sizes and resolutions, giving the user the ability to choose the level most suitable for the job at hand.

For those readers who don't want to invest in a scanner or who want file sizes greater than those available from the average desktop unit, third party scans may be the answer.

Fig 43 – Film scanners are usually more expensive than their flatbed counterparts and are capable of scanning negatives as well as slides.

Fig 44 – Print scanners are a very economical way to start making digital images from your film originals.

OTHER SOURCES OF DIGITAL FILES (fig 45)

During recent years, other options for obtaining digital versions of your silver-based images have started to be provided by high-street photo labs. It is now possible to drop your film off at the local processing business and have the negatives processed, printed, scanned and saved to CD-ROM as part of the service. The quality and resolution of the scans vary from one provider to the next, so ask to see examples before committing yourself.

Putting images on CD was a process pioneered by Kodak in the mid nineties with its ProCD product. This system still provides some of the best digital

Fig 45 – High-street processing businesses are now offering the option of processing, printing, scanning and saving to CD in the one service.

MANIPULATING

MANIPULATING

The real power of the digital process of image-making is only truly revealed in this stage of production. Just as with traditional photography, there are a range of techniques and equipment designed to help turn those precious captured images into printed ones. In this section we will start with some basic techniques that have their roots firmly grounded in familiar darkroom ideas and move to some ideas that are strictly digital.

THE SOFTWARE

The main tool that photographers use when working with digital photographs is an image-editing program. This piece of software enables the digital worker to creatively control and selectively change the images he or she has captured.

There are a range of different packages on the market (see fig 1). They fall roughly into three categories – entry, intermediate and professional level. Of all the groups Adobe's Photoshop is the clear leader. Despite being a piece of software designed specifically for the professional market it has gained wide acceptance with all levels of users irrespective of their experience

level. The rest of the packages have places in the market defined not so much by their cost but by how simple they are to use.

Entry Level – These packages are the easiest pieces of software to use. They offer simple approaches to common tasks and an interface that is uncomplicated and well laid out. Often they are designed so that children and new image workers can easily transfer images from camera or scanner, make a few changes and then print them out. Some even contain special "wizards" or automated step-by-step instructions for creating greeting or post cards, posters and stickers. With the upsurge of interest in the web more and more of these programs also include features that ease the process of publishing your images online.

As a first outing these products are well worth trying, especially because you will find them very competitively priced or, even better, bundled free with your camera or scanner or available free on the net. There are, however, two sides to the simplicity coin – the very approach that makes these products easy to use also means that they can be quite limiting.

Such limitations are not obvious when you restrict yourself to activities for which the program was designed. But when you try to be a little more creative you might find yourself frustrated. Over the last few years though these entry level packages have made major progress in terms of features and functions. So I believe that you can cut your teeth on these free or economically priced packages before spending the "big money" on something a little more sophisticated.

Fig 1 – Digital imaging software packages come in three different levels determined by their ease of use and sophistication more than by their price.

Intermediate Level – The programs in this group give you more features and tools and in so doing allow you to be more creative. It's here that you will find the biggest growth area of the image-editing market. Often programs that start their life with entry level features develop with maturity and sophistication to a level that meets the needs of the intermediate user. The software companies know that most digital workers want the power and the flexibility of the professional packages, but at budget prices.

To a large extent the software in this group provides what the imaging public wants. The products here contain most of the features and flexibility of the professional packages with less of the limitations of the entry level options. Of course there are differences. You would expect there to be when you can pay up to five times more for Photoshop than you do for Photoshop Elements. The feature sets of the intermediate packages can be smaller, the level of user interaction not as great, but on the whole these pieces of kit do a great job.

When you find that you are being limited by the program that came with your scanner or you access via the net, then these packages would be your next step.

Professional – This category contains the cream of editing software. It is here that you will find packages that are packed to the brim with features, functions and filters. The sheer range of options can often make these programs difficult to learn and even more difficult to master. These programs are used daily by professionals in a range of areas. The flexibility and sheer number of image-editing tools means that press, portrait, medical and commercial photographers can all find a *modus operandi* with the package that suits them.

Photoshop has always been a major player in this part of the market, but in recent years it has dominated the area, providing the model that all other packages are trying to emulate. There is no disputing that Photoshop is already a feature-rich mature package. When you couple this with the fact that Adobe releases a new version of its flagship software every 18 months or so, you can see why the others are finding it hard to play catch-up. The way that Photoshop links with professional level desktop and web publishing software means that it's not just photographers who are singing the program's praises.

If you are planning to use images you create professionally then skip the first two categories and dive straight into a professional package. The learning curve will be steep to start with, but you will be rewarded with a much more powerful and comprehensive image-editing environment.

MENU

TOOLBAR

DOCUMENT

WORKSPACE

DIALOG BOX

Fig 2 – Most packages have similar methods of setting up the screen work space.

THE WINDOW TO A NEW WORLD (fig 2)

The interface is the way that the software package communicates with the user. Each program has its own style but the majority contain a work space, a set of tools laid out in a tool bar and some menus. You might also encounter some other smaller windows around the edge of the screen. Commonly called boxes and palettes, these windows give you extra details and controls for tools that you are using.

Programs have become so complex that sometimes there are many different boxes, menus and tools on screen that it is difficult to see your picture. Photographers solve this problem by treating themselves to bigger screens or by using two linked screens – one for tools and dialogs and one for images. Most of us don't have this luxury so it's important that right from the start you arrange the parts of the screen in a way that provides you with the best view of what is important – your image. Get into the habit of being tidy.

KNOW YOUR TOOLS (fig 3)

Over the years the tools in most image-editing packages have been distilled to a common set of similar icons that perform in very similar ways. The tools themselves can be divided up into several groups depending on their general function.

Figure 3 – The toolbar contains the most often used imaging tools and functions.

DRAWING TOOLS (fig 4)

Designed to allow the user to draw lines or areas of colour onto the screen, these tools are mostly used by the digital photographer to add to existing images. Those readers who are more artistically gifted will be able to use this group to generate masterpieces in their own right from blank screens.

Most software packages include basic brush, eraser, pen, and line, spray-paint and paint bucket tools. The tool draws with colours selected as and categorized as either foreground or background.

Fig 4 – Drawing tools allow you to change and add to the pixels that make up your digital photograph.

SELECTING TOOLS (fig 5)

When starting out most new users apply functions like filters and contrast control to the whole of the image area. By using one or more of the selection tools, it is also possible to isolate part of the image and restrict the effect of such changes to this area only.

Fig 5 – Selection tools enable the user to isolate a group of pixels to work on.

Used in this way the three major selection tools – lasso, magic wand and marquee – are some of the most important tools in any program. Good control of the various selection methods in a program is the basis for a lot of digital photography production techniques.

TEXT TOOLS (fig 6)

Adding and controlling the look of text within an image is becoming more important than ever. The text handling within all the major software packages has become increasingly sophisticated with each new release of the product. Effects that were only possible in text layout programs are now integral parts of the best packages.

TYPE/TYPE MASK/VERTICAL/VERTICAL MASK

*Fig 6 – Adding text or type to your images
is a comparatively simple process with most packages.*

VIEWING TOOLS (fig 7)

This group includes the now familiar magnifying glass for zooming in and out of an image and the move tool used for shifting the view of an enlarged picture.

 ZOOM

 MOVE

 HAND

*Fig 7 – Viewing tools help you to
navigate, and zoom in and out of, your images.*

OTHERS (fig 8)

There remains a small group of specialist tools that don't fit into the categories above. Most of them are specifically related to digital photography. In packages like Hotshots they include a "Red Eye Remover"

tool specially designed to eliminate those evil-eyed images that plague compact camera users. Photoshop on the other hand supplies both "Dodging" and "Burning-In" tools.

DODGING/BURNING IN/SATURATION SPONGE

Fig 8 – Most packages contain a host of other tools and some even allow the user to customize the toolbar with those most used.

SOFTWARE – WHAT ARE SOME OF THE CHOICES?

To give you some idea of what is available the following is a summary of seven of the leading software packages on the market. Each program has its own strengths and weaknesses, and it wouldn't be possible to select any one product that would be suitable for all photographic jobs and users. When making your choice consider

- the type of activities you want to undertake
- your current level of experience
- the type of activities you want to undertake in the future

Figure 9 – Photoshop. com is an online application for photographers to manage, edit and present their photos.

PHOTOSHOP.COM (figs 9 & 10) *Level: Entry*

Adobe not only provides the photographer with the industry-leading Photoshop and entry level Photoshop Elements programs but it also offers a free, yes free, online application for photo management, editing and presentation. Photoshop.com is the pivot point for this online presence.

SUMMARY

Remember the days when photographers spent long hours by themselves in the darkroom carefully crafting prints? Well in the first years of digital such was the life of the digital photographer as well. Although with the new technology they weren't working in a darkroom, but rather they manipulated their photos in solitude at the desktop. Notice I said the first few years? That is because the lot of the image maker is changing. Now the process of working and presenting images is much more communal thanks to the connectivity of the internet. This change didn't go unnoticed by Adobe and early in 2008 they released of Photoshop Express (PSX).

FEATURES

Express was a free online image management, editing and presentation application. Employing a workflow that will be familiar to Photoshop Elements users as well as photographers who have worked with other online photo applications such as Google's Picasa, shooters upload their images to Albums before making adjustments using simple but effective tools, and then presenting the photos to the world in the form of animated slideshows or web galleries.

New users needed to sign up for an account before being able to upload images and access PSX features, but they did receive 2Gb of storage space and one of the slickest user interfaces around for their trouble. With direct output to social networking sites such as Facebook, the new application was loved by bloggers and those photographers who wanted a quick and easy way to get their images online.

With the release of Elements 7.0, Photoshop Express is now part of bigger initiative www.photoshop.com. More features have been added to the site and stronger links have been created with the application itself.

Figure 10 – Photoshop.com uses a simple task-orientated screen to guide users through common editing activities.

IN ACTION

To adjust an image online, click onto the My Photos heading first and then navigate to the photo. You can look for the photos visually by selecting an album entry or Library and then scrolling through the thumbnails in the main workspace.

Once you have located the photo, clicking on the picture's thumbnail switches the workspace to the edit mode and displays the photo as large as possible within the window. All the amendments that can be applied to the photo are grouped under three headings, Basic, Adjustments and Advanced, on the left.

For most options, when an adjustment is selected from the list, a series of thumbnails displaying varying degrees of application for the adjustment are displayed above the image. Clicking a thumbnail will preview a change to the photo. With some adjustments a slider control is also provided below the thumbnails for finer control. One thumbnail of the group will be displayed with a curved yellow arrow. Click this entry to reset the photo to the way it was before selecting the current adjustment. Click the green tick (top right)

to save the current adjustment changes and click the red cross to cancel the alterations.

BEST USES

- Home office
- School projects
- Family photos

Recommended Hardware Requirements

An internet-connected computer with Windows XP or Vista, or Mac OS 10.4 or later; a minimum screen resolution of 1024 x 768; 512 MB of RAM; Internet Explorer 6, 7 or 8, Safari 3.0.4 or later or Firefox 2 or later. Flash Player 10 or later.

Platform: PC, Mac

Price: Free

Download trial: No

Web link: www.photoshop.com

Fig 11 – Google's own image management and editing program provides easy-to-use functions for most home imaging needs.

GOOGLE PICASA (figs 11 & 12)
Level: Entry

There can't be many people around the world who don't know the name Google; after all their internet search engine is the most popular engine on the planet. But fewer people would realize that Google also produces a range of applications including word processing (Docs), email (Gmail), 3D models (SketchUp) and video (YouTube). Picasa brings all of Google's application expertise to the image editing and management area.

SUMMARY
Like Photoshop.com, Picasa is a free photographer's tool that can be used to organize, edit and upload your photos to the web from your computer in quick, simple steps. Unlike Adobe's offering though, Picasa is not a web application. It is a program that you download and install on your computer.

FEATURES
The latest version of Picasa increases the range of features, functions and tools available in the program. Now you can:
• Remove blemishes with the Retouch tool
• Preview photos quickly without having to open them fully
• Automatically sync Picasa photo collections with their online equivalents in Picasa Web Albums
• Create and edit movies
• Easily capture your screen
• Add text and watermarks to photos
• Print captions attached to your photos
• Upload your pictures quickly and easily to your online albums
• Manage the folders that contain your photos from inside Picasa
• Remove red-eye automatically
• Create a custom screen saver featuring your own pictures
• Create exciting slideshows
• Creatively mix your photos together with the Collage feature

Fig 12 – Picasa offers an amazing range of tools and features for a free desktop application.

BEST USES

- Home office
- School projects
- Family photos
- Organizing and searching photo collections
- Good general purpose image-editing program
- Linking images and albums to web sites

APPROACH TO EDITING

Picasa offers a single-click option for image enhancement tasks when ever possible. Editing activities are broken into three key groups and are listed under the Basic Fixes, Tuning and Effects tabs.

Most adjustments are applied by clicking onto a single button or thumbnail, with some adding the extra control of a slider to alter the strength of the enhancement.

One of the real strengths of Picasa is the ease with which you can share your photos. There are easy-to-use upload, email, print, export, print online, blog, create a collage, add to a movie or geo tag options.

Recommended Hardware Requirements:

Windows XP/Vista or Linux
256 MB RAM
100 MB available hard disk space
Picasa also runs on Mac OS X and Linux.

Current version: Picasa 3

Platform: PC, Mac

Price: Free

Download trial: No

Web link: picasa.google.com

ULEAD PHOTOIMPACT (figs 13 & 14)
Level: Entry/Intermediate

PhotoImpact X3 is an image editor that addresses both the image editing and web page creation needs of the average digital photographer. You can manipulate your images and lay out web graphics and then optimize and output them as complete web pages.

SUMMARY
Ulead's imaging program gives the user a range of tools, and a changing interface that is designed to support both simple and complex manipulation tasks. You can edit images and create web pages using functions such as:
- A full array of imaging and painting tools
- Vector 2D and 3D graphics
- Over 60 exclusive special effects and filters
- Visual web page layout and one-click HTML output

FEATURES
Image Editing and Enhancement Tools:
PhotoImpact includes an extensive set of creativity tools for creating and editing photographic content. Imaging Tools include:

Fig 13 – PhotoImpact is a very capable entry level package that has enough functions and features to be considered as a semi-intermediate candidate.

- Special Effects
- Path Drawing Tools
- Text Tools & Effects
- Wrap & Bend
- Masking

Painting Features
- 12 Paint brushes including Paintbrush, Airbrush, Crayon, Chalk
- 9 Clone brushes like Bristle, Oil Paint, Marker
- 14 Retouch brushes such as Dodge, Burn, Smudge. Cursor shows true brush shape
- Paint and clone using object mode for improved layer control
- Paint with textures
- New Colorize Pen retouch tool

Special Effects
Lighting: Create still and animated effects using Lightning, Bulb light, Fireworks, Meteor, Comet, Halo, Spotlight, Lens flare, Laser and Flashlight

Type: Add gradient, transparency, hole, glass, metal, emboss, emboss-outline, emboss-texture, sand, concrete, lighting, fire, snow, neon and seal effects to text, selections and objects

Transform: Create still and animated effects with smudge, pinch, punch, ripple, stone, mirror, horizontal and vertical mirror, whirlpool, diffuse and horizontal squeeze

Particle: Add element-based fire, rain, clouds, snow, smoke, bubbles, fireflies and stars

Artistic Textures: Create unlimited still or animated textures using palette ramps, hue shifts and colouring control

Warping: Distort images & objects using various effects

Image Organization Tools:
The program features a customizable interface and visual "Pick-and-Apply" galleries, providing the user with simple but effective tools for editing and enhancing their images. Features include:
- EasyPalette
- Quick Command Panel

Fig 14 – PhotoImpact makes use of the familiar toolbar and menu driven approach to its screen design.

- Album Management
- Screen Capture
- Digital Watermarking

BEST USES

- Home office
- School projects
- Family photos
- Image preparation for web

EXTRA FUNCTIONS
Web Toolkit

PhotoImpact X3 delivers the tools needed to create web graphics and complete HTML pages. Features include:

- Save as web page
- Component Designer
- HTML Text
- Interactive Rollovers & Buttons
- Image Optimization
- GIF Animation
- Image Slicing

Recommended Hardware Requirements:
Intel® Pentium® III, AMD® Athlon™ 800 or above CPU
Windows® XP Service Pack 2 Home Edition/ Professional, Windows® XP Media Center Edition, Windows® XP Professional x64 Edition, Windows Vista™ Operating System
CD-ROM Drive
512 MB RAM (for Windows XP), 1 GB RAM (for Windows Vista)
750 MB available hard-disk space
True Color or Hi-Color display adapter with 1024 x 768 resolutions or higher

Current Version: PhotoImpact X3

Platform: PC

Price: US$49.99 download version

Download Trials:
Yes – 30 day from www.ulead.com

Web Link: www.ulead.com

ADOBE PHOTOSHOP ELEMENTS (figs 15 & 16)
Level: Entry/Intermediate

Photoshop Elements 7.0 is a major revamp of the very successful previous versions of the program. In the Windows version of this release Adobe combines the editing and enhancement features of the original program (with a few new powerful tools added in for good measure) together with the great management and organization abilities of Photoshop Album. The result is a comprehensive program that meets both the image-editing and picture management needs of the digital photographer in the one package.

Version 7.0 retains the editing strength that the program derives from being based on the same robust technology as its bigger brother Photoshop CS4 but provides this power with a price tag (US$99.00/£69.99) that is equal to most budgets. Designed to compete directly with the likes of Corel's Paint Shop Pro and Ulead's PhotoImpact, Adobe's entry level package gives desktop image makers top-quality image-editing tools that can be used for preparing pictures for desktop printing, a variety of image projects or web work.

Fig 15 – Photoshop Elements is Adobe's entry level product and is squarely aimed at the home market.

Adobe makes use of task-based work spaces as a way of simplifying and separating typical photographic activities. They are:

Organizer – a comprehensive image organization and management utility that enables you to import, display, sort, search and browse your photo collections quickly and easily.

Editor – this space includes Quick, Guided and Full edit modes which allows users to move from easy adjustment scenarios to more sophisticated ones as their skills build.

Create – is a special wizard-based project creation area that provides options to add your photos into slide shows, photo albums or books, cards or wall calendars.

Share – is the newest of the task modules and provides the user with a range of output options for their photos. It is here that you can email photos, create online albums or order prints.

Thankfully the colour management and vector text and shape tools use the same robust technology that drives Photoshop itself, but Adobe has cleverly simplified the learning process by providing step-by-step interactive "How Tos" or recipes for common image manipulation tasks. These, coupled with new features like Shadows/Highlights, Spot Healing Brush and the Red Eye Brush tool, make the package a digital photographer's delight.

FEATURES
Organization
- Import photos from a scanner, digital camera, floppy disk, Kodak picture CD, or the internet
- Preview and download images from digital cameras with WIA direct camera access software
- Store, manage and locate photos with the built-in Photo Browser, which lets you create customized, fully searchable photo albums

Editing and Enhancement
- Touch up or repair photos
- Improve brightness, contrast and colour with the Quick Fix workspace
- Apply dozens of amazing special effects, ranging from fun to artistic
- Ensure that the colours you print match the colours on-screen with built-in colour management software

Fig 16 – Photoshop Elements breaks the photographic process into several tasks and then provides dedicated work spaces for each. Here the Full Edit space (left) is seen alongside the Organizer (right).

Creativity

- Use styles to quickly add drama and pizzazz to the way that your images look
- Create personalized slideshows to share with your friends
- Use Photomerge to create a panorama from multiple overlapping images
- Add your photos to a range of creative projects in the Create workspace

BEST USES

- Home office
- School projects
- Family photos
- Image preparation for web

Hardware Requirements:

2 GHz or faster processor
Microsoft® Windows® XP with Service Pack 2 or 3 or Windows Vista®
Certified for 32-bit version of Windows
1 GB of RAM
1.5 GB of available hard-disk space
Colour monitor with 16-bit colour video card
1,024 x 768 monitor resolution at 96dpi or less
Microsoft Direct X 9 compatible display driver
CD-ROM drive
Web features require Microsoft Internet Explorer 6 or 7 or Mozilla Firefox 1.5 to 3.5

Version: 7.0

Platform: PC (different version exists for Mac)

Price: US$99.00/£50.00 CD-ROM
　　　US$89.00 download
　　　Download Trials : Yes

Web Link: www.adobe.com

COREL PAINT SHOP PRO PHOTO X2
(figs 17 & 18) *Level: Intermediate*

Jasc, recently acquired by Corel, has cleverly positioned its product between the template driven entry level packages and comparatively expensive professional ones. Providing much of the feature set of the big products and more flexibility than the smaller ones, Paint Shop Pro has always had a huge user base the world over. Now named Photo X2, this is a mature package that provides what most serious photographers demand from their editing program.

SUMMARY
Start to use this package and you will discover what millions of users already know – Paint Shop Pro offers the easiest, most affordable way to achieve professional image editing results.

Paint Shop Pro enables users to:
- Retouch, repair and edit photos with high-quality, automatic photo enhancement features
- Create and optimize web graphics with built-in web tools and artistic drawing and text tools
- Design animations with Animation Shop 3 included free
- Save time with productivity tools: grids, guides, alignment and grouping
- Expand your creativity with over 75 special effects
- Share photos electronically via email, web sites and photo-sharing sites

FEATURES
Use the Express Lab to quickly fix and correct dozens of photos in the time it used to take to correct just a few. With the new Auto preserve option you can ensure that you don't overwrite important originals. Paint Shop Pro has support for raw files and over 50 other picture formats.

Image Editing and Enhancement Tools
New tools will help with everyday retouching tasks

Fig 17 – Paint Shop Pro is an editing and image-creation product designed with the professional image-maker in mind.

such as whitening teeth, smoothing wrinkles and removing blemishes with just a few clicks. Paint Shop Pro also includes tools for painting, drawing, text, image editing, layers and layer blend modes. There are screen capture features and Digimarc watermarks, special effects filters, Picture Tubes and Picture Frame functions. Advance features allow the removal of noise grain and age-based discolourations.

There are facilities to automatically adjust colour balance and enhance brightness, saturation and hue, and remove red eye. Restore damaged photos with the Scratch Removal Tool, and use the adjustable Histogram to enhance details without loss of information. Instantly remove noise, scratches, dust or specks and improve crispness and impact. Repeat the last command feature.

New professional level tools include the ability to combine multiple photos into a single High Dynamic

Fig 18 – Paint Shop Pro interface echoes the design of other key programs in the area such as Photoshop and Photoshop Elements.

Range picture, the support for layers and non-destructive adjustment layers, depth of field adjustments, lens distortion correction and 16 bits per channel editing.

Image Organization Tools

Direct digital camera support, photo enhancement filters, colour adjustments and adjustment layers. Visual browser, multiple-level undo/redo, multiple image printing and batch file format conversion features. Enhanced support for nearly 50 file formats, which is more than any other product on the market.

BEST USES

- Professional and intermediate level editing
- Home office
- School projects
- Family photos
- Image preparation for web

Recommended Hardware Requirements:
Windows Vista® or Windows® XP, with latest service packs installed
512 MB RAM (768 MB recommended)
768 MB RAM required if using Windows Vista
1 GHz processor (2 GHz recommended)
1.5 GB hard disk space
24-bit color display, 1024x768 resolution
Microsoft DirectX® 9.0c or higher (included in Windows Vista and XP)
DVD drive

Current Version: X2

Platform: PC

Price: US$129.00/£85.00 boxed

Download Trials: Yes

Web Link: www.corel.com

ROXIO CREATOR 2010 (figs 19–20) *Level: Entry*

Roxio Creator may seem a strange inclusion in this line-up of digital imaging software, but the range of products included in the 2010 version of their popular suite do echo the requirements of many shooters.

SUITE FEATURES
Creator 2010 includes utilities for six key areas:
- Burning, copying and backing-up to discs
- Video import, edit and export
- DVD creation
- Music management and editing
- Photo organization, editing and presentation
- Output files, mobile devices
- Disc label creation
- Upload files to the web

PHOTO FEATURES
The photo component of the Creator 2010 is called PhotoSuite. It has a clean "look and feel" and includes thorough step-by-step guides that allow users of all experience levels to employ a vast line-up of features available for getting, preparing, composing, organizing, sharing and printing photos.

With PhotoSuite you can source your images from scanner, digital camera, CD-ROM and the web.

Manipulation controls include cut, clone, crop, adjust colours and resize your photos. You can also remove red eye, wrinkles and blemishes or restore old, torn and faded pictures. You can choose from many special effects including warp, ripple, splatter, mirage, sepia, moonlight and more.

Other features allow users to organize, store and retrieve photos in customized electronic albums via the Media Manager. Fast, powerful keyword search makes it easy to find what you want. PhotoSuite comes with hundreds of professionally designed templates for use when creating albums, calendars, cards, gift tags, magazines, postcard and poster projects.

PhotoSuite includes support for creating and saving cutouts (selections). With this feature, users can create their own photo objects and easily insert them into photos or projects. The software also includes the ability to edit an image's transparency (alpha channel), allowing users to quickly make parts of a photo "see-through".

Recognizing that sometimes users simply want to view a photo rather than edit it, PhotoSuite ships with a dedicated Media Manager that acts as a separate image viewer and provides users with a means of quickly viewing and organizing image content.

The package supports sending photos directly through popular web-based email services such as Outlook, Hotmail and AOL Mail. Users are able to reduce and optimize file size before sending photos and can even send multiple photos as an executable file that launches a special slide-show viewer.

Fig 19 – Roxio Creator 2010 is a suite of programs and utilities designed as a toolkit for the modern photographer. By including easy-to-use programs for both video and stills imagery alongside the company's proven disc-writing technology they have been successful in this quest.

Fig 20 – PhotoSuite is the core picture-editing program available in Creator 2010, but like other options we have reviewed here, there is also a browsing application (Media Manager) for the quick review of your photos.

The inclusion of an enhanced stitch engine gives digital image makers the ability to stitch together overlapping photos (side by side) and to create wide-vista panorama photos that can be printed or saved in a variety of file formats.

BEST USES
- Home office
- School projects
- Family photos
- Image preparation for web
- Very good general-purpose image-editing program

CREATOR PRO 2010
Roxio have also released a Pro version of the suite which extends the power of the toolkit with the inclusion of Lightzone photo-editing software, Blu-ray disc writing, special disaster-recovery software, BackOnTrack, SondSoap for removing unwanted noise from video and audio clips, and Sonicfire for producing sophisticated music tracks.

Recommended Hardware Requirements:
Microsoft® Windows Vista™ (32- or 64-bit), Windows® XP SP3 (32- or 64-bit), Windows® 7 Home Premium, Professional or Ultimate (32-or 64-bit)
Intel® 1.6 GHz Pentium 4 processor or AMD equivalent
1 GB RAM for Windows Vista and Windows 7. For video editing: Intel Pentium 4 2GHz processor or AMD equivalent, Multi-core processor with at least 2GB RAM.
1024 x 768, DirectX 9 compatible graphics card with at least 16-bit colour setting, sound card, DVD-ROM drive
Hard drive with at least 3 GB free space
Windows Media Player 10
Internet Explorer 7

Current Version: Roxio Creator 2010 and Creator Pro 2010

Platform: PC

Price: US$99.00/£49.00 download

Download Trials: Yes

Web Link: www.roxio.com

ADOBE PHOTOSHOP (figs 21–22)
Level: Professional

Fig 21 – Adobe's Photoshop is the premier editing product in the market today. Its feature and tool range coupled with its robustness has made it the industry favourite for several years now. With the release of version CS4 don't think that this situation will alter too much in the future.

Now in its eleventh version, Photoshop is definitely the tall poppy of the image-editing market. Millions of professional users the world over have made this package the industry standard. With each new version of the product Adobe has cemented its position as the undisputed front runner.

Adobe Photoshop CS4 (11) software introduces the next generation of image-editing with the broadest and most productive tool set available. With an inbuilt browsing application, Bridge, and strong links to major web and desktop publishing packages, Photoshop enables the professional user to achieve the highest quality results across all media.

SUMMARY

Photoshop provides an impressive list of tools, features and filters that are tried and tested by millions of industry users worldwide. The sophistication of the program can sometimes put new or inexperienced users off but after the initial steep learning curve as you get to grips with how Photoshop likes you to do things, the payoff is control of the most powerful editing package available for the desktop.

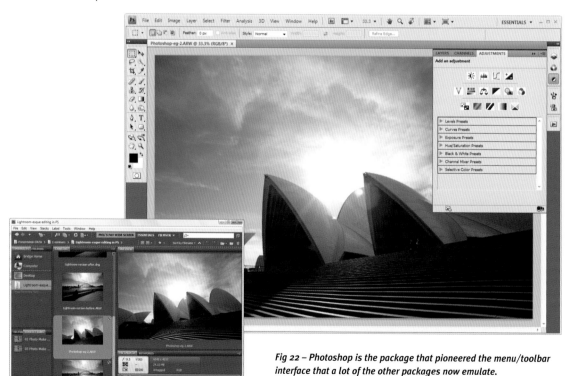

Fig 22 – Photoshop is the package that pioneered the menu/toolbar interface that a lot of the other packages now emulate.

FEATURES

CS4 software maximizes creative possibilities with a wealth of innovative tools. In the latest edition of the program this includes:

- Adjustments panel for accessing key image controls in the one place
- A new Masks panel for quickly creating masks to control enhancement changes
- New way to scale images that preserves detail and format or important picture parts
- Smoother image previews and panning
- Advanced blending of shallow focused images to create a large depth of field photo
- Local processing of raw files so that you can change just part of the photo
- Sophisticated alignment and blending options with Auto-Align and Auto Blend commands
- Vanishing Point filter allowing users to edit their photos in three-dimensional space
- Advanced layer control which means that multiple layers can be grouped, moved and even warped with ease
- Sophisticated options for processing multiple Camera RAW files
- Noise reduction filter for use with high ISO photos
- One-click red eye correction
- Facilities to create 32 bits per channel high-quality photos

- Customizable interface where you can even choose what menu items to display and which ones to hide
- Users can format and output images in secure Adobe Portable Document Format (PDF) files or directly to PostScript printers while maintaining the text as crisp, vector type
- Most extensive tool and feature set on the market
- Pixel-based editing, as well as vector shape drawing
- Tight integration with ImageReady, InDesign, Acrobat and GoLive
- Sophisticated browsing and management application – Bridge
- New Smart Objects that allow non-destructive manipulation
- Lens-correction filter that fixes common faults such as pincushioning and barrel distortion, while also correcting converging verticals

BEST USES

- Professional level photographic enhancement and editing
- Home office
- Image preparation for web and print publishing
- Extensive linking with professional publishing packages for web and print

Hardware Requirements – PC:
1.8 GHz or faster processor
Microsoft® Windows® XP with Service Pack 2 or Windows Vista® Home Premium, Business, Ultimate, or Enterprise with Service Pack 1
512 MB of RAM (1 GB recommended)
1 GB of available hard-disk space for installation;
1,024 x 768 display (1,280 x 800 recommended) with 16-bit video card
DVD-ROM drive
QuickTime 7.2 required for multimedia features

Hardware Requirements – Mac:
PowerPC® G5 or multicore Intel® processor
Mac OS X v10.4.11–10.5.4

512 MB of RAM (1 GB recommended)
2 GB of available hard-disk space for installation
1,024 x 768 display (1,280 x 800 recommended) with 16-bit video card
DVD-ROM drive
QuickTime 7.2 required for multimedia features

Current Version: CS2

Platform: PC, Mac

Price: US$699.00 for all platforms

Download Trials: Yes

Web Link: www.adobe.com

SIDE BY SIDE COMPARISONS

To give you a good idea about what each level of software is capable of, the techniques described in the following chapter will demonstrate how to use several different software packages to achieve similar effects. As the techniques become more complex you will notice that the simpler packages might not have the features needed to complete the task, but on the whole the differences of approach and flexibility will become obvious.

For entry level I will use PhotoImpact. From the intermediate group I have picked the much famed Paint Shop Pro, and for the professionals Photoshop will be used.

I have also included both Macintosh and Windows shortcuts for software that is available on both platforms.

WHAT EQUIPMENT DO I REALLY NEED ?

In this new photography the computer is a major part of your digital darkroom. This machine is the pivot point for image acquisition, manipulation and output. For this reason it is important to be clear about what equipment is really needed for the job.

The metal box that sits on the desk before you contains a variety of components that together give you access to your images. Each component plays a part in the image production cycle.

Processor (CPU) – It seems that every six months or so the major chip manufacturers produce a new version of their front-line processors. These chips are the engine of your computer and as such determine how quickly your machine will complete most tasks (see fig 23).

The processors are categorized in terms of their cycle speed and number of cores and generally speaking, the higher the number of cores and speed, the faster the chip. At present the best chips have four cores and a speed of about 3.20 KHz. Compared to the 12MHz "Turbo" chip that drove my computer in 1989 these new

processors just fly. But as soon as the chip makers develop faster models, software manufacturers and creative users dream of even more complex tasks to give them. The result is no matter what speed the machine is it never seems fast enough for the job at hand.

CPU Purchase tip – The fastest and latest are also the most expensive. Buying a machine with a slightly slower chip (the fastest and latest two months ago) will provide a more economical, albeit a little slower, entry machine.

Memory (RAM) – RAM memory is where your editing program and image are kept when you are working on them. It is different to the memory of your hard drive, as the information is lost when your computer is switched off. The amount of RAM your computer has is just as important as processor speed for graphics work. Photoshop recommends five times the amount of RAM as the biggest image you will be working on. When this is added to the amount required to run the editing program and the operating system, most users will need at least 2 GB of RAM memory.

RAM Purchase Tip – Buy as much memory as you can afford. The amount usually supplied with off-the-shelf systems is sufficient for most word-

Fig 23 – The CPU is both the brains and the brawn of your desktop computer.

processing and spreadsheet tasks but is usually not enough for good-quality digital imaging.

Screen – The screen is the visual link to your digital file. It follows then that money spent on a good-quality monitor will help with the whole cycle of production. Screen size is important, as you need to have enough working space to lay out tool bars, dialog boxes and images. Screens are categorized in terms of a diagonal measurement from corner to corner; 20-inch models are now the standard with 24-inch or greater being the choice of imaging professionals.

Screen Purchase Tip – Make sure that you "test view" a known image on a screen before purchasing as there can be a great difference between units of similar specifications.

Video Card – The video card is the most important part of the pathway between computer and screen. This component determines not only the number of colours and the resolution that your screen will display, but also the speed at which images will be drawn. Pick a card with a fast processor and as much memory as you can afford.

Video Card Purchase Tip – Read a few tests from the big computer magazines before deciding on a card. Don't assume that good 3-D performance will also be reflected in the area of 2-D graphics. Check the amount of memory enables you to view your desktop at higher resolutions in full 24-bit colour.

Mouse or Graphics Tablet – Much of the time spent working on digital images will be via the mouse or graphics tablet stylus. These devices are electronic extensions of your hand allowing you to manipulate your images in virtual space. The question of whether to use a mouse or stylus is a personal one. The stylus does provide pressure sensitive options not available with a mouse-only system. Wacom, the foremost company in the production of graphics tablets for digital imaging use, has recently produced a cordless mouse and stylus combination that allows the user to select either pointer device at will (see fig 24).

Mouse or Graphics Tablet Purchase Tip – My best advice is to try before you buy. The mouse, or stylus, needs to be comfortable to use and should fit your hand in such a way that your fingers are not straining to reach the buttons.

Storage – The sad fact is that digital imaging files take up a lot of space. Even in these days where standard hard disks are measured in terms of gigabytes the dedicated digital darkroom worker will have little trouble filling up the space. It won't be long before the average user will need to consider expansion options. For more details about the alternatives see the "Storage" chapter of this book.

Storage Purchase Tip – A DVD writer provides the most economical way of storing large image files.

Fig 24– The tools and menus of your program are accessed by using either a mouse or stylus. Wacom produces a cordless combination package that provides the option of either system.

TIDY SCREEN TIPS (fig 25)
No matter what size screen you have it always seems that there is never enough space to arrange the various palettes and images needed for editing work. Here are a few tips that will help you make the most out of the "screen property" that you do have.

Docking – Docking is a feature that allows several palettes or dialog boxes to be positioned together in one space. Each palette is then accessed by clicking on the appropriate tab at the top of the box.

Rollups – Most editing packages allow for large palettes to be rolled up so that the details of the box are hidden behind a thinner heading bar. The full box is rolled out only when needed.

Resizing the Work Window – If you have a small screen then it is still possible to work on fine detail within an image by zooming in to the precise area that you wish to work on. For this reason it is worth learning the keyboard shortcuts for zooming in and out. This function is a little like viewing your enlargement under a focus scope.

Hide All the Palettes – Once you have selected a tool, it is possible with some editing programs to hide all the palettes and dialogs to give you more room to manoeuvre. In Photoshop this is achieved by hitting the tab key.

SAFE WORKING (see figs 26–29)

For your comfort, work efficiency and safety it is worth following a few basic guidelines when setting up your digital imaging environment. Most of these suggestions are based upon research undertaken in business environments where the computer is the central work tool and are designed to reduce muscle and eye fatigue.

Lighting – Position the screen of your computer to minimize glare from lights in the room or from any windows. Do not set your computer up in front of

DOCKING

SCREEN RESIZE

ROLLUPS

Figure 26 – Some of the frustrations that come from having limited screen space can be alleviated by employing some basic "tidy screen" tips.

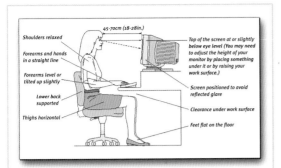

Fig 26 – Correct positioning of computer, desk and chair can help reduce fatigue and reduce the risk of injury.

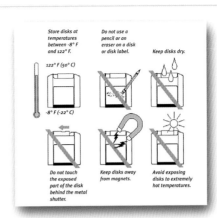

Fig 28 – Despite their external appearances to the contrary zip disks are very similar to your hard drive. Use these tips to help ensure a long life for your cartridges.

a window as this will affect the way that your eyes perceive contrast and colours on the screen. The top of the screen should be just below eye level when you are seated.

Seating – Use an adjustable chair that will give you good lumbar support and allow your thighs to be horizontal with your feet flat on the floor.

Breaks – You should always take rest breaks when working on long intensive projects with the computer. This generally means getting up and moving around, focusing your eyes on distant objects regularly and resting your wrists.

Electrical – Take all the same precautions with your computer setup that you would with any other electrical device. Keep water and any other liquids away from it.

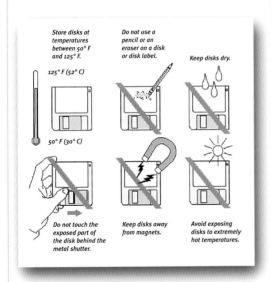

Fig 27 – Proper care of floppy disks will help ensure that you can retrieve your data when you next need it.

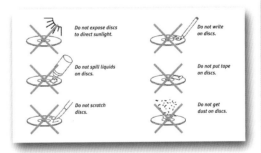

Fig 29 – Scratches to the written surface of a CD can mean that the information stored will not be able to be retrieved. A few simple precautions can help prevent this problem.

Desk – The height of the desk should be adjusted so that your shoulders are relaxed when using the keyboard. The mouse should be at the same level as the keyboard.

General precautions – Your machine and any portable storage disks such as floppies, zips or CDs should always be kept away from dust, water and magnetic sources. These things can adversely affect your ability to retrieve data from these media.

:::MANIPU

MANIPULATION TECHNIQUES

MANIPULATION TECHNIQUES

STARTING YOUR JOURNEY –
OPENING YOUR IMAGES

With your images transferred from the camera or scanner, it's a simple job to open them into your image-editing package. Most programs provide you with the opportunity to view small thumbnails of each image before opening it fully (see fig 1).

PhotoImpact

1. Select File····›Browse from the menu bar.

Fig 1 – You start the manipulation phase of the digital-imaging process by opening your saved images from disk.

2. Browse the disk and folders to select your image.
3. Double click the thumbnail to open your image.

Paint Shop Pro

1. Select File····›Browse from the menu bar.
2. Browse the disk and folders to select your image.
3. Double click to open the selected thumbnail file into the Paint Shop Pro workspace.

Photoshop

1. Select File····›Browse from the menu bar.
2. Browse the disk and folders to select your image.
3. Double click to open the selected thumbnail file into the Photoshop workspace.

ONE: CHANGING BRIGHTNESS

One of the first things you learn when printing traditional photographic images is how to control the exposure of the print. Too much and the image is dark, not enough and the image is too light. The digital equivalent of this is the brightness control. Usually in the form of a slider, this feature allows you to increase or decrease incrementally the brightness of your images.

Make sure that when you are making your adjustments you don't lose any picture detail. Too much light-

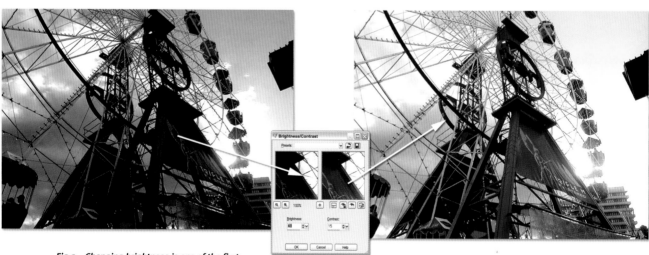

Fig 2 – Changing brightness is one of the first tasks to undertake with a new image.

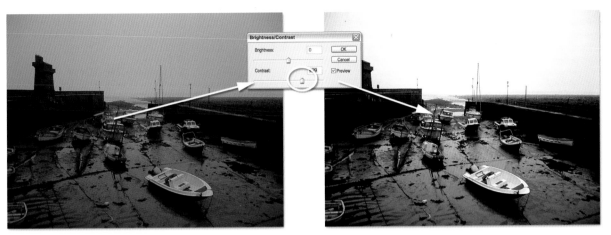

Fig 3 – Sometimes confused with brightness, contrast controls the spread of tones within your image.

ening and delicate highlights will be converted to white and lost forever. Conversely if you radically decrease the brightness of your photograph much of the shadow detail will be converted to black (see fig 2).

PhotoImpact

1. Select Photo⸱⸱⸱⸱›Brightness and Contrast from the menu.
2. Change the brightness level using the slider, or
3. Select the thumbnail that looks like the best spread of tones.
4. Click Preview to confirm your changes.
5. Click OK to finish or Continue to make more changes.

Paint Shop Pro

1. Select Adjust⸱⸱⸱⸱›Brightness and Contrast⸱⸱⸱⸱› Brightness and Contrast from the menu.
2. Adjust Brightness slider.
3. Check preview for changes.
4. Click OK button when finished.

Photoshop

1. Select Image⸱⸱⸱⸱› Adjustments⸱⸱⸱⸱› Brightness/ Contrast from the menu.
2. Adjust Brightness slider.
3. Check Preview for changes.
4. Click OK button when finished.

What if I make a mistake?

First of all, don't worry! Select the Undo option from the edit menu of any of the programs. This will undo the last step that you completed. In this case it would restore your image to the original brightness before your alteration. Remember, though, Undo can only erase the last step.

TWO: ADJUSTING CONTRAST

Contrast can be easily confused with brightness, but rather than being concerned with making the image lighter or darker, this function controls the spread of image tones.

If an image is high in contrast it will typically contain bright highlights and dark shadows. Both of these areas will contain little or no detail. These images are usually taken on sunny days. Low contrast pictures are typically captured on overcast days where the difference between highlights and shadows is less extreme.

All image-editing software packages provide the user with the ability to alter the contrast of their images (see fig 3).

PhotoImpact

1. Select Photo⸱⸱⸱⸱›Brightness and Contrast from the menu bar.
2. Change contrast level using the slider, or
3. Select the thumbnail that looks like the best spread of tones.
4. Click Preview to confirm your changes.
5. Click OK to finish or Continue to make more changes.

Fig 4– Removing colour casts from images is definitely a photographic job that is more easily accomplished digitally than traditionally.

Paint Shop Pro

1. Select Adjust····>Brightness and Contrast····> Brightness and Contrast from the menu.
2. Adjust Contrast slider.
3. Check preview for changes.
4. Click OK button when finished.

Photoshop

1. Select Image ····>Adjustments····>Brightness/ Contrast from the menu.
2. Adjust Contrast slider.
3. Check Preview for changes.
4. Click OK button when finished.

AUTOMATIC CORRECTIONS

Most software packages also include ways of applying contrast and brightness automatically. These features are based on the computer assessing the image and spreading the tones according to what it perceives as being normal. In most instances, using these features results in clearer images with better overall contrast and brightness, but I would always suggest that you make the changes manually when you are manipulating important or complex pictures. Manual correction allows much finer control of the shadow and highlight areas.

PhotoImpact users can use the Auto-Process ····>Level option found under the Adjust menu to automatically correct contrast and brightness. Photoshop provides Auto Levels and Auto Contrast that allow users to automatically correct and distribute their image's tones.

THREE: GETTING RID OF COLOUR CASTS

Working in colour brings with it both pleasure and pain. Sometimes what our eyes see at the time of shooting is quite different to what appears on the computer screen. Skin tones appear green, white shirts have a blue tinge or that beautiful red carnation ends up a muddy scarlet hue – whatever the circumstances, sometimes the colour in pictures seems to go astray.

In the old days, if you didn't have your own colour printing set-up you would have had to live with these problems. Now, with the flexibility of modern image-editing programs, ridding your favourite picture of an annoying cast is easily achieved (see fig 4).

PhotoImpact

1. Select Adjust····>Colour Balance from the menu.
2. Select the thumbnail that looks like the best colour correction.
3. Click Preview to confirm your changes.
4. Click OK to finish or Continue to make more changes.

NB: You can change the amount of difference in the colour cast of the thumbnails by altering the Thumbnail Variation slider.

Paint Shop Pro

1. Select Adjust from the menu.
2. Adjust the individual colour sliders.
3. Check proof for changes.
4. Click OK button when finished.

Photoshop

1. Select Image····>Adjustments····>Variations from the menu.
2. Adjust Fine-Coarse slider.
3. Select the version of your picture that is cast-free.

4. Check Current Pick for changes.

5. Click OK button when finished.

WHERE DO MY CASTS COME FROM?

Our eyes are very accommodating devices. Not only do they allow us to see objects and colours, but they also help interpret what is around us. For instance, if we view a white piece of paper under a fluorescent light, a household bulb or in the shadow of a building, it will always appear white to us. If we photographed the same sheet under similar lighting conditions the results would be quite different.

Under the fluorescent tube the paper would appear to have a green tinge, lit by the household bulb it would look yellow and in the shadow the sheet would look blue. Each light source has a slightly different colour. The professionals refer to these differences as changes in the colour temperature of the light. The sensor, or film, in our cameras records these differences as colour casts in our pictures.

Most modern digital camera have an automatic "white-balance" facility that helps the sensor record the image as if it were shot under white light. Similarly, a lot of the camera-based software programs available contain a function that accounts for different lighting conditions (see fig 5).

Adding Casts to an Image

Although it might feel like a strange thing to do at

AUTO WHITE BALANCE

FLUORESCENT LIGHTING

Fig 5 – Automatic white balance functions on modern digital cameras help to alleviate mixed lighting problems that still plague film users.

first, there will be times when you want to add a cast or a dominant colour to your pictures. A good example of this is adding a tint to a black-and-white image to produce effects similar to sepia or blue-toned prints (see fig 6).

To add colour to a black-and-white or greyscale image you will need to save the image as an RGB file

Fig 6 – Toning of a black-and-white image can be achieved digitally by intentionally adding a cast to your image.

Fig 7 – Israel Rivera makes good use of the enhancement features of Photoshop in his moody images.

even though it contains only black, white and grey information. Most programs allow you to do this by changing the colour mode of the image to RGB. You will not notice any immediate difference in the image but the file will now be able to accept colour information.

Photoshop users can then add tints to their image by selecting the Hue/Saturation option from the Image menu. Ensure that the Colorize option is checked, then change the colour of the tint via the Hue slider control and the strength by adjusting the Saturation slider.

If you use Paint Shop Pro then you can achieve similar results by using the Colorize option from the Colours menu. Again moving the settings of both the saturation and hue controls will change the strength and colour of the tint.

TRICKS OF THE TRADE: TINTING AT WORK (figs 7 & 8)

Israel Rivera, a landscape and documentary photographer, loves the look and feel of moodily printed and toned photographs. His latest project involved careful shooting and long hours of darkroom printing to achieve the emotion he desired in his prints.

Late in the project, Israel realized that the techniques he was using in the darkroom could be easily duplicated digitally. Cautiously at first, he started making pixel-based versions of his emotive prints. He says, "Initially I felt that the digital images might look a little gimmicky, but once I saw the results, there was no turning back. The pictures are great and the image quality speaks for itself."

Fig 8 – Brightness, texture and colour are all manipulated digitally during production.

FOUR: CROPPING YOUR PHOTOGRAPH

The framing of images is one skill that easily transfers between traditional and digital photography. By the careful positioning of the four edges of the image you can add impact and drama as well as improving the composition of your images.

For most of us, framing or cropping occurs twice during the image-making process – once when we compose the picture within the viewfinder and a second time when we make final adjustments before printing.

Digital cropping is a simple matter of drawing a rectangular border around the area of your photograph that you wish to keep. What is inside this selection will remain, what is outside will be discarded.

Fig 9 – Cropping your images can help to concentrate the viewer's attention on the most important aspects of your shot.

Often it is what you choose to throw away that makes an image strong. So, before making that final decision, be sure that the cropped image is more dynamic and balanced than the original (see fig 9). Remember, if you don't like the results of your crop, you can always Undo and start again.

PhotoImpact

1. Pick the Standard Selection tool from the toolbar.
2. Click and drag a selection around the part of the image you want to keep.
3. Select Edit····⟩Crop from the menu bar to discard the parts of the image outside the selection.

Paint Shop Pro

1. Select the Cropping tool from the toolbar.
2. Draw a rectangle around the section of the image you wish to keep.
3. Adjust the selection using the "handles" in the four corners of the rectangle.
4. Double-click in the centre of the rectangle to complete the crop.

Note: If the toolbar is not visible, select the Toolbar option from the View····⟩Toolbars menu.

Photoshop

1. Select the Cropping tool from the toolbar.
2. Draw a rectangle around the section of the image you wish to keep.
3. Adjust the selection by clicking on the edge or corner "handles" of the rectangle and moving them to a new position.

4. Double-click in the centre of the rectangle to complete the crop.

Note: If the toolbar is not visible, select the Toolbar option from the Windows····⟩Tools menu. If the Cropping tool is not visible, click and hold the marque tool. This will produce a "tool rollout" which will contain the Cropping tool as one option.

FIVE: RETOUCHING OUT UNWANTED DETAILS

All of us are struggling to capture the perfect picture, the one image where everything comes together – composition, focus, lighting and exposure – to make a photograph that is both memorable and dramatic. How often you capture such an image depends on your experience and skills, but for every one image that you feel makes the grade, there are many that come really close. With a little digital help, these images can also become success stories.

Traditionally, retouching was the sole domain of the photographic professionals. Using fine brushes and special paints, these artists would put the finishing touches onto photographic prints. The simplest changes would involve the removal of dust and scratch marks from the print. More complex jobs could require a total fabrication or reconstruction of destroyed or unwanted parts of an image.

The advent of digital techniques has changed the retouching world forever. The professionals have traded in their paints and brushes for graphics tablets and big screens and more and more amateurs are carrying out convincing spotting jobs at home (see fig 10).

There are many methods for retouching images,

Fig 10 – Once the domain of back-room artisans, high-quality photographic retouching is within easy reach of most digital workers. The Clone Stamp or Healing Brush tools are used to erase photo defects.

and here we will concentrate on the most basic techniques used for removing from your photographs marks that are usually the result of dust on the negatives during scanning. Most of the programs use a healing brush or rubber stamp type tool to copy a clean part of the image over the offending dust mark. The best results are achieved by careful use of the retouching tools on enlarged sections of the image.

Photoimpact

1. Select the Remove Scratch tool from the toolbar. Note: If the tool isn't visible you can display all the retouching tools by making the Retouch Tool Panel visible by selecting Workspace····▸Tools/Retouch Tools from the menu bar.
2. Adjust the size, edge softness and shape of the brush using the Attribute toolbar.
3. Adjust the level of the effect.
4. Position the mouse pointer over the scratch and click to retouch.

Paint Shop Pro

1. Select the Clone Brush (or Scratch Remover) from the toolbar.
2. Select a brush size and type.
3. Move the pointer over the part of the image that you want to copy over the dust mark.
4. Hold the Shift key down and click over the area to be copied. This specifies the copy point.
5. Move the cursor to the dust mark and click and hold to start over-painting with the copied area.

Photoshop

1. Select the Clone Stamp tool from the toolbox.
2. Select a brush size and type.
3. Move the pointer over the part of the image that you want to copy over the dust mark.
4. Hold the Alt key for Windows and Option key for Macintosh and click over the area to be copied. This specifies the copy point.
5. Move the cursor to the dust mark and click and hold to start over-painting with the copied area.

Of course, for red eye you can use the Red Eye Reduction feature found in most packages (see fig 11).

TOP TIPS FOR CLONING

1. Carefully select the area to copy. This is the biggest factor in how successful your retouching will be.
2. Adjust the brush size to suit the size of the dust mark.
3. Use a brush style that has a soft edge; this way the copied area will be less noticeable against its new background.
4. Sometimes adjusting the transparency (opacity) of the cloning brush will help make your changes less noticeable. This will mean that you have to apply the tool several times to the dust mark to ensure coverage.

TRICKS OF THE TRADE:
BETTER RETOUCHING TECHNIQUES

Although the techniques above are more than up to the task of smartening up your images, the professionals often have their own pet methods for tweaking their photographs. Commercial photographer Florian Groehn uses a combination of Photoshop's Dust and Scratches filter and the History brush.

He says that if you use the filter by itself your whole image becomes soft and unsharp. "It is much better to apply the filter only in the area of the dust problems. Combining the filter and the History Brush allows this." Follow the steps below to use Florian's technique (see figs 12–14).

1. Open your image into Photoshop.
2. Select the Dust and Scratches filter from the Filter⋯⟩Noise menu.
3. Highlight a typical dust mark in the preview area of the filter dialogue.
4. Adjust the Radius slider until the mark disappears. Notice that the image becomes soft and areas of colour become flat and textureless.
5. By adjusting the Threshold slider you can now reintroduce some texture (grain) back into image. High values here will bring the dust mark back so aim for a balance between texture and the elimination of marks.
6. When you are satisfied with the preview select OK to filter the image.
7. Select the step before the filter in the History palette.
8. Select the History Brush from the toolbox.
9. Change the mode for the brush to Darken for light marks on a dark background and Lighten for dark marks on a light background.
10. Apply the brush to the marks.

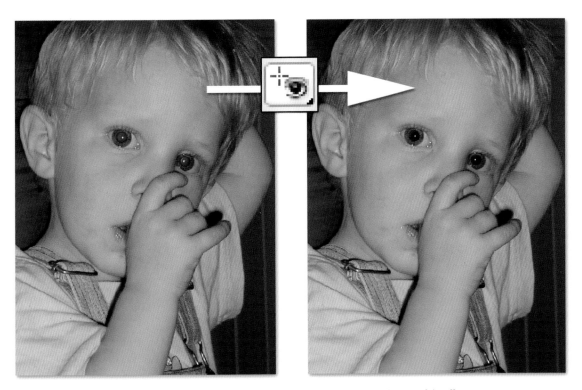

Fig 11 – Most of the entry-level packages have a "Red Eye Reduction" feature that rids your images of the effect that seem to plague compact camera users.

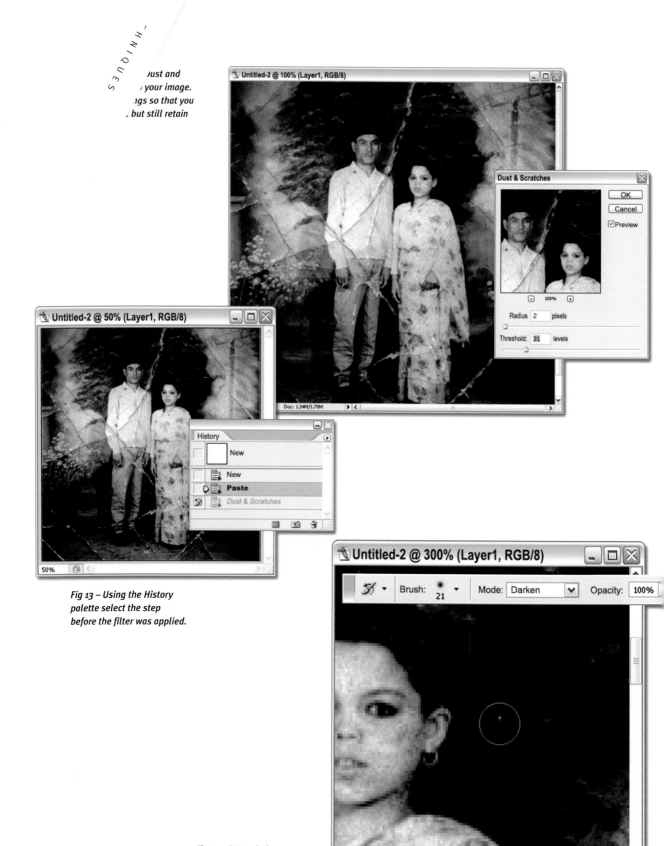

...ust and
... your image.
...gs so that you
... but still retain

Fig 13 – Using the History
palette select the step
before the filter was applied.

Fig 14 – Retouch the
white dust spots using the
History Brush set to Darken

SIX: ADDING BORDERS TO YOUR PRINT

There is no doubt that the quality of the image is every-thing. A good picture needs no tricks or frills to help make an impression. As if to prove this point, some photographers go so far as to refrain from any form of post-shooting "embellishment". They regard even the addition of borders to an image as sheer gimmickry.

This attitude ignores the fact that the edges of an image have always been important to photographers. Some shooters always include the black frame of the negative's edge as part of their image. The border does three things – contains the picture elements of the photograph, visually separates the image from its surroundings, and passes on to the viewer the compo-sition that the photographer intended.

their audience to know that the image was shot full-frame. It was a way to show off the in-camera com-positional skill of the photographer. When you saw the black edges of a print, you knew that the image had not been subjected to any cropping during the enlarging process – you were seeing exactly what the photographer saw.

To some extent this assumption is still made with black frames, but don't let this stop you experiment-ing. Remember that, once you have mastered the basic steps of this technique, there is no reason why you can't use a range of other border colours.

Photoshop has a function called Stroke which forms the basis of the technique I use to make black borders around my images. This command can be

 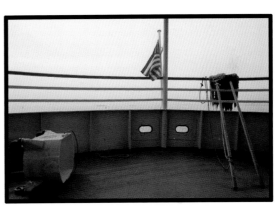

Fig 15 – A simple black border added to your image can help to contain the viewer's eye.

What is even more significant is that borders have been a part of print-making tradition for years. Whether it is the black edges of the negative's frame or the chemical overspill of a Polaroid print, many photographers have found that the edge of the image helps to define the photograph.

The world of digital imaging means that print bor-ders in all manner of shape, size and style are readily available. Any image, no matter its origin, can be sur-rounded by a border easily. This technique section will show you how to make two of the most popular border types – black edge and drop shadow.

Simple Black Frame Border (fig 15)

Select a suitable image to which to apply your border. Keep in mind that traditionally this type of edge treat-ment was reserved for photographers who wanted

used to draw a line that follows the edge of a selec-tion. In this example we simply select the whole image and stroke the selection with a line of a given colour and pixel width.

Paint Shop Pro, on the other hand, has a specialist Add Borders command that allows the user to place a coloured line around the whole image quickly and sim-ply. No selection step is needed, and the lines at differ-ent edges can be of different thicknesses – a bonus for those of us who prefer a slightly thicker border on the bottom edge of the picture.

Paint Shop Pro
1. Ensure the background colour is black.
2. Select Image⋯⟩Add Borders.
3. Adjust the size of each border.

Fig 16 – Popular drop shadow effects have been made a lot simpler by the inclusion of shadow functions within most sortware packages.

Photoshop

1. Select····⟩All.
2. Ensure that the foreground colour is black.
3. Select Edit····⟩Stroke (Width = 16 pixels, Location = Inside).

Shadowed Print Edge (fig 16)

As in a lot of areas of our life, fashion exists within the realms of digital imaging. The drop shadow – a subtle blurry shadow that gives the illusion that the text or image is sitting out from the page – is one "look" that has been very popular over the last couple of years. Such is the extent of its usage that most image-editing software, including Photoshop and Paint Shop Pro, now has automated processes for creating this effect.

The example that I have detailed below adds a white border to the image first, before increasing the canvas size and finally adding the shadow.

Paint Shop Pro

To make the white border:

1. Ensure the background colour is white.
2. Select Image····⟩Add Borders.
3. Adjust the size of each border.

To make the canvas big enough for the shadow:

4. Select····⟩All.
5. Select Edit····⟩Cut.

6. Select Image····⟩Canvas Size (adjust the size to account for the shadow).
7. Select Edit····⟩Paste····⟩as a new selection.
8. Click to stamp down when positioned (keep selected).

To make the shadow:

9. Select Effects····⟩3D Effects····⟩Drop Shadow.
10. Adjust sliders to change the style of the shadow.

Photoshop

To make the white border:

1. Select····⟩All.
2. Ensure that foreground colour is black.
3. Select Edit····⟩Stroke (Width = 16 pixels, Location = Inside).

To make canvas big enough for the shadow:

4. Select····⟩All.
5. Ensure background colour is white.
6. Select Edit····⟩Cut.
7. Select Image····⟩Canvas Size.
8. Adjust the size to account for the shadow.
9. Select Edit····⟩Paste.

To make the shadow:

10. Select Layer····⟩Layer Styles····⟩Drop Shadow. Adjust sliders to change style of shadow.

SPECIALIST BORDER AND EDGE EFFECTS SOFTWARE

Some software companies have devised specialist packages to help make border and edge effects on digital images. One such company is onOne Software whose Photoframe product is now in its fourth version. A downloadable demo version is available from www.ononesoftware.com (see fig 17). The product installs easily into Photoshop or Photoshop Elements and is accessible through the Filters menu. It is very simple to use. After opening your image go to Filter⋯⟩ OnOne⋯⟩PhotoFrame. A specialized dialogue box appears which then allows you to select, add and adjust borders and edge effects from a range supplied with the software. The manufacturer claims that well over one thousand different frames are possible.

The real power of the product is apparent when you see the extent to which you can control the application of the effects. With the image previewed it is possible to use the controls to change size, softness, opacity, colour, and width of the border. In addition, you can use the mouse pointer to change the size, shape and position of the frame.

When you are happy with the results of your adjustments, click the apply button and you are returned to the Photoshop interface with the finalized version of your image.

Other Border Types (fig 18)

Sometimes a slick straight-edged neat and tidy border is not what you want for a particular image. Providing an edge that is more rough and ready photographically would mean printing through a glass carrier, or using a roughly cut mask sandwiched with the negative at the time of printing. These techniques do, however, provide borders with a unique look and feel.

Digitally speaking, it is possible to achieve a similar effect by combining a ready-made "rough frame"

Fig 17 – OnOne's Photoframe product automates the frame-making process via a Photoshop plug in.

Fig 18 – Specialist frame or edge software can provide almost infinite variations to the surrounds of your image.

file with your image file. Putting both images together requires a bit of forethought though. Make sure that the images are of a similar size and orientation. Check the colour mode of each file. If you want a coloured final image then both files need to be in a colour mode

Fig 19 – You can make and apply your own borders by scanning the edges of a pre-existing print or one specially made for the purpose.

before you start – this applies even if the border is just black and white.

The process is fairly simple – select the frame, copy it to memory and then paste it over the image. The tricky bit is resizing the pasted frame so that it fits the dimensions and shape of the picture. To achieve this, Photoshop workers will need to practise manipulating the image using the Free Transformation command. Those readers who prefer Paint Shop Pro will need to become familiar with the Deformation tool.

Paint Shop Pro
To select a frame:
1. Open Frame and Image files
2. Ensure that the image file has enough white sur-round to accommodate a frame.
3. Select the white areas of the frame picture using the Magic Wand.
4. Click on Selections····⟩Invert to select actual frame.
5. Select Edit····⟩Copy.

To paste the frame onto the image:
6. Switch to the image file.
7. Edit····⟩Paste····⟩as a new layer (to paste frame onto image file).

To adjust the frame to fit the image:
8. Select the Deformation tool from the toolbar.
9. Move the corner and side nodes to re-size the frame to fit.

Photoshop
To select frame:
1. Open Frame and Image files.
2. Ensure that the image file has enough white surround to accommodate the frame.
3. Select the white areas of the frame picture using the Magic Wand.
4. Select····⟩Inverse (to select the actual frame).
5. Edit····⟩Copy.

To paste the frame onto the image:
6. Switch to the image file.
7. Edit····⟩Paste (to paste frame onto image file).

To adjust the frame to fit the image:
8. Select Edit····⟩Free Transform.
9. Move the corner and side nodes to re-size the frame to fit.

MAKING YOUR OWN BORDER FILES (fig 19)
The border used with the image above was made by scanning the edge of a black-and-white photograph printed with a glass carrier. Once converted to a digital file you can then select the image area and cut it away. The resulting border file can then be used with any other image file.

Try making your own files by scanning old prints or the edges of ones made specially for the purpose.

SEVEN: USING FILTERS

OK, hands up all of you who have a range of "Cokin" filters in your camera kit bag. If your arm is raised in timid salute then you are not alone – I too admit to buying a few of these pieces of coloured gelatine in an attempt to add drama and interest to my images. Ranging from the multi-image split prism to the key-hole mask for that all-important wedding shot, these photographic "must haves" seem to be less popular now than they were in the seventies and eighties.

It's not that these handy "end of lens add-ons" are essentially bad, it's just that we have all seen too many hideous examples of their use to risk adding our own images to this infamous group. In fairness, though, I still would not leave home without a good set of colour correction filters, and I am sure that my landscape colleagues would argue strongly for the skilful use of graduated filters to add theatre to a distant vista.

As much as anything, the filter's decline in use can be attributed to changes in visual fashion and just like

Fig 20

COLOURED PENCIL

CUTOUT

FRESCO

PAINT DABS

PLASTIC WRAP

ROUGH PASTEL

those dreaded flares, the filter effects of the seventies have made a comeback, thanks to digital. This time they don't adorn the end of our lenses but are hidden from the unsuspecting user, sometimes in their hundreds, underneath the Filter Menu of their favourite image-editing program.

NEVER FORGET... SO YOU'LL NEVER REPEAT IT!

The association with days past and images best forgotten has caused most of us to overlook, no, let's be honest, run away from, using any of the myriad of filters that are available. These memories, coupled with a host of garish and look-at-this-effect-type examples in computing magazines, have overshadowed the creative options available to any image-maker with the careful use of the digital filter.

To encourage you to get started, I have included a few examples of the multitude of filters that come free with most imaging packages. I have not covered Gaussian blur or any of the sharpening filters as most people seem to have overcome their filter phobia and made use of these to enhance their imagery, but I have tried to sample a variety that you might consider using.

If you are unimpressed with the results of your first digital filter foray, try changing some of the variables. An effect that might seem outlandish at first glance could become useable after some simple adjustments using the sliders contained in most filter dialog boxes.

The filter examples are grouped according to their type. For ease of comparison, each of the filters have been tested using a common image.

Artistic Filters (fig 20)

Coloured Pencil: Sketchy pencil outlines on a variable paper background.
Variables: Pencil Width, Stroke Pressure, Paper Brightness.

Cutout: Graded colours reduced to flat areas much like a screen print.
Variables: Number of Levels, Edge Simplicity, Edge Fidelity.

Fresco: Black-edged painterly effect using splotches of colour.
Variables: Brush Size, Brush Detail, Texture.

Fig 21

ACCENTED EDGES

CROSSHATCH

INK OUTLINES

SUMI-E

Paint Dabs: Edges and tones defined with daubs of paint-like colour.
Variables: Brush Size, Sharpness, Brush Type.

Plastic wrap: Plastic-like wrap applied to the surface of the image area.
Variables: Highlight Strength, Detail, Smoothness.

Rough Pastel: Coarsely applied strokes of pastel-like colour.
Variables: Stroke Length, Stroke Detail, Texture, Scaling, Relief, Light Direction, Invert.

Brushstroke Filters (fig 21)
Accented Edges: Image element edges are highlighted until they appear to glow.
Variables: Edge Width, Edge Brightness, Smoothness.

Crosshatch: Coloured sharp-ended pencil-like crosshatching to indicate edges and tones.
Variables: Stroke Length, Sharpness, Strength.

Ink Outlines: Black ink outlines and some surface texture laid over the top of the original tone and colour.
Variables: Stroke Length, Dark Intensity, Light Intensity.

Sumi-e: Black outlines with subtle changes to image tone.
Variables: Stroke Width, Stroke Pressure, Contrast.

Distort Filters (fig 22)
Pinch: Image is squeezed in or out as if it is being stretched on a rubber surface.
Variable: Amount.

Shear: Image is distorted in the middle in one direction whilst the edges remain fixed.
Variable: Undefined areas.

Twirl: Image is spun and stretched to look as if it is being sucked down a drain hole.
Variable: Angle.

Wave: Image is rippled in a wave-like motion.
Variables: Number of Generators, Type, Wavelength, Amplitude, Scale, Undefined Areas, Randomize.

Pixelate Filters (fig 23)
Colour Halftone: Creates an effect similar to a close-up of a printed colour magazine image.
Variables: Maximum Radius, Screen Angles for channels one to four.

Fig 22

PINCH

SHEAR

TWIRL

WAVE

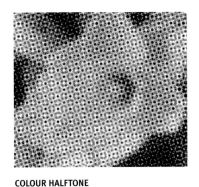

COLOUR HALFTONE

Fig 23

MEZZOTINT

MOSAIC

POINTILLIZE

Mezzotint: Adjustable stroke types give tone to the image.
Variables: Type.

Mosaic: The image is broken into pixel-like blocks of flat colour.
Variable: Cell Size.

Pointillize: Random irregular dot shapes filled with colours drawn from the original image.
Variable: Cell Size.

Sketch Filters (fig 24)
Bas Relief: Image colour is reduced with cross lighting that gives the appearance of a relief sculpture.
Variables: Detail, Smoothness, Light Direction.

Chalk and Charcoal: A black-and-white version of the original colour image made with a charcoal-like texture.
Variable: Charcoal Area, Chalk Area, Stroke Pressure.

Graphic Pen: Stylish black-and-white effect made with sharp-edged pen strokes.

Variables: Stroke Length, Light/Dark Balance, Stroke Direction.

Stamp: Broad flat areas of black and white.
Variables: Light/Dark Balance, Smoothness.

Fig 24

BAS RELIEF

CHALK AND CHARCOAL

GRAPHIC PEN

STAMP

Fig 25 CRAQUELURE STAINED GLASS

Texture Filters (fig 25)

Craquelure: Cracks imposed on the
surface of the original image.
Variable: Crack Spacing, Crack Depth, Crack Brightness.

Stained Glass: Image is broken up into areas of col-
our which are then bordered by a black line
to give an effect similar to stained glass.
Variables: Cell Size, Border Thickness, Light Intensity.

THE TEN COMMANDMENTS FOR FILTER USE

1. Subtlety is everything. The effect should
 support your image, not overpower it.
2. Try one filter at a time. Applying multiple filters
 to an image can be confusing.
3. View at full size. Make sure that you view the
 effect at full size when deciding on filter
 settings.
4. Filter a channel. For a change, try applying a
 filter to one channel only – red, green or blue.
5. Print to check effect. If the image is to be
 viewed as a print, double-check the effect when
 printed before making any final decisions about
 filter variables.
6. Fade strong effects. If the effect is too strong,
 try fading it. Use the Fade selection under the
 Filter menu.
7. Experiment. Try a range of settings before
 making your final selection.
8. Mask then filter. Apply a gradient mask to an
 image and then use the filter. In this way you
 can control which parts of the image are
 affected.
9. Different effects on different layers. If you want
 to combine the effects of different filters, try
 copying the base image to different layers and
 applying a different filter to each. Combine
 effects by adjusting the opacity of each layer.
10. Did I say that subtlety is everything?

FILTER DIY (fig 26)

Can't find exactly what you are looking for in the
hundreds of filters that are supplied with your edit-
ing package or available to download from the Net?
I could say that you're not really trying, but then
again, some people have a compulsion to do it
themselves. If that's you, all is not lost. Photoshop
provides the opportunity to create your own filtra-

tion effects by using its Filter····▷Other····▷Custom option.

By adding a sequence of positive/negative numbers into the 25 variable boxes provided, you can construct your own filter effect. Add to this the options of playing with the scale and offset of the results and I can guarantee hours of fun. Best of all, your labours can be saved to use again when your specialist customized touch is needed.

EIGHT: CHANGING SHARPNESS

Sharpness has always been an image characteristic for which photographers have striven. Shooters spend a lot of time and money on purchasing equipment and developing techniques that help ensure that their images are always pin sharp. Strangely, in recent years and in direct contrast to these ideas, just as much care and attention has been paid to intentionally blurring parts of the photograph.

A predominant picture style in the late nineties and into the new millennium has been the photograph with an ultra-small depth of field. Used to great effect in glossy food magazines, these images contain large areas that are purposely shot out of focus to contrast with a small section of the picture that is kept very sharp.

Traditional techniques for capturing these images involve the use of good-quality lenses, judicious selection of F-stop settings and, in some cases, a studio camera that is capable of changing the plane of focus. Apart from these manual techniques, a certain amount of control over sharpness is also possible within the digital field. In this section we will look at two methods that can help change the appearance of sharpness in your images.

Increasing Sharpness

At the outset, let me state clearly that an image that is taken out of focus can never be made sharp. Good focusing is the key to sharp images, and this fact is not altered by using digital techniques. The sharpening options offered by most software programs can only

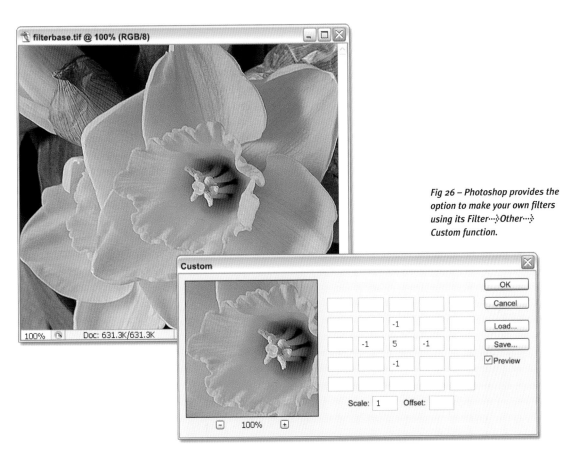

Fig 26 – Photoshop provides the option to make your own filters using its Filter····▷Other····▷ Custom function.

enhance the appearance of sharpness in an image, not make bad focusing good.

Entry level software usually offers at least one method for sharpening images. The more sophisticated image-editing programs offer a range of sharpening choices. Most of these have fixed parameters that cannot be changed or altered by the user. Some programs provide another choice – unsharp masking. This feature has a greater degree of flexibility and can be customized in order to get the best out of your images. The unsharp mask filter gives the user the most choice over his or her sharpening activities and should be used for all but the most simplistic sharpening needs.

PhotoImpact

Basic sharpening:

1. Select Format···>Focus from the menu bar.
2. Pick the thumbnail that represents the best sharpening effect, or
3. Click the Options button.
4. Adjust Sharpen/Blur slider and Levels settings.
5. Click OK to finish.

Unsharp masking:

1. Select Photo···>Sharpen···>Unsharp Mask from the menu bar.
2. Pick the thumbnail that represents the best sharpening effect, or
3. Click the Options button.
4. Adjust Sharpen Factor and Aperture Radius sliders.
5. Click OK to finish.

Paint Shop Pro

Basic Sharpening:

1. Select Adjust···>Sharpness or Sharpen More from the menu bar.

Unsharp Masking:

1. Select Adjust···>Sharpness···>Unsharp Mask from the menu bar.
2. Adjust Radius, Strength and Clipping settings. Click OK to finish.

Photoshop

Basic Sharpening:

1. Select Filter···>Sharpen···>Sharpen, Sharpen Edges or Sharpen More from the menu bar.

Unsharp Masking:

1. Select Filter···>Sharpen···>Unsharp Mask from the menu bar.
2. Adjust Amount, Radius and Threshold settings.
3. Click OK to finish.

WHAT IS UNSHARP MASKING?

Those of you who have a history in photography will recognize the term "unsharp masking" as a traditional film compositing technique used to sharpen the edges of an image. The sharpened edges, when seen at a distance, give the appearance of increased sharpness to the whole image. A different technique, which had the same type of results, involved developing black-and-white film in a high "Acutance" developer like Agfa's Rodinal. The developer produced an increase in the contrast between edges, giving an appearance of increased sharpness.

Photoshop and the other software programs combine the spirit of both these techniques in their Unsharp Masking filters. When the filter is applied to an edge, the contrast between two different tones is increased. This gives the appearance of increased sharpness at the edge.

Controlling Your Unsharp Mask Effects (fig 27)

In Photoshop the user can control the effects of the filter in three ways, via the slider controls in the dialog box (other programs use similar controls with varying names):

Amount: Ranges from 0 to 500 per cent and determines the degree to which the effect is applied to the image. Start at a value of about 150 per cent.

Radius: Controls the number of pixels surrounding the edge pixels that are affected by the sharpening. To start with, try setting the radius at the resolution of your image divided by 200. For example if the resolution is 600 dpi then the radius should be set at three (600/200 = 3).

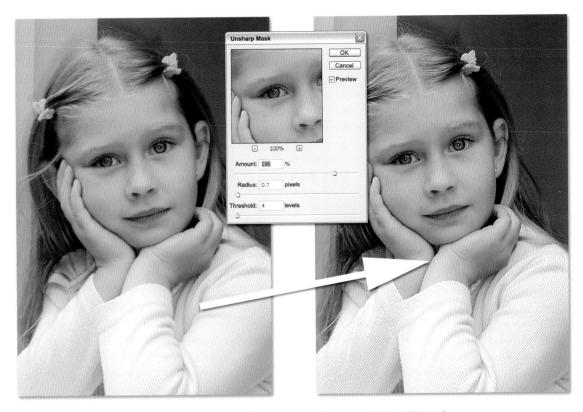

Fig 27 – Unsharp masking provides the ability to control the sharpening of the image via three slider settings.
In Photoshop these are called Amount, Radius and Threshold.

Threshold: This setting determines how different in brightness pixels need to be before the sharpening filter is applied. Although much under-used, this filter is essential for controlling which parts of your image will be affected by the sharpening. When you apply sharpening to flat areas of tone, like sky or flesh, they become very "noisy". By adjusting the threshold value you can stop the sharpening of these areas whilst maintaining sharpening everywhere else. A value of zero sharpens all the pixels in the image.

PRO'S SHARPENING TIP

Convert your image to LAB mode and apply the sharpening to the L channel only. As all the colour information is held in the other two channels, the sharpening will only affect the detail of the image, not the colour.

Intentionally Blurring Your Images (fig 28)

Although the notion of artificially introducing blur into your carefully focused images might seem a little sacrilegious, this digital technique is an important one to learn. Most photographers know that a blurred background will help to direct the viewer's eyes towards the main subject in your image. The blur functions contained within modern image-editing packages enable you to change the areas of focus within your picture and control the viewer's gaze more easily than ever before.

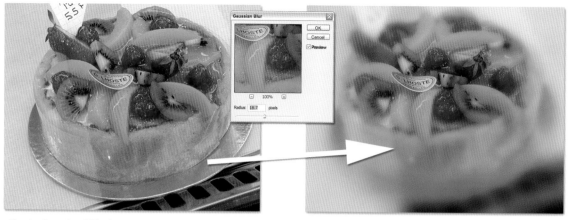

Fig 28 – Intentional blurring, or defocusing as some photographers prefer to call it, is a technique that is widely used in glossy food photography. A similar effect can be obtained by careful use of the Gaussian blur filter.

Again the more sophisticated software programs provide the greatest number of blur functions, Photoshop and Paint Shop Pro giving six or more possibilities, but most packages include at least one blur filter. Just like the unsharp mask function, the Gaussian blur filter gives the user more control over the amount of blur applied to an image.

PhotoImpact

1. Select Photo····⟩Blur, or
2. Select Photo····⟩Blur····⟩Gaussian Blur from the menu bar.
3. Pick the thumbnail that represents the best blurring effect, or
4. Click the Options button.
5. Adjust Variance sliders.
6. Click OK to finish.

Paint Shop Pro

1. Select Adjust····⟩Blur····⟩Blur or Soften filters from the menu bar or, for more control,
2. Select Adjust····⟩Blur····⟩Gaussian Blur.
3. Adjust Radius slider to the desired setting.
4. Click OK to finish.

Photoshop

1. Select Filter····⟩Blur····⟩Blur or Blur More from the menu bar or, for more variations and control,
2. Select Filter····⟩Blur····⟩Gaussian Blur, Motion Blur, Radial Blur or Smart Blur.
3. Adjust the sliders to the desired settings.
4. Click OK to finish.

NINE: ADVANCED TONAL CONTROL

The tones within a typical digital image are divided into 256 levels of red, green and blue. Each part of the image is uniquely described according to its colour, brightness and position within the grid that makes up the whole image. Apart from viewing the file as a picture, there are several other ways that the pixels can be displayed.

The Histogram and Levels Function (fig 29)

The histogram is a basic graph of the spread of pixel tones from black to white. High points in the graph indicate that there are a lot of pixels grouped around these specific tonal values. Conversely, low points mean that comparatively few parts of the image are of this brightness value. In simple terms, this graph maps the amount of pixels in the highlight, midtone and shadow areas of the image.

The histogram becomes particularly handy when used in the context of Photoshop's Levels function. Here the user can control the spread of the image tones. This means that flat or compressed tone images can be expanded to allow the display of a full range of brightnesses from black to white.

Paint Shop Pro implements a similar histogram-based feature located under the Adjust····⟩Brightness and Contrast section.

Paint Shop Pro

1. Select Adjust····⟩Brightness and Contrast····⟩ Histogram Adjustment from the menu bar.

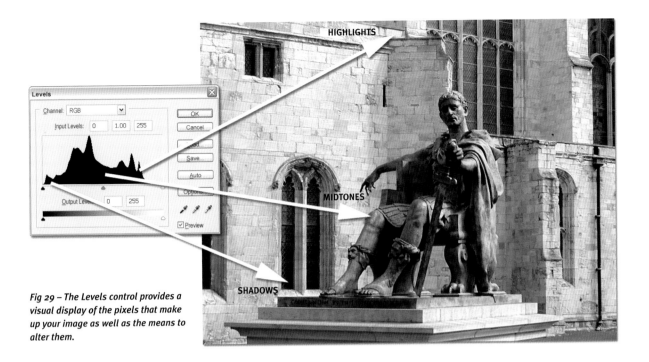

Fig 29 – The Levels control provides a visual display of the pixels that make up your image as well as the means to alter them.

Photoshop

1. Select Image⋯⋯⊳Adjustments⋯⋯⊳Levels from the menu bar.
2. Adjust the white and black points of the graph by either dragging the left and right triangles until they meet the first pixels, or by
3. Sampling the brightest and darkest parts of the image using the eyedroppers.
4. Midtones can be adjusted by moving the middle triangle beneath the graph.
5. Click OK to finish.

Curves! What Curves? (fig 30)

Characteristic curves have long been used by photographers to describe the specific idiosyncrasies of the way that different films and papers respond to light. In both Photoshop and Paint Shop Pro the curve has been used as a way of displaying and modifying an image's tonal areas.

When a user opens the curves dialogue box in Photoshop he or she is confronted with a straight-line graph at 45 degrees. The horizontal axis represents the current brightness of the pixels in your image, or input levels, the vertical axis represents the changed values, or output levels.

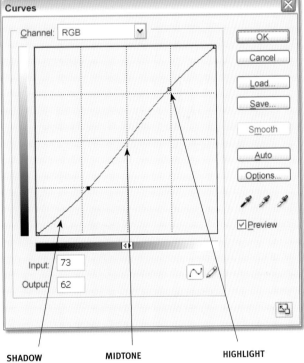

Fig 30 – The Curves function provides a way to visualize and control the tones in your image. It does this in a way that echoes the ideas used for years by photographers to illustrate how film and paper respond to light and development.

The diagonal straight line that appears by default when opening the curves dialogue box indicates that input and output levels are the same.

Changes are made to the image by moving the position of parts of the curve. When the pointer is clicked on the curve an "adjustment point" appears. When this point is clicked and dragged the pixels associated with that value will be lightened or darkened. Because the point is just part of a curve values on either side of the adjustment will also be affected. Many adjustment points can be added to the curve to anchor or change a set of pixels.

In Paint Shop Pro the curve idea is used to represent image tones in the Gamma Correction function. Red, green and blue channels can be adjusted together or independently. Unlike Adobe's product, making changes in Paint Shop Pro will only alter the midtones of the image. Black and white points are effectively fixed and are best altered through the contrast and brightness controls.

Paint Shop Pro

1. Select ····⟩Adjust····⟩Brightness and Contrast····⟩ Curves from the menu bar.
2. Move the sliders to the left or right to change the values of the midtone areas of your image.
3. Deselect the Link option to allow independent alteration of red, green or blue channels.
4. Click OK to finish.

Photoshop

1. Select Image····⟩Adjustments····⟩Curves from the menu bar.
2. Using the mouse, move parts of the curve to adjust shadow and midtone and to highlight areas of your image.
3. Click OK to finish.

Fig 31 – Pegging parts of the curve before alteration gives the user more control over the pixels that are changed.

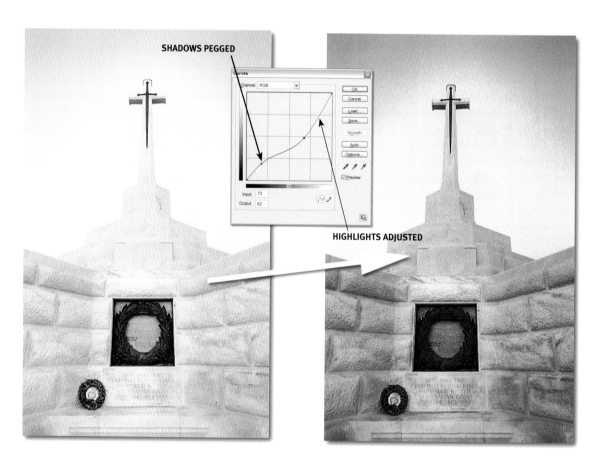

SHADOWS PEGGED

HIGHLIGHTS ADJUSTED

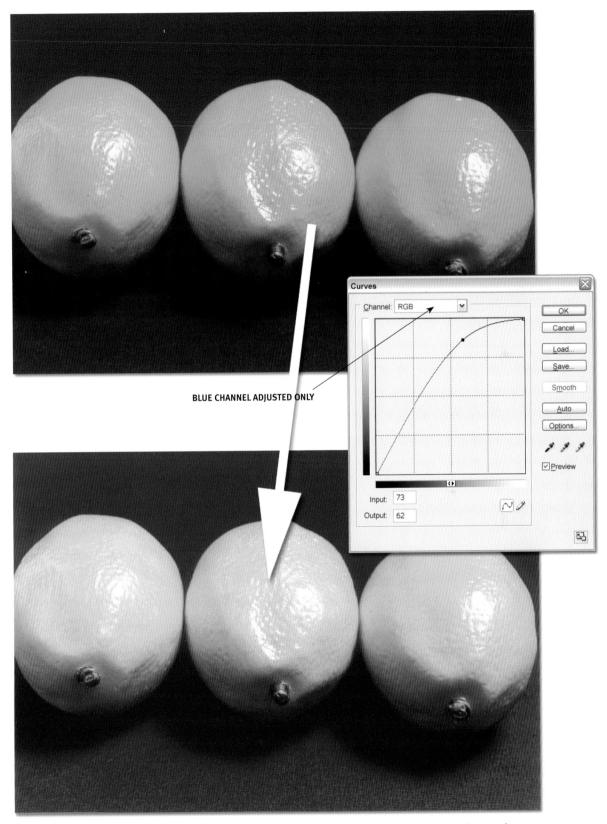

BLUE CHANNEL ADJUSTED ONLY

Fig 32 – The curve of individual channels can be altered independently allowing for manipulation of just one colour at a time.

Changes can be subtle or dramatic depending on the amount that the curve is altered from its original state. To help you with your first set of adjustments, here are a couple of helpful hints:

- Moving an adjustment point to the left will result in a lightening of these pixels,
- Conversely, a movement to the right will darken the pixels,
- A steepening of a section of the curve will result in higher contrast of the values selected, and
- A flattening of the curve will result in a lower contrast image.

If selecting and moving points is not precise enough for your needs, then you can change to the pen mode and freehand draw your own curve directly onto the graph. Those working with precise changes can note input and output value adjustments as they appear at the bottom of the box.

FINER CURVE CONTROL USING PHOTOSHOP (fig 31)

By clicking on a section of your image you can easily locate the value of that pixel and its position on the curve. This method was used to identify a specific group of highlight pixels in the Memorial Cross image. This image is made up mainly of light tones, with a small amount of shadow detail contained in the wreaths. To add some drama to the image, I located the shadow details and pegged their position on the curve. I then adjusted the highlight detail, safe in the knowledge that the shadows would remain largely unchanged. It is easy to see the changes to the resultant image, as the lighter tones have been modified to included more midtone area.

USING CHANNELS AND CURVES TOGETHER (fig 32)

At the top of the curves dialogue box is a select-able drop-down menu that allows the user to choose "combined" or "individual" channels. This feature provides the user with the ability to modify each individual channel that makes up your image. In the case of the Lemons image, which is an RGB file, it is possible to select and adjust one channel at a time. To demonstrate this I selected the blue channel and made the mid and shadow tone areas lighter. This adjustment made the blue background more vibrant without affecting other areas of the image.

TEN: SELECTING AREAS TO WORK ON

New and experienced users alike agree that being able to select specific areas of an image to work on is one of the most basic, but essential, skills of the digital darkroom worker. Sure, it is possible to make broad and general adjustments to pictures without such skills, but it's not too long before you will find yourself wanting to be a little more particular about which parts of the image you want to change.

With selection being such an important part of modern image-editing techniques, it is no surprise that all the main software products have a variety of methods that can be used to isolate wanted pixels.

The majority of these tools can be grouped into three major techniques:

1. Lasso- and pen-type tools that are used to draw around objects,
2. Marquee tools that, again, draw around objects, but in predefined shapes such as rectangles or ellipses, and
3. Colour selection tools, such as the Magic Wand, that define selection areas based on the colour of the pixels.

Added to these are selection tools designed specifically for isolating foreground objects from their digital backgrounds. The Extract function from Adobe's Photoshop and the Mask Pro plug-in from onOne Software are two such products.

The Basic Tools

Not all tools are suitable for all jobs. For this reason the software companies generally provide several different selection tools that can either work in isolation or together.

Marquee (fig 33)

Out of all the standard offerings, the marquee tool is the most simple. The user has a choice of rectangular or elliptical marquees, providing the ability to make square and rectangular selections along with circular and oval shaped ones. This is appropriate for selecting regular hard-edged objects in an image and is often used in conjunction with other tools.

Fig 33

that is in contrast to others within the picture, then the Magic Wand is a good choice.

The precision of the colour selection can be adjusted using the Tolerance setting found in the wand's palette. The higher the number, the less fussy the tool will be about its precise selection. To get the tolerance level just right, you might need to deselect and reselect several times. If you are lucky enough to have a clean and colour-consistent object or background, this is the tool for you.

Photoshop

1. Select the Magic Wand tool.
2. Click on the dominant colour in the background of your image.
3. Check the resultant selection to see that all background pixels have been encompassed by the marching ants.
4. If the selection isn't quite right, deselect (ctrl+d or Select⋯⟩Deselect), adjust the tolerance of the wand (double click the Magic Wand in the tool box to reveal the palette), and select again.

Fig 34

Photoshop

1. Select Marquee tool.
Note: Remember, to change tools you select and hold down the mouse button until the other options become available.
2. Locate the starting point of the rectangle, or ellipse. This is usually the upper right or left of the image.
Click and drag the mouse to draw the selection.

Magic Wand (fig 34)

The Magic Wand makes its selections based on pixel colour, not drawn area. If the part of the image you want to select has a dominant colour

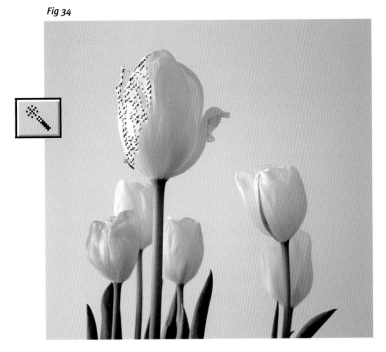

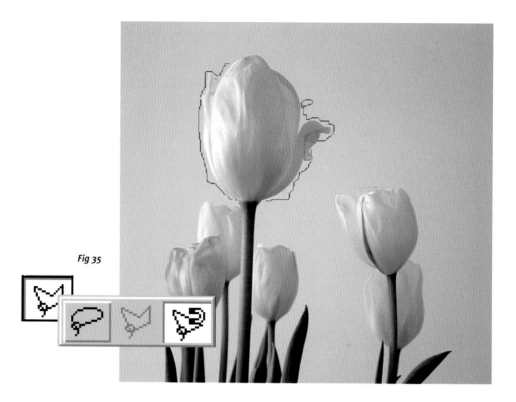

Fig 35

Lasso (fig 35)

Using the Lasso tool or, for even more accuracy, the Magnetic Lasso which sticks to edges, the user can draw around irregular-shaped objects. An alternative to this approach is to select the parts of the image that you don't want changed and then invert the selection. Inverting swaps the selection from object to background and vice versa.

Photoshop:

1. Select the Lasso tool.
2. Carefully outline the objects that you want selected, or
3. Draw around the objects you don't want in the selection, and
4. Inverse the selection (Select⋯⟫Inverse).

Pen Tool (fig 36)

The Pen tool, like the Lasso, is essentially used to draw the outline of the objects to be selected. Again, with this tool you have the option of a magnetic version, which aids in drawing by sticking to the edges of objects. The Pen draws a path rather than a selection. Once drawn, it has to be converted to a selection before use.

Photoshop

1. Select the Pen tool.
2. Carefully outline the objects that you want selected.
3. Once completed, show Paths palette (Window⋯⟫Paths).
4. Convert path to a selection (in the Paths palette select Make Selection).
5. Delete path and leave selection (in the Paths palette select Delete Path)

ADDING TO AND SUBTRACTING FROM SELECTIONS

You can add to a selection using any of the standard tools by holding down the shift key and then reusing the selection tool. You can also subtract from a selection by using the tool whilst depressing the Control key for PCs or Option key for Mac. In this way you can progressively build a complex selection that encompasses many irregular shapes, tones and colours.

ELEVEN: ADDING TEXT (fig 37)

Adding text to your images is an important next step towards digital proficiency. Traditional photographic techniques rarely gave the opportunity for shooters to easily add a few well-chosen words to their images. This is not the case with digital image-making. All of the major image-editing software packages have a range of text features. All have functions that allow the selection of font size and type and positioning within the picture. The most sophisticated packages also provide extra enhancements for the text, such as automatic "drop shadows" or "outer glows".

Fig 37

PhotoImpact

1. Pick the Text tool from the toolbar.
2. Position the cursor, now a text icon, in the image and click.
3. Enter the text directly on the picture.
4. Use the settings to adjust font size, type and colour.
5. Click OK to finish.

Paint Shop Pro

1. Pick the Text tool from the toolbar.
2. Position the cursor, now a text icon, in the image and click.

3. Use the Text Entry dialog box to enter text.
4. Use the settings to adjust font size, type and colour.
5. Click OK to finish.

Photoshop

1. Pick one of the Text tools from the toolbar.
2. Position the cursor, now a text icon, in the image and click.
3. Enter the text directly on the picture.
4. Use the settings to adjust font size, type and colour.
5. Click OK to finish.

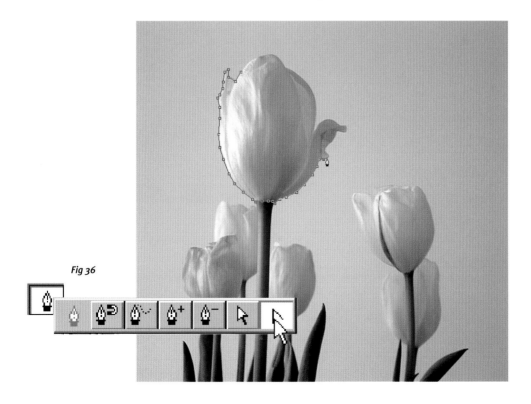

Fig 36

THEORY INTO PRACTICE

THEORY INTO PRACTICE

This chapter contains a series of examples of how the manipulation techniques you have just learned can be used to create exciting and refined images that communicate your ideas in ways that traditional photography cannot.

ONE: RESTORING AN OLD BLACK-AND-WHITE PHOTOGRAPH

Difficulty level: 1
Programs: PhotoImpact, Paint Shop Pro, Photoshop

Restoring an old photograph is typical of the type of jobs that the digital photographer is presented with on a regular basis. The type of skills needed to make repairs to damaged or faded images makes picture restoration a good exercise for new users.

Capturing Your Image (fig 1)

Most restoration tasks start with the careful scanning of the original image. It is this process that captures all the information you will be working with, so be sure to adjust the contrast and brightness controls within the scanner plug-in to guarantee that you don't lose delicate highlight or shadow detail.

In some cases, where the original has been torn to pieces, it is worth spending a little time making sure all the relevant sections are located and scanned. Repositioning and stitching the offending pieces together is a lot easier than trying to create complex bits of an image anew.

Even if the original is a black-and-white print, I still scan it as a colour original. This way I can capture the tint of the emulsion or toner that was used to produce the print originally. It also means that stains on the print surface can be isolated more easily (using Select ····⟩Colour Range in Photoshop) and removed.

Contrast and Brightness Control (fig 2)

Once the image is captured, the first step is to adjust the contrast and brightness. This can be undertaken using the automatic controls contained within your

Fig 1 – More than just the start of the restoration process, scanning captures the information that will be the basis of your completed image. Lack of care here will lose important information that is vital to the process.

Fig 2 – Adjust the spread of the tones in your image by altering its contrast and brightness.

PHOTOIMPACT

PAINTSHOP PRO

PHOTOSHOP

imaging package or by manually pegging the white and black points of the image. Apart from these general changes, I also tend to make small adjustments to the brightness of the shadow areas, so that subtle details, which tend to get lost at the printing stage, are more apparent.

STEPS FOR SHADOW ENHANCEMENT (fig 3)

PhotoImpact

1. Select Adjust····▸Highlight Midtone Shadow
2. Move the Midtone slider to the right or increase the values to lighten shadows.

Paint Shop Pro

1. Select Adjust····▸Brightness and Contrast····▸ Highlight/Midtone/Shadow from the menu bar.
2. Move the sliders right to lighten shadow detail.

Photoshop

1. Select Image····▸Adjustment····▸Curves
2. Carefully push the shadow area of the curve upwards so that the section from the black to this point is steeper than before.

Or

1. Select Image····▸Adjustment····▸Shadow/ Highlight
2. Start with the Shadow Amount slider set to 0 and gradually move the control to the right.

Fig 3 – A little adjustment to the shadow area of your image will help, as it's this detail that is often lost in the printing process.

Removing Dust and Scratches

Dust and scratches are a fact of life for most of us who scan our own negatives and prints. Sure, careful cleaning of the original will produce a file with fewer of these problems, but, despite my best efforts, some marks always seem to remain. All imaging packages contain good tools for removing these annoying spots. Most are based on either blending the mark with the surrounding pixels or stamping a piece of background over the area. Time spent on this helps ensure a professional result.

Repairing Damaged Areas

Reconstructing damaged or missing areas of an image is the most skilful part of the restoration process. Most tears and major scratches can be fixed by using the Clone Stamp and Healing Brush tools in Photoshop, PhotoImpact's Clone-Paintbrush or the Clone Brush in Paint Shop Pro. Search the picture for areas of the image that are of similar tone and texture to the damaged area to sample. The quality of your selection will determine how imperceptible the repair will be.

Large areas can be constructed quickly by selecting, copying and pasting whole chunks of the background onto vacant or missing parts of the image. Feathering the edges of the selection will make the copied areas less apparent when they are pasted. Remember, credibility is the aim in all your reconstruction efforts.

Fig 4 – To disguise the smoothing that is associated with some restoration steps, add a little texture to the image. Try to match the size and type of grain structure with that of the original.

Putting Texture Back (fig 4)

Often one of the telltale signs of extensive reconstruction work is a smoothing of the retouched areas. Even though cloning samples texture as well as colour and

tone, continual stamping tends to blend the textures, producing a smoother appearance. To help unify the new area and disguise this problem, a little texture should be applied to the whole image.

This can be achieved by adding "noise" to the image. This option is situated under the Filter menu in Photoshop, the Adjust⋯⟩ Add/ Remove Noise menu in Paint Shop Pro and the Photo⋯⟩Noise menu of PhotoImpact. In an enlarged view of your image (at least 1:1 or one hundred per cent) gradually adjust the noise effect until the picture has a uniform texture across both the new and old areas.

Adding Colour (figs 5 & 6)

A lot of historical images are toned so that they are brown-and-white rather than just black, white and grey. A similar, sepia-like effect can be created digitally using the Colorize options of Photoshop (Image⋯⟩Adjustments⋯⟩Hue/Saturation), PhotoImpact (Photo⋯⟩Hue/Saturation), and Paint Shop Pro (Adjust⋯⟩Hue and Saturation⋯⟩Colorize). With the Colorize box ticked, you can make changes to the tint of the image by sliding the Hue selector.

Fig 5 – Adjusting the Hue/Saturation control is an easy way to add a digital tone to your print.

Fig 6 – Restoration is a common job for digital photographers and one that hones important imaging skills and techniques.

Fig 7 – Deep etching is a frequently used preliminary step to adding multiple images together in a montage.

TWO: GETTING RID OF BACKGROUNDS

Difficulty level: 1
Programs: Photoshop, Mask Pro

In the old days, placing an object against a clean, white background was achieved by a process called "deep etching". This technique required a graphic designer or photographer to cut away background information by carefully slicing the image with a scalpel. Today, the job is completed in a less dramatic and more effective manner using a blunt mouse instead of a sharp knife.

Achieving this deep-etched look digitally requires the careful selection of objects and the deletion of their backgrounds. As an example, I chose an illustration containing a sign in the background. I wanted to extract the sign from the image and combine this image with a second picture (see fig 7). I could, and usually would, use one of Photoshop's in-built tools

to complete this task, and, as we have already seen, there are a variety of ways to reach the same goal.

Lasso Tool

Using the Lasso tool, or for even more accuracy, the Magnetic Lasso, I could draw round the whole sign, being careful to pick out the edges. Any overlaps could be tidied up using the eraser. I would then inverse the selection (Select·····⟩Inverse) and delete the background (Edit·····⟩Cut) (see fig 8).

Fig 8 – The Lasso is a selection tool that is based on an area drawn by the user.

Marquee Tool

The Marquee tool is not really an option here as the shape of the object to be selected is not regular. A rectangular marquee would leave a lot of the background area still to be erased (see fig 9).

Fig 9 – The Marquee tool also bases its selection on a drawn area.

Magic Wand

The Magic Wand tool makes its selections based on colour, not a drawn area. For this example, it would be best to select the background colour and then adjust the tolerance (found in the Magic Wand palette) to try to encompass all the required pixels. It would then be a simple matter to delete the unwanted pixels (see fig 10).

Fig 10 – The Magic Wand selects objects based on their colour.

Colour Range

In a similar way, the Colour Range tool, which is found nestled under the Selection menu in Photoshop, would allow me to select interactively the background or foreground colours, from which I could make a selection or mask (see fig 11).

Why the Need for More?

With such a variety of ways to achieve that all important selection, there would seem to be little or no need for another group of tools in this area. As the software versions of each of the leading packages have developed, so too has the sophistication of their selection tools. What more could specialist selection or masking products give the user that would warrant their use?

Fig 11 – Colour Range is a refined colour selection tool that allows the user to adjust and add to the colours that are selected.

The short answer is that, despite the strengths of these standard tools, for most jobs, specialist software can provide a greater level of flexibility and adjustment.

The Mask Pro Way

OnOne Software have obviously designed their (previously Extensis) Mask Pro plug-in around the tasks that digital workers find themselves doing most often, and have been careful to provide a range of options that, although similar to Photoshop in flavour, provide an extension to Adobe's tool set.

When you select Mask Pro from the Extensis heading under the Photoshop Filter menu, you are presented with a new working window containing the image, four palettes and the toolbox (see fig 12). Standard and Extensis versions of traditional tools like the Brush,

Paint Bucket, Magic Wand and the Pen are provided (see fig 13). Use the Keep and Drop Eyedroppers to select the colours within the image to be saved or discarded (see fig 14). These colours will now form the basis of the selection made with any of the specialized tools.

Next, drag the Magic Wand or Magic Brush tool along the outside edge of the image that you want to isolate from the background. Mask Pro will mask the area based on the Keep and Drop colours you have selected. Once completed, the image can be returned to Photoshop with the foreground figure now free of its background (see fig 15).

Once the sign is isolated, it is a comparatively simple job to drag it from its original window to that of the new background (see fig 16). If, like me, you need some white space to the side of the background image, change the size of the canvas before combining the images.

MASK PRO TOOLBOX BRUSH AND KEEP AND DROP PALETTES WORK WINDOW
THRESHOLD PALETTES

Fig 12 – Mask Pro is a dedicated selection system designed to make the job of cutting objects from their backgrounds easier and faster than ever before.

Fig 13 – The tools in Mask Pro are customized versions of the ones available in Photoshop.

Fig 14 – The Keep and Drop palettes determine what parts of the image are saved or deleted from the image.

Fig 15 – Brushing around an object in the Mask Pro window automatically drops unwanted pixels from the image.

Fig 16 – Combining two separate images is as simple as dragging the image layer from one open window to the other.

MASK PRO USAGE SUMMARY

1. Crop the image if necessary.
2. Open the Mask Pro plug-in by selecting the desired mode from the Extensis selection underneath the Filters menu in Photoshop:
 Filters····⟩Extensis····⟩Mask····⟩Mask Pro.
3. Use the eyedroppers to select the colours you wish to keep or drop from the image.
4. Select the areas to mask away using one of the painting or drawing tools like the Magic Wand or Magic Brush.
5. Search for the any holes and complete the mask using the Bucket Fill and Magic Fill tools.
6. Save the mask and return to Photoshop satisfied with a job well done!

Optional: Before returning to Photoshop you can apply other Mask Pro options such as:

- Using the Make Work Path to create a clipping path, or
- Using Edgeblender to reduce or eliminate halo effects.

Those of you who are Net connected can download trial versions of all the Extensis software from www.ononesoftware.com.

Adobe's Extract Tool (fig 17)

Hidden away under the Image menu in Photoshop is Adobe's specialist selection tool. Revised and updated for CS2, the concept is simple – draw around the outside of the object you want to select, making sure that the highlighter overlaps the edge between background and foreground, and then fill in the middle. The program then analyzes the edge section of the object using some clever fuzzy logic to determine what should be kept and what should be discarded, and Hey Presto! the background disappears.

The tool is faster than lasso or pen tools as you don't need to be as accurate with your edge drawing, and it definitely handles wispy hair with greater finesse than most manual methods I have seen. There are several ways to refine the accuracy of the extraction process that are handy for those areas where the computer has difficulty deciding what to leave and what to throw away.

Fig 18 – The first step in the extract process is to highlight the edges of the object to be extracted.

Fig 17 – Adobe's answer to advanced selection tools like Mask Pro is the Extract function.

Fig 19 – Once completed, the highlighted object can be filled.

EXTRACT USAGE SUMMARY

1. Select the layer you wish to extract.
2. Choose Filter⋯⟩Extract from the Photoshop menus.
3. Using the Edge Highlighter tool, draw around the edges of the object you wish to extract (see fig 18).
4. Select the Fill tool and click inside the object to fill its interior (see fig 19).
5. Click Preview to check the extraction.
6. Click OK to apply the final extraction (see fig 20).

Extraction Tips:

- Make sure that the highlight slightly overlaps the object edges and its background.
- For items such as hair use a larger brush.
- Make sure that the highlight forms a complete and closed line around the object

Fig 20 – Photoshop processes the command to extract by determining which part of the object is to be kept and which is to be dropped. The result is the selected object with its background deleted.

THREE: DIGITAL DEPTH OF FIELD

Difficulty level: 2
Program: Photoshop

Photographers have long considered control over the amount of sharpness in their images a sign of their skill and expertise. Almost all shooters display their depth of field agility regularly, whether it's by creating landscape images that are sharp from the very foreground objects through to the distant hills, or the selective focus style so popular in food and catalogue shots. Everyone from the famed Ansel Adams and his mates in the F64 group to today's top fashion and commercial photographers makes use of changes in areas of focus to add drama and atmosphere to their images.

In the digital age, the photographer can add a new technique to the traditional camera-based ones used to control depth of field in images. Unlike silver-based imaging, where once the frame is exposed, the depth of sharpness is fixed, pixel-based imaging allows the selection of focused and defocused areas after the shooting stage. In short, a little Photoshop trickery can change an image which is sharp from the foreground to the background to one that displays all the characteristics normally associated with a shallow depth of field.

Basic Defocusing of Pixels with Early Versions of Photoshop

1. Choose an image that has a large depth of field. This way you will have more choice when selecting which parts of the image to keep sharp and which parts to defocus. The example I have used has a large depth of field in its original form: it's sharp from the holy man in the foreground to the temple walls at the back of the frame. The picture demonstrates all the characteristics of an image made with a small aperture, such as F16 or F22. If I had shot this image with a larger aperture (F2.8 or F2), the holy man in the mid-ground would be sharp, while the foreground and background would be defocused (see fig 21).

2. Use one of Photoshop's selection tools to isolate the part of the image you want to remain sharp.

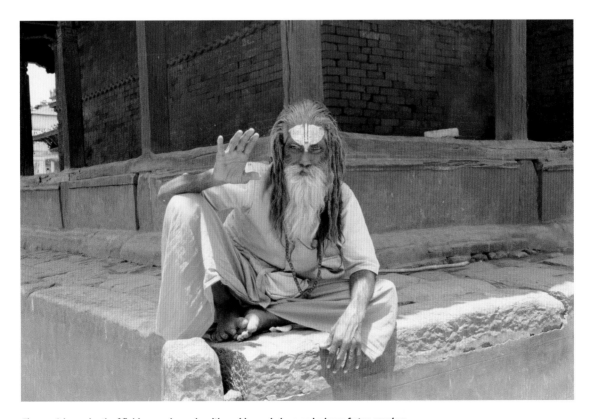

Fig 21 – A large depth of field example made with a wide-angle lens and a large f-stop number.

Fig 22 – Even with a feathered edge, a simple one-selection blur does not provide a very realistic shallow depth of field image.

I selected the whole figure of the holy man. Inverse the selection (Selection⸱⸱⸱⸱▹Inverse). In the example, the new selection included both the background and foreground information.

3. Add some feathering to the edge of the selection so that the transition points between focused and defocused picture elements is more gradual. This step can be omitted if you want sharp-edged focal points that contrast against a blurry background.

4. Filter the selected area using the Gaussian Blur filter (Filter⸱⸱⸱⸱▹Blur⸱⸱⸱⸱▹Gaussian) set at a low setting to start with. Make sure the Preview option is selected – this way you can get an immediate idea of the strength of the effect.

5. Hide the "marching ants" that define the selection area so you can assess the defocusing effect. Use the magnifying tool to examine the transition points between sharp and blurred areas. Re-filter the selection if the effect is not obvious enough.

This technique provides a simple in-focus or out-of-focus effect (see fig 22). It reflects, in a basic way, a camera-based shallow depth of field effect and draws our attention to the holy man. However, it is not totally convincing. To achieve a result that is more realistic, the technique needs to be extended.

Producing a More Realistic Depth-of-Field Blur

If realism is our goal, it is necessary to look a little closer at how camera-based depth of field works and, more importantly, how it appears in our images.

Imagine an image shot with a long lens using a large aperture. The main subject, situated midway into the image, is pin sharp, but the depth of field is small, so other objects in the image are out of focus. Upon examination, it is possible to see that those picture elements closest to the main subject are not as blurred as those further away. The greater the distance from the point of focus, the more blurry the picture elements become. The same effect can be seen in images with large depths of field, through the depth of sharpness is greater.

This fact, simple though it is, is the key to a more realistic digital depth of field effect. The application of a simple one-step blurring process does not reflect what happens with traditional camera-based techniques.

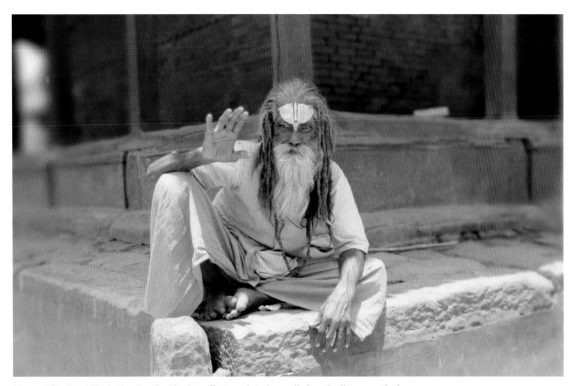

Fig 23 – If believability is the aim, the blurring effect needs to be applied gradually across the image.

More Realism – Step by Step (fig 23)

1. Using your raw scan image, repeat the first few steps of the basic defocusing process using Gaussian Blur filter settings that produce only a slight effect. A pixel radius of one is a good start. In my example, the holy man and the portion of the step beneath him was kept sharp, the rest of the image slightly blurred.

2. Now change the selection so that those parts of the image that are just in front of the subject or just behind are not included. Apply another Gaussian Blur filter. This time, increase the pixel radius to two. In the example image more of the step in front and behind the main subject was excluded from this second application of the filter.

3. Change the selection again removing the image parts that are next furthest away from the main subject. Reapply the Gaussian Blur filter with a setting of four. Part of the temple behind the subject in the example was now removed from the selection which was then blurred again.

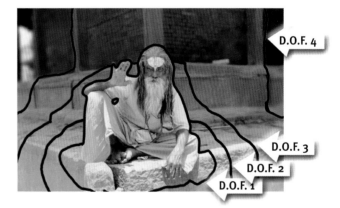

Fig 24 – A series of four selections was used to produce an image with a more realistic shallow depth of field effect.

4. This step can be repeated as many times as is needed to give a more realistic appearance to the effect. Each time, the selection is changed to exclude picture parts that are progressively further away from the subject, and each time the filter setting is doubled. In my example, four different selections were used to produce a more realistic depth of field effect (see fig 24).

If the simply created depth of field in the first example is compared with the more refined version in the second image, it is possible to see how an authentic feeling can be created by gradually increasing the amount of blur within the image.

Taking the Story Further

The Lens Blur filter (Filter····⟩Blur····⟩Lens Blur) was first introduced into Photoshop in the CS version of the program. The feature is designed specifically to help replicate the gradual change of sharpness that is present in real-life shallow depth of field effects. The filter uses selections or masks created before entering the feature to determine which parts of the picture will be blurred and which areas will remain sharp. In addition, if you use a mask that contains areas of graduated grey (rather than just black and white) the filter will adjust the degree of sharpness according to the level of grey in the mask.

The white area of the mask receives the most blurring, the black parts no defocusing effect and the grey areas proportional filtering. To create a realistic shallow DOF effect you will often need to com-

bine both mask types together. The following tutorial demonstrates a process for achieving just such a combination.

1. Start by making a selection of the image parts that are to remain sharp in the picture. Here I selected the Holy Man towards the front of the frame. The selection was feathered (Select····⟩Feather) by 1 pixel before being saved (Select····⟩Save Selection) as a new channel (alpha channel mask).

2. Next, switch to the Quick Mask mode and using the Gradient tool set to Reflective Gradient, drag out a gradient mask that equates to the gradual defocusing of the picture moving from the foreground to the background.

3. Switch back to Selection mode (Standard mode) and save (Select····⟩Save Selection) the graded selection to the same channel ("Holy Man") as the first selection. This time instead of making a new channel mask choose the Add to Channel option in the Save Selection dialog. This will combine the two selections into one channel mask.

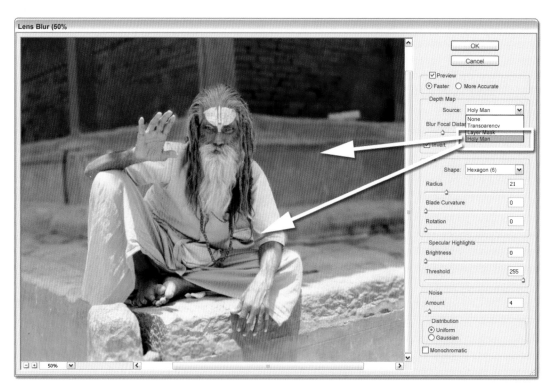

Fig 25 – The Photoshop Lens Blur filter provides a one stop focus control for your photos and is by far the best way to create realistic depth of field effects. Its changes are based on masks (selections) that you create before opening the filter.

4. Make sure that the RGB combined channel is selected in the Channels palette and then open the Lens Blur filter. Choose a preview option. Select the pre-made mask ("Holy Man") from the Depth Map Source drop-down list. Set a low focus distance and choose an Iris shape from the Shape pop-up. To add specular highlights to the picture drag the Threshold slider to set the brightness cut-off point. Select Gaussian or Uniform to add noise back to the smoothed parts of the picture. Click OK to process the picture.

Fig 26 – Before using the Lens Blur filter you need to create a mask that the feature will use to determine the sharp (black mask areas) and blurry (white mask areas) parts of the photo.

FOUR: DIGITAL LITH PRINTING

Difficulty level: 2
Programs: PhotoImpact, Paint Shop Pro, Photoshop

The craft printing revival of the last few years introduced a new generation of monochrome enthusiasts to a range of printing techniques, both old and new, that transform the mundane to the magnificent. Lith printing is one such technique. For the uninitiated, the process involves the massive over-exposure of chloro-bromide-based papers coupled with development in a weak solution of lith chemistry. The resultant images are distinctly textured and richly coloured and their origins are unmistakable.

The process, full of quirky variables like the age and strength of the developer and the amount of over-exposure received by the paper, was unpredictable and almost impossible to repeat. In this regard at least, printers found this technique both fascinating and infuriating. This said, it's almost a decade since lith printing started to become more commonplace and there is no sign of people's interest declining.

"Long live lith," I hear you say, "but I don't have a darkroom." Well, there's no need. The digital worker, with basic skills, a good bitmap imaging program, and a reasonable colour printer, can reproduce the characteristics of lith printing without the smelly hands or the dank darkroom of the traditional technique.

Step A: Decide What Makes a Lith Print

If you ask photographers what makes a lith print special, the majority of them will tell you it's the amazing grain and the rich colours. Most lith prints have strong, distinctive and quite atmospheric grain that is a direct result of the way in which the image is processed. This is coupled with colours that are seldom seen in a black-and-white print. They range from a deep chocolate, through warm browns, to oranges and sometimes even pink tones. If our digital version is to seem convincing, the final print will need to contain all of these elements.

Step B: Get Yourself an Image

Whether you source your image from a camera or a scanner, make sure that the subject matter is conducive to a lith-type print. The composition should be strong and the image should contain a full range of tones, especially in the highlights and shadows. Good contrast will also help make a more striking print.

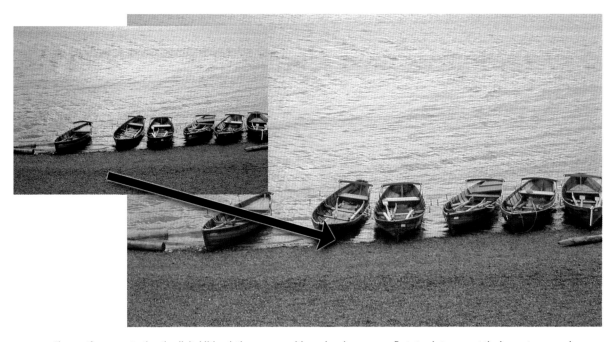

Fig 27 – If you are starting the digital lith-printing process with a colour image, your first step is to convert the image to greyscale.

Step C: Lose the Colour (fig 27)

Unless you are scanning from a monochrome original, you will need to change the mode of your digital file from either RGB or CMYK colour to greyscale. Even though lith prints do have a distinct colour, they all start life as a standard black-and-white image.

To change colour to greyscale:
PhotoImpact – Adjust ⋯⟩Convert Data Type ⋯⟩ Greyscale
Paint Shop Pro – Image ⋯⟩Greyscale
Photoshop – Image ⋯⟩Mode ⋯⟩Grayscale

Fig 28 – After desaturation, images tend to be a little flat. This can be rectified with a small adjustment of the Contrast and/or Brightness sliders.

Fig 29 – Grainy texture is one of the most recognizable characteristics of lith prints. Adding it to our digital image is critical if the effect is to be reproduced.

Step D: Adjust Contrast and Brightness (fig 28)

Sometimes when a colour image is changed to greyscale there is a noticeable flattening of the tones – the image looks low in contrast. Using the tools in your editing program, adjust the contrast and brightness of the image to make up for any loss of contrast. Make sure that all the tones are well spread and that the image contains good black and white as well as textured shadows and highlights.

To adjust brightness:

PhotoImpact – Photo····⟩Brightness/Contrast
Paint Shop Pro – Adjust····⟩Brightness and Contrast····⟩ Brightness/Contrast
Photoshop – Image····⟩Adjust····⟩Brightness/Contrast.

Step E: Add Texture (fig 29)

There are a couple of ways to simulate the texture of the lith print. You can filter the whole image using a film grain filter. Most of these type of filters have slider controls that adjust the size of the grain and how it is applied to the highlights of your image. I prefer to use a Noise filter as it gives an all-over textured feel that is more suited to the lith print look. Again, variations of the intensity of the effect can be made via the filter's dialogue box.

To add texture:

PhotoImpact – Photo Noise····⟩Add Noise
Paint Shop Pro – Adjust····⟩Add/Remove Noise····⟩Add Noise
Photoshop – Filter····⟩Artistic····⟩Film Grain or Filter····⟩Noise····⟩Add Noise.

Step F: Add Colour (fig 30)

The simplest and most effective way to add lith-like colours to your image is to make another change to its colour mode. For Photoshop users, instead of reverting back to an RGB, change to a duotone mode. This special colour mode is designed to allow a greyscale image to be printed with the addition of another user-selected colour. In effect, we can select whether the digital lith print will have a chocolate brown or pink colour by selecting the second colour that will mix with the grey tones of the monochrome print.

Paint Shop Pro and PhotoImpact devotees will need to colourize an RGB file that has been reconstituted from the greyscale, and then create the lith colour by adjusting the Hue and Saturation sliders.

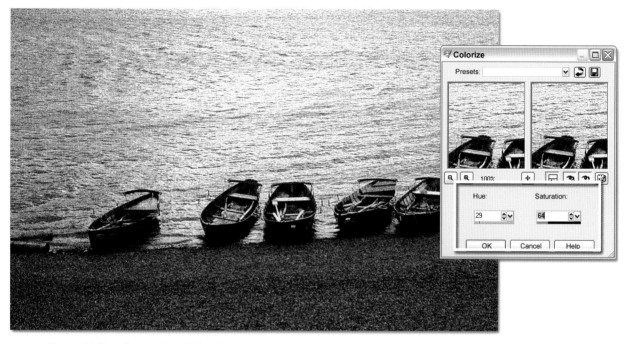

Fig 30 – Lith-like colours can be added to the black-and-white image using the Hue/Saturation controls.

To add colour:

PhotoImpact – Adjust⸱⸱⸱⸥Convert Data Type⸱⸱⸱⸥RGB True Colour and then select Adjust⸱⸱⸱⸥Hue and Saturation. Check Colourize option and adjust Saturation and then Hue sliders to add colour to the greyscale.

Paint Shop Pro – Image⸱⸱⸱⸥Combine Channel⸱⸱⸱⸥ Combine from RGB.

Select the greyscale image for each channel source, then Adjust⸱⸱⸱⸥Hue and Saturation⸱⸱⸱⸥Colourize. Adjust Saturation and then Hue sliders to add colour to the greyscale.

Photoshop – Image⸱⸱⸱⸥Mode⸱⸱⸱⸥Duotone.

Change type from monochrome to duotone.

Double click the colour space in ink 2.

Select a colour from the colour swatch.

Step G: Print Your Results

Printing, the final step of the process, shouldn't be underrated. Be sure to use the best quality settings for your printer. This means selecting the highest resolution possible and making sure that check boxes like Finest Detail are always ticked. Finally, use good-quality heavy-weight photo paper. Remember, most photographic paper is about 225gsm so if you want the same feel as a photograph, make sure you use a similar weighted stock to print on.

ACTION STATIONS

Because I like texture and grain, the lith printing effect is one I use often. The process is always the same – de-colour, texturize and re-colour – and, exciting as watching my colour images changing to something altogether more atmospheric is, the steps can become a little tedious.

Actions to the rescue! Many of you will be aware of the macro language that allows users of Photoshop 4 or greater to record a series of actions and apply them, at a later date, to another image. This facility is perfect for creating lith effect.

I simply activate the recording button, proceed through the steps of making a colour image into a lith one, and save the action for later use (fig 31). Then, when the action is started, the steps are carried out one by one as if I am pressing the buttons. Not only can I apply the effect to another image with just one button click, I can also change a whole folder, or directory, of candidate images by using the associated batch function.

I now possess a whole series of self-recorded actions that carry out a range of routine tasks that

would otherwise have me chained to the desktop for longer periods than I already am. These are, in effect, my digital toolkit.

BEFORE

AFTER

Fig 31 – The steps of the digital lith process can be recorded as a Photoshop action, making the whole process a one-button-push affair.

TRICKS OF THE TRADE: STEPHEN MCALPINE'S TEXTURED MONTAGE TECHNIQUE
(figs 32 & 33)

Difficulty level: 2

Programs: PhotoImpact, Paint Shop Pro, Photoshop

Stephen McAlpine is a professional portrait and wedding photographer who spent the first ten years of his career creating beautiful hand-crafted black-and-white images for his clients. Long hours were spent in the darkroom moulding and shaping a visual style that is both distinctive and emotive.

The approach was a success with his clients but his best work took many hours to complete. When he started to play with digital techniques, he realized he could provide the same style of work within a time frame that suited his bottom line.

"Digital is an extension of what I was already doing in the darkroom." McAlpine explains. "The new technology provides me with a way of working that is both creatively satisfying and efficient. I can now offer clients a fully customized service that would have been prohibitively expensive if produced traditionally. What's more, with current digital RA4 printing [photographic colour printing] the image looks and feels no different than what I would have produced if I had spent hours in the darkroom."

Fig 32 – Stephen McAlpine's imagery was initially produced in a darkroom-only process. Now he makes use of digital techniques to create images that are both stunningly beautiful and highly emotive.

The following is a summary of the steps that McAlpine uses to create his beautiful images.

Step 1: Scan the various image parts from black-and-white original negatives.

Step 2: Adjust the contrast and brightness of the individual parts so that they have a uniform look. Double-check that the light direction and quality is consistent with all parts.

Step 3: Drag all components onto separate layers of one image. Resize and adjust edge areas to fit the parts together.

Fig 33 – The steps used by McAlpine to create his photographs are designed to unify separate image components.

Step 4: Introduce uniform grain (or noise) across all components to give the appearance that they were all sourced from one negative.

Step 5: Add drama to the image by selectively darkening and lightening areas using the Dodging and Burning-in tools. Artificially create drop shadows for foreground objects to give the appearance that they were shot in situ.

Step 6: Use the Variations filter (or Hue/Saturation control) to add toning colours to the black-and-white images.

Step 7: Output proofs to a desktop inkjet and final client images to a digital RA4 colour printer.

FIVE: DIFFUSION PRINTING
Difficulty level: 2
Programs: Paint Shop Pro, Photoshop

Most photographers are obsessed with sharpness. We all strive for the ultimate quality in our images, carefully selecting good lenses, picking and choosing between film types and always, yes always, double-checking that the enlarger is focused before making that final exposure. All this so we can have sharp, well-focused images, of which we can be proud.

It seems almost a mortal sin, then, for me to be introducing you to a technique that shows you how to make your images "blurry", but, as we have seen, these days the photographic world is full of diffused images. From the food colour supplements in our weekend papers to the latest in portraiture or wedding photography, subtle, and sometimes not all that subtle, use of diffusion is a regular feature of contemporary images.

Traditionally, adding such an effect meant placing a "mist" or "fog" filter in front of the camera lens at the time of shooting. More recently, in an attempt to gain a little more control over the process, photographers have been placing the same filters below their enlarging lenses for part of the print's exposure time. This process gave a combination effect where sharpness and controlled blur happily coexisted in the final print.

The digital version of these techniques allows much more creativity and variation of the process and relies mainly on the use of layers and the Gaussian Blur filter. Both Photoshop and Paint Shop Pro have these facilities, coupled with simple interfaces that allow the user to control the application and control of the blur.

The Basics of Digital Diffusion (fig 34)
The Gaussian Blur filter, which can be found in most image-editing packages, effectively softens the sharp elements of an image when it is applied. Used by itself, this results in an image that is quite blurry and, let's be frank, not that attractive. However, when this image is carefully combined with the original sharp picture, we achieve results that contain sharpness and diffusion at the same time, and are somewhat more desirable.

Essentially we are talking about a technique that contains three distinct steps:

First, make a copy of your image and place it on a second layer that sits above the original. Rename this layer "blurred layer".

With this layer selected, apply the Gaussian Blur filter. You should then have a diffused or blurred layer sitting above the sharp original (see fig 35).

(Photoshop users who don't like the look of the Gaussian diffusion can choose to use the Diffuse filter instead. This filter is not as controllable but does achieve a different effect.)

Fig 34 – Digital diffusion printing provides the user with more controllable options than are traditionally available.

Finally, change the layer blending mode and/or the opacity of the blurred layer to adjust the way in which the two layers interact as well as how much of the sharp layer shows through.

Photoshop contains 23 and Paint Shop Pro 13 different blending modes that allow the user control over how any layer interacts with any other. After testing them all, I found that the modes that worked best for the example image were normal, soft light, multiply and luminosity. Of course, other modes might work better on your images so don't just take my word for it, make sure you experiment.

Adjusting the blurred layer's opacity changes the transparency of this image. This, in turn, determines how much of the layer below can be seen. More opacity means less of the sharp layer characteristics are obvious.

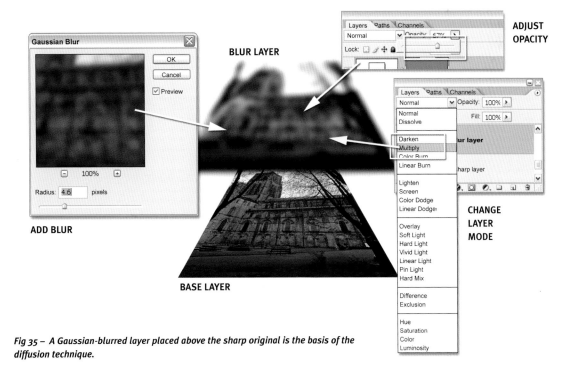

Fig 35 – A Gaussian-blurred layer placed above the sharp original is the basis of the diffusion technique.

By carefully combining the choice of blending mode and the amount of opacity, the user can create infinite adjustments to a diffusion effect.

Paint Shop Pro
1. File⋯⟩Open – Select image.
2. Layers⋯⟩Duplicate.
3. Rename new layer "blurred layer".
4. Make sure this layer is selected.
5. Adjust⋯⟩Blur⋯⟩Gaussian Blur.
6. Adjust blending mode and opacity in layers dialogue.

Photoshop
1. File⋯⟩Open – Select image.
2. Layer⋯⟩Duplicate Layer.
3. Rename new layer "blurred layer".
4. Make sure this layer is selected.
5. Filter⋯⟩Blur⋯⟩Gaussian Blur or
 Filter⋯⟩Stylize⋯⟩Diffuse.
6. Adjust blending mode and opacity in layers dialogue.

One Step Further: Graduated Diffusion
In some instances, it might be preferable to keep one section of the image totally free of blur. If you use Photoshop this can be achieved by applying the Gaussian filter to your original image via a selection.

For example, I could select the gradient tool, making sure that the options were set to "foreground to transparent" and "radial gradient". I could then switch to "quick mask" mode and make a mask from the centre of the image to the outer right-hand edge of the image. When switching back to the selection mode, I would now have a graded circular selection through which I could apply the blurring filter.

If this extra step is applied to a duplicate of the original image on a separate layer, it will still be possible to use blending modes and opacity to further refine the image.

Photoshop
1. File⋯⟩Open – Select image.
2. Layer⋯⟩Duplicate Layer.
3. Rename new layer "blurred layer".
4. Make sure this layer is selected.
5. Ensure that the gradient blur tool is set to "foreground to transparent" and "radial".
6. Switch to "quick mask" mode.
7. Draw gradient.
8. Switch back to selection mode.
9. Filter⋯⟩Blur⋯⟩Gaussian Blur or Filter⋯⟩ Stylize⋯⟩Diffuse.
10. Adjust blending mode and opacity in layers dialogue.

Even More Control: Erased Back Diffusion Technique (fig 36)
You can refine your control over the diffusion process even more by using the Eraser tool to selectively remove sections of the blurred layer. At its simplest, this will result in areas of blur contrasted against areas of sharpness. However, if you vary the opacity of the Eraser, you can carefully feather the transition points (see fig 37).

BEFORE

AFTER

Fig 36 – The erase back diffusion technique provides the user with control over which areas of the image remain sharp and which are blurred.

SELECTIVELY ERASE FROM LAYER

PLACE BLUR OVER ORIGINAL LAYER

Fig 37 – The Eraser tool is used to delete sections of the upper blurred layer to reveal the sharp image below.

The addition of the erasing step allows much more control over the resultant image. It is possible to select and highlight the focal points of the photograph without losing the overall softness of the image.

Paint Shop Pro

1. File····>Open – Select image.
2. Layers····>Duplicate.
3. Rename new layer "blurred layer".
4. Make sure this layer is selected.
5. Select Eraser tool.
6. Adjust opacity of the tool.
7. Erase unwanted sections of the blurred layer.
8. Image····>Blur····>Gaussian Blur.
9. Adjust blending mode and opacity in layers dialogue.

Photoshop

1. File····>Open – Select image.
2. Layer····>Duplicate Layer.
3. Rename new layer "blurred layer".
4. Make sure this layer is selected.
5. Filter····>Blur····>Gaussian Blur or Filter····>Stylize····>Diffuse.
6. Select Eraser tool.
7. Adjust opacity of tool.
8. Erase unwanted sections of blurred layer.
9. Adjust blending mode and opacity in layers dialogue.

LAYER BLENDING MODES

These modes determine how layers interact together. The following modes work best with the diffusion technique examples described here and are common to both Photoshop and Paint Shop Pro, but don't limit your experimentation. Try other modes – the effect they give might be more appropriate for the images you use.

Normal: This is the default mode of any new layer and works as if you are viewing from above the group of layers. In this mode, a layer that is only partially opaque (that is, partly transparent) will allow part of the layer beneath to show through. As the opacity level drops, the layer concerned becomes more transparent.

Multiply: Multiplies the top layer colour with that of the layer directly beneath it. This always results in a darker colour.

Soft Light: Darkens or lightens the bottom layer colours, depending on the top layer colour. If the top colour is lighter than fifty per cent grey, the image is lightened, as if it were dodged. If the top colour is darker than fifty per cent grey, the image is darkened, as if it were burned in.

Luminosity: Creates a result colour with the hue and saturation of the bottom layer colour and the luminance of the top layer colour.

SIX: PANORAMIC IMAGING

Difficulty level: 1

Programs: Panorama Maker, Photoshop, Photoshop Elements

All right, I admit it, I love the shape of panoramic pictures. There is just something about a long thin photograph that screams "special" to me. I have often dreamed of owning a camera capable of capturing such beauties but, alas, my bank balance always seems to be missing the amount needed to make such a purchase.

Lately the pragmatist in me has also started thinking about whether the comparatively few shots that I would take in this format would warrant the expense. I was in the midst of such thoughts when I stumbled onto a solution to my wide-vista problems.

A More Economical Approach (fig 38)

The first panorama software I used came free with my new Epson printer. Since it was designed to generate impressive virtual reality tours from a series of individual shots, I initially thought that it would be of little use to someone interested in print-based images. I was wrong.

In the process of stitching together a series of images, the program allowed the user to save the final scene as a JPEG file. As most photographers interested in digital-imaging know, this is an eminently useful format. My mind started to turn over and I realized that this could be a way for me to make panoramic pictures without having to pay for new equipment.

Field Test

A leisurely visit to a local National Trust property provided a great opportunity to test this technique for making panoramic images. Situated in a man-made landscape, the main house is fronted by a ornamental lake. To the left, a statue on its plinth rises from the water. The opposite side is just a bare stage.

Keeping in mind the recommendations of a 10 to 20 per cent overlap in each successive image, I shot a series of four stills, keeping the camera at the same height and focal length throughout.

The Results

As soon as the images were processed, I scanned them into my computer and used the software to match and stitch the images together (see "How to Use Shoot and Stitch Panoramas" below). As you would expect, areas where overlapping objects were obvious and sharp-edged stitched together perfectly, but the computer had a little more difficulty with more ill-defined picture sections, such as random foliage.

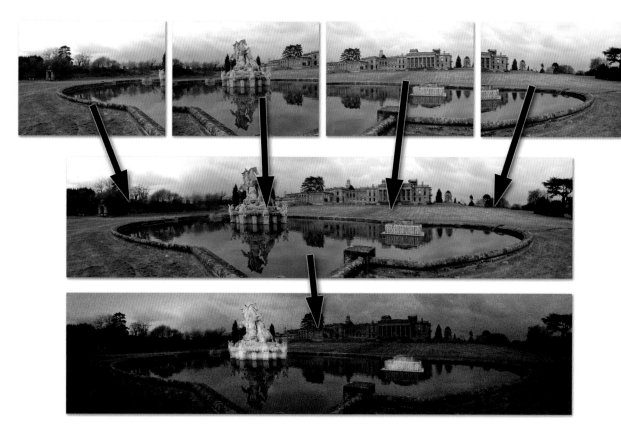

Fig 38 – It is possible to produce digital panoramic images using several standard images stitched together at the edges.

Stitching complete, I cropped the panorama to remove edge areas that would reveal its stitched nature and saved the whole project as a JPEG file.

Finishing Touches

The base work now done, I was ready to add some finishing touches in Photoshop. I felt that the nature of the scene deserved alterations that would suit the atmosphere of the environment. First I used the rubber stamp tool to eliminate the dust that appeared on the original scans. I then discarded the colour in the image by converting the mode to greyscale. Using the Levels tool I was able to position precisely the blacks, whites and, more importantly, midtone greys of the image. I then used the Dodging tool to lighten the statue detail in the front left of the picture. I also used a feathered selection and the Levels feature to darken the edges of the picture.

To complete the atmosphere I filtered the image using the Noise filter set to Gaussian and Monochromatic and added a lith printing-type colour via the Hue/Saturation control.

A Successful First Date

Don't tell my wife, but I think that Panorma Maker and I have just started a beautiful friendship. I feel that I can confidently shoot a series of images knowing that, when stitched together, they will produce stunning wide-angle vistas in the format that I so adore. All this for a fraction of the cost of purchasing a dedicated panoramic camera.

HOW TO USE SHOOT AND STITCH PANORAMAS

Shoot your images making sure that you have an overlap between successive images of around 20 per cent. Hold the camera steady and before you start to take the photographs pan through the vista to check to see if your view point, exposure, height and position are the best for the location. For the most accurate results you should pan "around the camera" keeping it as the centre of your pivot (see fig 39).

Start the Panorama Maker program choosing which format image you wish to create – Horizontal, Vertical, 360 Degree or Mosaic Tile. If you know the focal length of the lens used to shoot the source images you can input that value in the Camera Lens section of the dialog. If you are unsure then use the Automatic option. Select

the output size you require and make sure that the Automatic Exposure Correction feature is checked (see fig 40). Click Next.

Create a new Album using the New option from the drop-down menu. Add the source images from either your camera or computer to the album preview area. Drag the images from here to the story board section at the bottom of the screen. Change the order of the pictures by clicking and dragging to a new position. Alter

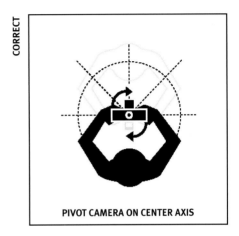

Fig 39 – Shooting around the axis of the lens will provide images that are more easily stitched.

orientation, contrast or brightness of any picture by double clicking on the thumbnail to take you to the Edit Screen (see fig 41). Click Next.

The program produces an automatically stitched image. Use the magnify options to check the stitch points of overlapping picture edges. To increase the accuracy of difficult areas you can adjust the stitch

Fig 40 – After starting the Panorama Maker program choose the style of image, focal length of lens and size of final result.

Fig 41 – Add the source images to the album section of the screen and then drag them to the storyboard.

points for each overlap manually by clicking on the Fine Tune button. This screen allows you to manually drag the matching stitching points for two consecutive images. Match image parts from both pictures. Sometimes it is necessary to try a range of stitching points before achieving a convincing result (see fig 42).

Click OK and then Finish to complete the panorama.

Output the final panorama. The final step in the process allows you to save the completed panorama as a picture in a variety of formats (Save button), a QuickTime movie file (Export button) or to print the wide vista photograph (Print button, see fig 43).

Fig 42 – You can manually place the stitching points using the Fine Tuning screen if the automatic process does not produce good results.

Fig 43 – With the stitch complete you can choose between three types of output – image file, QuickTime movie or print.

Software Details

Panorama Maker is produced by Arcsoft and a free demo version of the program is available for download from www. arcsoft.com.

PhotoImpact, Photoshop Elements and Photosuite also have dedicated stitching functions that you can use to create panoramic images.

SEVEN: RECAPTURING THE DRAMA OF YOUR IMAGES

Difficulty level: 3
Programs: Photoshop

At times it's hard to make decisions about which images to print and which to file. Like a lot of photographers, I find it difficult to judge my own work and am often disappointed with my results. The images don't reflect the atmosphere I saw and felt at the

Fig 45 – This portrait image, though already striking, can be improved by some drama-enhancing digital techniques.

Fig 44 – Sometimes shots have the potential to be a lot more dramatic than they first appear. There are several characteristics in this image that can be improved via a little digital enhancement.

time of shooting. In years past, I sought to recapture this atmosphere through the use of sophisticated darkroom techniques. More recently I have found that digital manipulation provides me with a range of options, some not even possible in the darkroom, that help bring the drama back to my images. The following process combines a series of basic techniques that together will help transform your images.

As examples I selected a couple of images that, in my eyes, failed to reproduce the atmosphere that was evident to me on the day. The first is a typical beach scene, complete with deckchairs, gravel (alas, no sand) and the obligatory old pier in the background (see fig 44). The second is a portrait of a stylish young gent intent on "tanning his tatts". Both images seemed stronger in the viewfinder than the straight prints indicate, and are good candidates for me to demonstrate the techniques I use to enhance the theatrical nature of my images (see fig 45).

Step A: Defocusing, or Depth of Field (fig 46)

Photographers have long used depth of field to control what is sharp within their images. We all know that shallow depth of field, produced by a long lens or a small aperture number (or both), isolates the focused object against a blurred background. This technique has more recently been called "defocusing", indicat-

Fig 46 – Defocusing parts of the image can help direct the eyes of your audience towards the focal points you choose.

ing that the photographer has made a definite decision about the sharpness of all elements in the image and that it didn't just happen by accident.

This term is handy to use for the digital version of the technique as it describes the process of blurring that occurs. Background objects, like the fence in the punk portrait, can be selected using one of the Photoshop selection tools, the edge of the selection feathered, and a Gaussian Blur applied. The contrast between the blurred and sharp parts of the image gives the appearance of a shallow depth of field. This directs the viewer's eye to the main part of the image.

In the beach scene, which has a large depth of field courtesy of a wide-angle lens and a small aperture, the areas in both the foreground and background were defocused, directing attention to the reading man. A series of selections and blur amounts were used to graduate the sharpness from the subject to the other parts of the image. This has the effect of most closely replicating the depth of field effects created by a standard camera lens and aperture.

Photoshop tools/menus used:
- Selection tools (Magic Wand, Marquee, Lasso)
- Feather (applied to the edge of the selection)
- Gaussian Blur filter.

Step B: Darkening Specific Areas (fig 47)

Dodging and burning is a traditional photographic technique that has been used for decades to help change and manipulate the tones in a photograph. Photoshop, again through the use of a series of feathered sections, allows the user to darken and lighten specific areas of an image.

Your first thought might be to use the Brightness/Contrast control to adjust the tones in the selected area, but this type of manipulation can produce very crude results. Instead, use your Levels control. If you carefully move the grey point in the dialog box you will find that

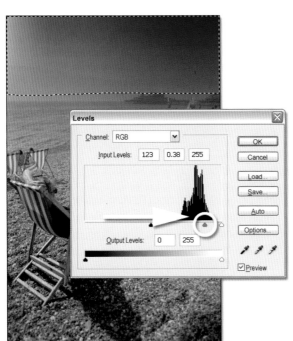

Fig 47 – The use of carefully drawn and feathered selections, together with the Levels dialog, gives the user great control over the darkening or lightening of specific image areas.

you can change the midtones without adversely affecting either the shadows or highlights. This solves the problem of clogged shadows, or blown highlights, that sometimes occurs when using the Brightness/Contrast control. Remember, with the selection "active", adjusting the levels will only affect the areas selected. The feathering will mean that the change in tone will happen gradually.

In the portrait, the forearms and the edge of the frame were darkened using this technique. The sky in the background, together with the foreground, were altered in the beach scene.

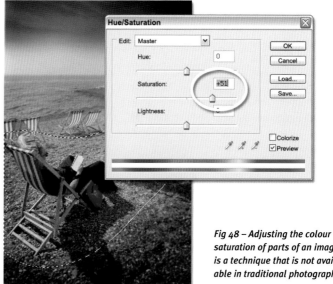

Fig 48 – Adjusting the colour saturation of parts of an image is a technique that is not available in traditional photography.

Photoshop tools/menus used:
- Selection tools (Magic Wand, Marquee, Lasso)
- Feather (applied to the edge of the selection)
- Levels dialog box

Step C: Saturation and Desaturation (fig 48)

This technique, unlike the previous two, does not draw easy parallels from the world of traditional photography. Again, the user selects and feathers areas of the image to work on. Making adjustments in the Hue/Saturation dialog box will then allow a change in the saturation of the colours in the image. Desaturate, and the image will gradually turn black-and-white; saturate, and the colours will become vibrant and, if pushed to extremes, garish.

In the portrait, the background was changed to become almost monochrome. To add even more contrast, the subject was then selected and its saturation increased. Back on the beach, the deck chairs were the obvious choice to saturate. Again, fore- and backgrounds were desaturated.

Photoshop tools/menus used:
- Selection tools (Magic Wand, Marquee, Lasso)
- Feather (applied to the edge of the selection)
- Hue/Saturation dialog box

Step D: Eliminating Unwanted Details (fig 49)

A lot of you will probably have used the Rubber Stamp tool before. As we have seen it's great for removing scratches and dust marks in all those restoration projects that the family insist on giving you. In the beach scene, I used the Clone

RUBBER STAMP UNWANTED DETAILS

Fig 49 – Eliminating unwanted details from an image can improve the overall composition of the photograph.

Stamp, or Healing Brush, not only to retouch dust marks but also to change whole sections of the image.

In the foreground, you will notice that the diagonal walls on the right and left sides have been replaced with more gravel. The sailing boat and countless people have been removed from the background.

When the boat and the life preserver were removed, the pier was repaired and, most significantly, the people in the mid-ground in the water, on the beach and sitting on the chairs have also been removed.

These adjustments add to the desired feeling of the isolation of the main subject, and provide an image that is now free of clutter.

Photoshop tools/menus used:
- Clone Stamp or Healing Brush tools

REALISM VERSUS EMOTION

I'm sure that, looking at the results, a lot of you will say to yourselves that these techniques create photographs that lie or, at least, don't reflect the truth of the scene (fig 50).

In one respect I agree with you. I have made definite changes to the images that did not occur on the day – people being removed from chairs, the sky made to appear menacing, colourful

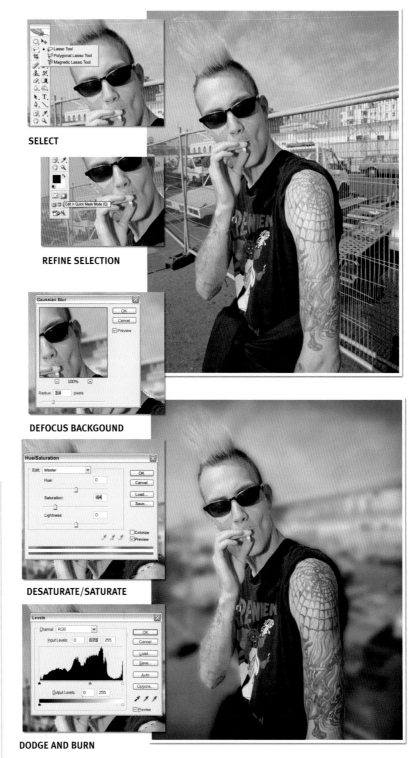

SELECT

REFINE SELECTION

DEFOCUS BACKGOUND

DESATURATE/SATURATE

DODGE AND BURN

Fig 50 – Dramatization of the portrait is a matter of five simple steps.

backgrounds turned to black and white. But remember, realism was not my aim. I was attempting to recreate the atmosphere of the image I saw through the viewfinder, and perhaps partly imagined.

The man reading the book in the deck chair seemed totally unaware of what was going on around him. He was in a world of his own. I gave life to this feeling by removing the other people from the image, saturating the area nearest to him and desaturating the background. The darkening and defocusing of the areas around him focuses attention on him and increases the sense of his isolation (see fig 51).

The punk in the portrait was standing with his friends enjoying the sun like everyone else, but his choice of personal grooming and style made him stand apart from the other beach-goers. In comparison, everything and everyone else looked a bit drab. To emphasize this, I desaturated and defocused the background. This draws the viewer's attention straight to him (see fig 52).

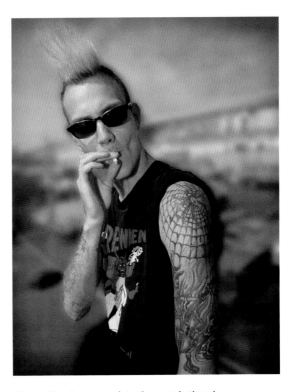

Fig 52 – The changes made to the portrait, though not objectively accurate, reflect the atmosphere of the individual at the time of shooting.

Fig 51 – The enhanced beach photograph is a lot more dramatic than it originally appeared.

TRICKS OF THE TRADE: MARTIN EVENING'S CROSS-PROCESSING EFFECTS (fig 53)

Difficulty level: 2
Programs: Photoshop

One of the most popular photographic techniques in the last few years has been the cross-processing of print and transparency films. There are two different ways of producing these distinctive images. You can process colour negative film in slide chemistry (E6) or colour slide film using the negative process (C41). Either way, you end up with images in which the basic details remain but the tones and colours are changed.

By some careful manipulation of the colours in the image, it is possible to reproduce the results of cross-processing digitally without having to shoot or develop your film any differently from normal. Martin Evening, the undisputed guru of Photoshop

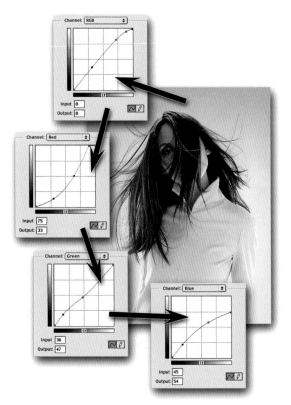

Fig 53 – The digital version of the cross-processing effect can be made from colour negatives that were processed as recommended, scanned and then manipulated using the curves function.

Produce yellow highlight tones (fig 54)

3. Create a curves adjustment layer and change to the blue channel.
4. Peg a mid-point on the curve.
5. Lower the white point on the curve to introduce a yellow cast into the image.

Add more warmth.

6. Change to the green channel.
7. Again, peg the mid-point and lower the highlight level – this time not to the degree of the change in the blue channel.

Make the shadows cyan.

8. Change to the red channel, peg highlight and shadow areas and then pull the midtone areas of the curve downwards to introduce a cyan cast.

Readjust the final contrast/brightness settings.

9. Return to the composite (RGB) channel and adjust the overall brightness and contrast so that it is lighter and the skin tones are more blown out.

for photographers, uses a digital technique which uses the Curves function to introduce casts and compression image tones. Define the characteristics you want.

To start the process it would be helpful to describe the characteristics of a typical image that has been shot on colour negative film and then processed as if it were a transparency. Immediately obvious is the yellowing of the light tones and the presence of a strong cyan cast in the shadow and midtone areas. Add to this compression, and consequential loss of detail in the highlight areas, and you are left with an image that contains some distinctive characteristics that we can replicate digitally.

To achieve Martin Evening's cross-processing effects, follow these steps:

Open a high key image.

1. Adjust for brightness and contrast.
2. Change to 16-bit mode.

Fig 54 – Martin Evening's technique for replicating the cross-processing effect uses the Curves function in Photoshop to both compress tones and adjust image colours.

THE ART OF

THE ART OF DIGITAL PRINTING

THE ART OF DIGITAL PRINTING

The new wave of inkjet printers that is hitting the market means it is cheaper than ever to produce photo-quality images direct from your home PC or Mac (see fig 1). Reading through the literature that accompanies these devices has you imagining richly coloured, sharp, high-quality images flowing from the machine at the click of one simple button. Unfortunately simple is not a word that most desktop photographers use a lot when it comes to printing.

Sure, there are those sweet occasions when everything seems to come together at once. The times when a great and memorable printed version of our digital masterpiece emerges, just as we had imagined, from the jaws of our whirring inkjet. But for most of us these occasions are the exception rather than the rule. The majority of new digital enthusiasts I talk to complain that their printed output does not match their expectations.

The following techniques are designed to help you prepare your images for printing and to push your desktop output device to the very edge of its capabilities.

PRINTERS – WHAT ARE MY CHOICES?

A few years ago there was only one printing option capable of producing photographic results – Dye Sublimation. This system was based on transferring dye from donor ribbons and fusing it to a special transfer paper. The results looked and felt like continuous tone photographic images. For a long time these printers held the high ground of digital printing. The downside to the image quality produced by these machines was the high cost of each print and the machine itself.

Today, thermal wax, solid inkjet and colour laser printers are all capable of reasonable results but in the last couple of years it is the inkjet printer that has taken the desktop digital market by storm. Led by the Epson company, manufacturers have continued to improve the quality of inkjet output to a point where now most moderate-to-high-priced printers are capable of producing photographic-quality images. Add to this the fact that the price per printed sheet and initial outlay for the machine is comparatively very low and you can see why so many photographers are now printing their own images.

The only drawback with inkjet technology is that the prints made with some machines, papers and ink sets have a shorter life compared to traditional photographic images. Thankfully this is a situation that is ever improving. Now all the big printer companies such as Epson, Canon, Hewlett Packard and Lexmark produce models and ink sets that outlast conventional colour prints (but only if they are used with

Fig 1 – The modern inkjet printer is capable of producing photographic-quality images right from your desktop.

specific archival papers). In addition, independent testing companies such as www.wilhelm-research. com regularly publish results from their accelerated archival tests of the output of a multitude of printers. It is good advice to review the results of these tests alongside the printer manufacturer's recommendations for ink and paper combinations when considering what printer to buy.

WHICH MODEL?

Image quality is everything when you are picking a printer. Sure, it makes sense to compare resolution, number of inks, and price of the printer and its consumables but the reason you are buying the machine is to make great images. Never make a purchase without seeing printed results. If possible, take your own file to the showroom and ask to have it output via several different machines. This way you will have a means of comparing exactly what each printer is capable of.

KNOW YOUR TOOLS

There is no doubt that modern-day inkjet printers are amazing pieces of machinery. The precision with which they can lay down minute coloured droplets in patterns that simulate a continuous tone photograph is nothing short of remarkable. This said, the average printer still has its limitations, or to be fair, its own imaging characteristics. The first part of the process of making great prints is getting to know these characteristics.

TESTING YOUR PRINTER

When I start using a new printer, specialist types of inks or a different printing paper, I carry out four simple tests to help me understand how the setup works.

Tonal Testing

First I look at how the printer handles difficult tonal areas. In particular, I find it very useful to be able to predict how a specific printing setup deals with delicate highlight and shadow details. I am talking about the region of an image that lies between 85 per cent grey and 100 per cent black, and 15 per cent grey and zero per cent bright white.

The performance of each printer, ink and paper combination can vary greatly in this area. By printing a test image made up of some carefully prepared grey and colour scales, I can examine how each combination works and compare the results from a variety of setups. In particular I look for the point in the highlight area where the last printed tone is no longer distinguishable from the white of the paper. In the shadows I locate the last step in the scale where dark grey becomes black (see fig 2).

These two points are the extent of my printer's tonal capabilities. Note down the exact percentages for later use. With these values known, I can adjust the spread of the tones in my images with the assurance that delicate highlight and shadow detail will not be lost or unprintable.

Fig 2 – Make a special greyscale image to test how your printer handles printing difficult areas like shadows and highlights. Use five per cent changes for each of the steps from zero to a hundred. Make two more scales with one per cent steps for highlights and shadows.

Colour Testing

To help with further evaluation, I also add a known image to the tonal scales. The one I use contains a mixture of skin colouring as well as a range of bright

Fig 3 – Add to your tonal scales a test colour image that contains a range of bright colours as well as some skin tones.

colours. Once printed, colour cast differences due to specific ink and paper combinations become more obvious. When trying to define the colour of your cast, look to the midtones of the image as your guide. Adjustments can then be made, either in the printer setup or via the image file itself, to account for the colour variations (see fig 3).

Testing sharpness

Often overlooked but definitively just as important for producing great prints is the amount of sharpness that is applied to the photo. Thankfully it is generally no longer necessary to remind photographers to sharpen before printing, but unfortunately most image makers apply a standard degree of sharpening to all their photos irrespective of the final printed size, subject matter and stock that they will be reproduced upon. And when it comes to sharpness one, size (setting) definitely does not fit all.

To find what works best for your setup, copy an indicative section of your image and duplicate it several times (at 100 per cent) in a new document. Now open up the Smart Sharpen filter (or the Unsharp Mask filter) selecting each duplicate in turn and filtering the picture part using successively more aggressive settings. Save off each of the sharpening settings in the Smart Sharpen dialog for use later. Now print the test file using the same setup that you use for making final prints.

Carefully examine the printed results using the same lighting conditions and viewing distance that will be used to display the print and select the best overall sharpness. This part of the process is pretty subjective but most viewers can pick over-and-under sharpened images when confronted with several versions of the same image sharpened to different degrees, making the task of selecting the best sharpness much easier.

Now to apply the sharpness to the original print photo. Rather than applying the filter directly to the document it is best to sharpen a copy of the document. To do this I usually select all of the document (Select·····≻Select All) and then copy the merged layers (Edit·····≻Copy Merged) before pasting (Edit·····≻Paste) the copy as a new layer at the top of the image stack. Next I select the copied layer, open the Smart Sharpen filter and apply the saved setting selected from the test print.

Print Quality Testing

The modern inkjet printer is capable of amazingly fine detail. The measure of this detail is usually expressed in dots per inch (dpi). A typical photographic-quality Epson printer is able to print at 2880dpi when set on its finest settings. Logic says that if I am to make the best-quality print from this machine then I will need to make sure that my image file matches this resolution. This may be logical but it is definitely not practical. A file designed to produce a 10 x 8 inch (254 x 203mm) print at 2880 dpi would be about 1.35 GB in size. Start playing with files this size and you will find that your machine will quickly have a coronary.

The answer is to balance your need for print quality with file sizes and image resolutions that are practical to work with. To this end, I tested my printer by outputting a variety of images with resolutions ranging from 100dpi through to 800 dpi, all made with the machine set on its best-quality setting (2880 dpi). The results showed that big changes in print quality were noticeable to the naked eye with resolutions up to about 300 dpi. Settings higher than this resulted in very little if any change in perceivable print quality. So, to get the best from my printer, I set its resolution to the finest it is possible to produce (2880 dpi) and make files that have an image resolution of between 200 and 300 dpi.

With the tests now completed we have a set of parameters that can be used to adjust the characteristics of our images prior to printing.

PREPARING FOR PRINTING – STEP BY STEP (fig 4)

I use the steps below regularly when preparing my images for print. By now I'm sure you wil be aware of, or use regularly, most of the techniques, but used together they will help push up the abilities of your printer and produce high-quality results regularly and consistently.

Fig 4 – Once you have finished testing your machine, it is time to implement your knowledge in a series of print preparation steps.

Step One: Adjust Contrast and Brightness

To spread the tones of your image using the results of your test information, peg your black and white points (see fig 5).

PhotoImpact

1. Select Photo····≥Highlight Midtone Shadow from the menu bar.
2. If the shadow areas of your test prints are clogged then move the shadow slider to the right. This lightens the dark tones.
3. Take note of the shadow value.
4. If the highlight areas of the test print are blown then move the highlight slider to the left. This darkens the light tones.
5. Take note of the highlight value.
6. Reprint your test image, checking the changes. If the results are not satisfactory make further adjustments and print again.
7. Continue this process until you can print all the tones in the test image.

Paint Shop Pro

1. Select Adjust····≥Brightness and Contrast····≥Highlight Midtone Shadow from the menu bar.
2. If the shadow areas of your test prints are clogged then move the shadow slider to the right. This lightens the dark tones.
3. Take note of the shadow value.
4. If the highlight areas of the test print are blown then move the highlight slider to the left. This darkens the light tones.

DOUBLE CLICK BLACK/WHITE EYEDROPPER

INPUT HIGHLIGHT OR SHADOW PERCENTAGES

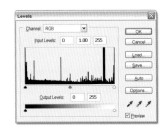

CLICK AUTO BUTTON TO APPLY NEW SETTINGS

Fig 5 – Use the information about how your machine prints shadow and highlight areas to peg your black and white points in the Levels dialog. Applying the auto function will now spread, or constrain, your image tones to the range that your printer can output.

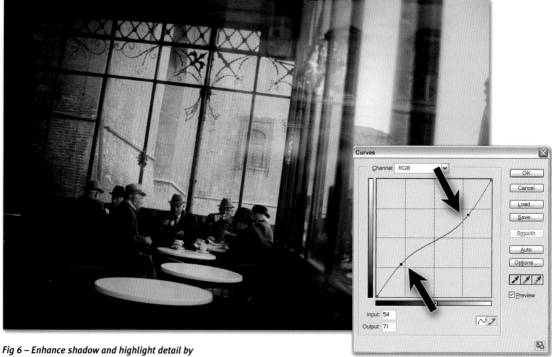

Fig 6 – Enhance shadow and highlight detail by carefully manipulating the Curves function in Photoshop.

5. Take note of the highlight value.
6. Reprint your test image, checking the changes. If the results are not satisfactory make further adjustments and print again.
7. Continue this process until you can print all the tones in the test image.

Photoshop

1. Select Image····⟩Adjustment····⟩Levels from the menu bar in Photoshop.
2. Double click the black eye dropper in the dialogue.
3. Input the percentage of the black point from your test in the "K" section of the CMYK values.
4. Click OK to set the value.
5. Repeat the procedure inputting the white point.
6. Click the Auto button in the Levels box.

Notice that the histogram of your image has changed. The shadow and highlight information has moved towards the centre, catering for the characteristics of your printing setup.

Step Two: Enhance Shadow Detail

Even with the changes made above, a lot of images need particular help in the shadow and highlight area. Enhancing the detail here can be achieved easily by some subtle manipulation (see fig 6).

PhotoImpact

1. Select Photo····⟩Tone Map from the menu bar.
2. Click the Use Control Points box.
3. Click and drag the shadow part of the line (bottom left) upwards and the highlight section (top right) downwards.
4. Click OK to finish.

Paint Shop Pro

1. Select Adjust····⟩Brightness and Contrast····⟩ Gamma Correction from the menu bar.
2. Make sure that the Link box is checked.
3. Move any of the sliders to the right.
4. Click OK to finish.

Photoshop

1. Select Image····⟩Adjustment····⟩Curves from the menu bar in Photoshop.
2. Carefully push the curve slightly upwards in the shadow area and slightly downwards in the highlight region.
3. Click OK to finish.

These actions will increase the contrast of the shadow detail and reduce the contrast of the highlight area. When printing, both these steps will help produce images that display more detail in these difficult areas.

Step Three: Reduce Colour Casts

Photoshop has a range of techniques that you can use to reduce colour casts. Probably the simplest is the Variations control in Photoshop. Here the user can select from a variety of small thumbnails each displaying slight changes in colour (see fig 7).

PhotoImpact

1. Select Photo····⟩Colour Balance from the menu bar.
2. Select the Preset tab from the top of the dialogue.
3. Select the thumbnail that looks the most neutral. If a cast still exists, continue to select more neutral

thumbnails until you are happy with the results.
4. Click OK to finish.

Paint Shop Pro

1. Select Adjust····⟩Colour Balance····⟩Red Green Blue from the menu bar.
2. Move adjustment sliders until the image looks neutral.
3. Click OK to finish.

Photoshop

1. Select Image····⟩Adjustment····⟩Variations from the menu bar.
2. Click on the thumbnail with the least colour cast.
3. Continue this process until the image is colour neutral.
4. Click OK to finish.

Casts that are the result of a particular paper and ink combination should be reduced by changes to the colour setup in the printer's software (see step 6).

Step Four: Sharpen the Image

Digital files captured by scanning print or film originals

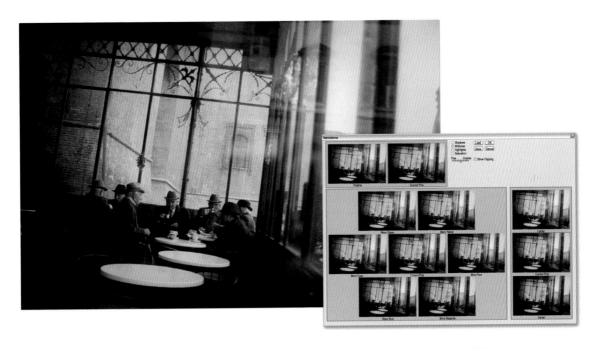

Fig 7 – To reduce a prominent colour cast, select the most neutral image from the thumbnails in the Variations dialogue.

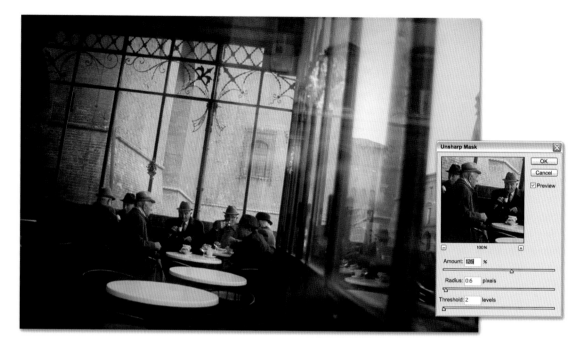

Fig 8 – Digitally generated images can often be improved by the application of a little sharpening. In this example, the Unsharp Mask filter was used as it provides the most options for the user to control the sharpening effect.

can usually benefit from a little sharpening before printing. As with most digital controls, it is important to use any sharpening filter carefully as over-application will cause a deterioration in the appearance of your image. My own preference is to use the Unsharp Mask sharpening tool as it offers the user the most control over the effects of the filter (see fig 8).

PhotoImpact

1. Select Photo⋯⟩Sharpen⋯⟩Unsharp Mask from the menu bar.
2. In thumbnail view it is a simple matter of selecting the preview with the sharpness that suits your needs. Users who want a little more control can click the Options button and adjust the Sharpen Factor and Aperture Radius sliders.
3. Click OK to finish.

Paint Shop Pro

1. Select Adjust⋯⟩Sharpness⋯⟩Unsharp Mask from the menu bar.
2. Adjust Radius, Strength and Clipping controls until the preview is acceptable.
3. Click OK to finish.

Photoshop

1. Select Filter⋯⟩Sharpen⋯⟩Unsharp Mask from the menu bar in Photoshop.
2. Adjust Radius, Amount and Levels sliders to achieve the desired effect.
3. Click OK to finish.

Step Five: Check Print Size/Paper Orientation (fig 9)

Sometimes the scanning or camera software will save your file with image settings that are not suitable for the size of paper you are using. In these cases, you will need to change the size of your output. Photoshop has a couple of aids to help with checking that the size of your image suits that of the paper.

PhotoImpact

1. Select File⋯⟩Print Preview from the menu bar.
2. Using the preview screen change the position and size of your image.
3. A title may also be added here.

Paint Shop Pro

1. Select File⋯⟩Print from the menu bar.
2 The basic layout of image and page can be

checked with this dialog.

3. If further changes are needed, select File····⫶Print Layout from the menu bar.

4. Drag the picture thumbnail from the left of the screen onto the paper background where you can resize (using the handles) or reposition the photo.

5. Select File····⫶Print from inside the Print Layout dialog to finish.

Photoshop

1. Select File····⫶Print with Preview from the menu bar.

2. Unlike earlier versions of the program this will provide a preview of your photo on the paper currently set for the printer.

3. To automatically scale your photo to fit the paper and place it in the centre of the page place a tick in the Scale to Fit Media and Centre Image checkboxes.

4. To manually adjust the position and size of your printed photo make sure that neither the Centre Image nor the Scale to Fit options are selected and then click on the Show Bounding Box option.

5. Now click and drag the corner handles of the picture to resize and click-drag the whole image to

reposition the photo on the page. If the handles are not visible because the picture is too big then type a smaller percentage (like 50 per cent) into the Scale box.

6. Click Print to continue. In the Print dialog that displays next double check that the correct printer is listed and that the properties of the printer are suitable for the paper that you are using as well as the level of quality that you are aiming for.

Step Six: Adjust the Printer Settings

The printer's dialog box contains an array of settings and controls that act as the last fine-tuning step in outputting your digital masterpiece. Most new users follow the automatic everything approach to help limit the chances of things going wrong. For most scenarios this type of approach will produce good-quality results, but those of you who want a little more control will have to abandon the auto route.

There are several adjustments that can be made via the printer control (see fig 11):

- Paper size, orientation and surface type,
- Dots per inch that the printer will shoot onto the page (printer resolution), and
- Colour and tone control.

PRINT PREVIEW

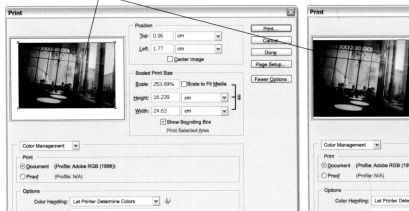
IMAGE BIGGER THAN PAPER

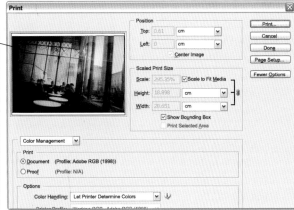
IMAGE SMALLER THAN PAPER

Fig 9 – In the Print with Preview dialog you can change the position and size of the printed photo manually by click-dragging the corner handles of the photo or automatically by selecting the Center Image and Scale to Fit Media options.

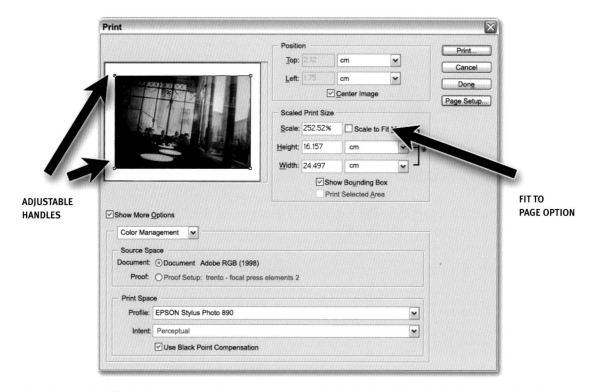

Fig 10 – You can check the size that your image will print on the paper by selecting the File⋯⫶Print with Preview option in Photoshop.

The surface of the paper is critical to how much of the detail produced by your printer and your image preparations ends up in the final print. Paper manufacturers have spent the last few years perfecting coatings that maintain the integrity of the inkjet dots whilst producing images that simulate a traditional photograph.

Choosing a paper type in your printer settings changes the dots per inch that the inkjet head will place on the paper. Papers with finer surfaces, or better coatings, can accept finer dot quality, or higher dpi settings.

You should always check the dpi after choosing a paper type as sometimes the selection that the program determines might not suit your needs. Some Lyson papers, for instance, have a rough-textured surface that would lead you to pick a Photo Paper setting from the dialogue. This, however, would result in the print head being set at 720 dpi, much lower than this type of paper can handle. To get the most from both the printer and paper, you would need to change manually, or customize, the dpi to the highest quality possible.

It is also at this stage that any colour change, or cast, that results from paper and ink combination, rather than from shooting conditions, is corrected. If, after your tests, you find that your prints all exhibit a shift of hue that is not present in the screen original, then changes can be made to the colour balance within the print dialog box.

As an example, I have found that some non-branded papers have a distinct magenta cast that is consistent throughout all prints. To correct this I add more green in the printer's dialog box until the resultant print is neutral. I then save this setting for use with that combination of ink, paper and printer in the future. Using the printer's dialog box to make paper- and ink-based adjustments means that I can always be assured that an image that appears neutral on screen will print that way.

SUMMING UP

Make sure that all the hard work you put into taking great pictures is reflected in their printing. Take the time to get to know your printer, paper and inks and the reward will be high-quality prints that exhibit all the care and skill used in their taking.

INKJET PAPER CHARACTERISTICS

Weight: Paper weight is measured in grams per square metre. This factor, more than any other, affects the feel of the printed image. To give you a sense of different paper weights, photocopy paper is usually 80gsm, drawing cartridge 135gsm and standard double-weight photographic paper 200gsm. If your aim is to produce images that look and feel like the photographic real thing, don't underestimate the effect of paper weight. For the best effect, try to match the weight of your inkjet paper with its photographic equivalent. Weight can also be a factor in how much the paper ripples after it is printed. Heavy paper is more resistant to this effect.

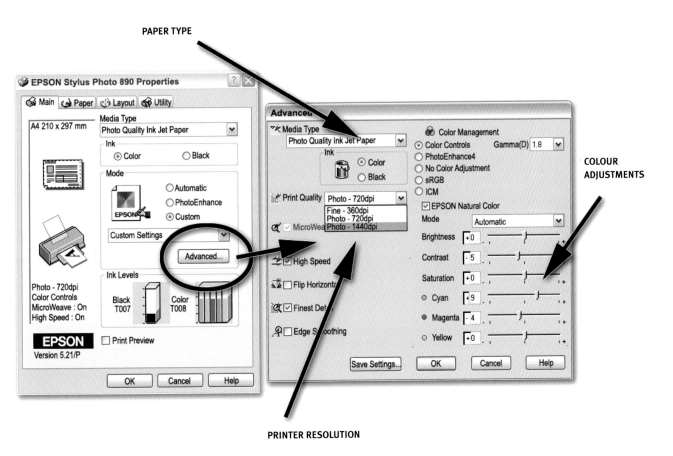

Fig 11 – Make the final changes to how the image will print using the printer's own dialog box. Colour casts due to specific ink and paper combinations can be illuminated here and the settings saved for later use.

Surface: Most photographers I know are particular about the surface of the photographic printing paper they use. One friend likes the surface of a specific paper so much that he imports it from the States because he says that his images just don't look the same on anything else. I'm sure that certain inkjet paper surfaces produce no less loyalty among the ranks of image-makers. In an attempt to woo punters, some manufacturers have even reproduced their photographic paper surfaces in their inkjet range. Kentmere is a good example. K. Tapestry and K. Classic both have their textured photographic counterparts. Using these papers, it is possible to produce a mixed series of pictures containing both digital and traditional photographic images on similar paper bases – all the images will have the same look and feel despite their different origins.

Base colour: Inkjet papers come in a variety of colours which can range from subtle neutral tones to bright and vibrant hues. The base is coloured either by adding pigment during the paper-making process, in which case the colour is present right through the paper, or when the surface of the paper is treated to receive inks in which case the colour is only on the printable side of the paper. Care should be taken when using papers with a base colour as they will cause a colour shift in the printed image. The clever printer can make allowances for the shift by adjusting the digital file to account for the paper colour prior to printing.

Paper Sizes: A3, A4, A5 and A6 as well as the traditional photographic sizes of 6 x 4 and 10 x 8 inches (152 x 102mm and 254 x 203mm) are all commonplace in the more popular paper types and surfaces. Panoramic sizes and rolls of paper are also available for the image-maker who prefers a wider format.

Price: Buying larger quantities than the normal pack of 10 to 25 sheets will almost always get you a better price, and remember to shop around – there will always be someone who wants your custom a little more than the next guy.

PAPER TYPES (fig 12)

Glossy Photographic: Designed for the production of the best photographic-quality images. These papers are usually printed at the highest resolution that your printer is capable of and can produce either photo-realistic or highly saturated colours.

Matt/Satin Photographic: Designed for photographic images but with surfaces other than gloss. The surfaces are specially treated so that, like the gloss papers, they can retain the finest details and the best colour rendition.

Art Papers: Generally thicker papers with a heavy tooth or texture. Some in this grouping are capable of producing photographic-quality images, but all have a distinct look and feel that can add subtle interest to images with a subject matter that is conducive. Unlike other groups, this range of papers also has examples that contain coloured bases or tinted surfaces.

General Purpose: Papers that combine economy and good print quality and are designed for general use. They are different to standard office or copy papers as they have a specially treated surface designed for inkjet inks. Not recommended for final prints but useful for proofing.

Specialty Papers: Either special in surface or function. This group contains papers that you might not use often, but it's good to know that they are available when you need them. The range is growing all the time and now includes such diverse products as magnetic paper, back light films (plastic based translucent media which are viewed with a light from behind) and a selection of

Professional 285
(Lyson Fotonic)

Instant Dry P
(Paper Selec

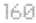

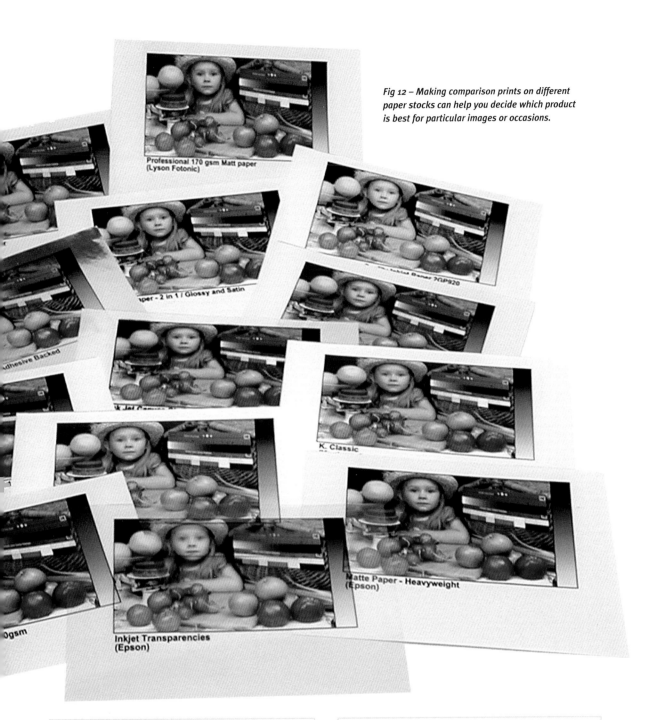

Fig 12 – Making comparison prints on different paper stocks can help you decide which product is best for particular images or occasions.

metallic sheets.

When trying to choose what stock is best for your purposes, compare on the basis of weight, surface, colour, sizes available, number of sheets in a standard pack, price per sheet and special features. When you have narrowed the field down, it is worth testing each with a print made using the same print settings, inks, digital file and printer. This will give you a visual comparison that will help you make the final decision.

STORAGE

STORAGE – THE DIGITAL STORY

The good news about modern digital photography is the high quality of the files produced by digital cameras and scanners. The bad news is that this quality is directly linked with file size. Photographic quality means big files. Digital images are notorious for the amount of space they consume. A typical file that will print a photographic-quality picture 5 x 7 inches in size can take up as much as 9 MB. A 10 x 8 inch version can take up to 20.6 MB.

The storage of images this size on a hard drive is no real problem, but if you want to move them from one machine to another then you will face some difficulties. Very quickly manufacturers became aware of a need for a big capacity portable storage solution for digital photographers and other graphics professionals. A few systems have come and gone but the range of devices that we now have are bigger, faster and cheaper than ever before.

CD-ROM

The CD is a stable and familiar format that is used universally for storing large amounts of data cheaply. As recently as 10 years ago CD readers were an expensive add-on to your computer system. Now writers, and sometimes even rewriters, are thrown in as part of system package deals. The CD has become the floppy of the new millennium.

Drives and media are available in two formats. "Write once, read many" or Worm drives (CD-R) are the cheapest option and allow the user to write data to a disk which can then be read as often as required. Once a portion of the disk is used it cannot be overwritten.

The advanced version of this system (CD-RW) allows the disk to be rewritten many times. In this way it is similar to a hard drive, however the writing times are much longer. Rewriters and the disks they use are more expensive than the standard CD writer. The more recent drives can read, write and rewrite all in one unit.

DVD

DVD is fast becoming the storage medium of choice for the professional image-maker. Holding as much as 8 CDs worth of data or pictures on a single disc, DVD technology comes in three distinct formats: DVD-R (write once), DVD-RW (re-recordable), and DVD-RAM (rewritable). These three formats each have unique applications:

- DVD-R: write-once archiving for video and data that you do not want to lose or accidentally erase
- DVD-RW: re-recordable DVD for video and data material that can be erased and reused again and again
- DVD-RAM: rewritable DVD for mission critical data needing as many as 100,000 rewrite cycles

Fig 1 – Small portable hard drives that are powered by battery or USB cable provide extra storage space or a place to back-up important pictures. Some devices such as Apple's iPod or iPhone can be used as an external storage device as well as a music player or phone.

The DVD-R format is the most compatible with DVD players and should be used wherever possible.

As drive and disk prices continue to fall this technology is set to replace the CD as the digital photographer's main storage medium.

Portable Hard Drive (fig 1)

A new category in portable storage is the range of portable digital hard drives available for photographers. These devices operate with mains or battery power and usually contain a media slot that accepts one or more of the memory cards used in digital cameras or a cable connection for downloading files from the computer. The most well known of these devices are the MindStor (previously called the Digital Wallet) and Apple's iPod or iPhone.

Designed to be used on the road, pictures are transferred from your camera's memory card to the device, freeing up space and allowing you to continue shooting. Back at the desktop the images are downloaded to your computer via a fast cable set up such as Firewire or USB 2.0.

External Hard Drive

With the ever-increasing need for storage and the desire of many users to be able to move their image archives from one machine to another, companies like Maxtor are developing more and more sophisticated external hard drive options. Their latest offerings include capacities from 40 to 300 GB and the choice of USB, USB2 Firewire or even Firewire800 connections.

When connected these devices act like another drive in your machine.

USB Flash Drive

As memory prices continue to fall and storage capacities rise the USB Flash Drive has become a handy tool for all photographers. These devices plug directly into the USB port on your computer and provide a fast and convenient way to move images and data from one machine to another. Once connected the flash drive functions like any other drive on your system allowing you to save and resave your work many times over. Current models range from a humble 128 MB right up to a massive 2 GB (2000 MB) and that's all in a device that you can carry in your pocket and is no bigger than your finger.

Fig 2 – Great for backing up important photos as well as storing files that you may want to access while travelling, online web storage spaces such as those provided by Iomega (iStorage) are managed by a simple web interface.

Web Storage (fig 2)

It's not a totally new idea to store data on the web, but it is only in recent years that products like Iomega's iStorage have been making the whole notion a lot more viable. With the number of machines now connected to the net and the speed of broadband connection it is not unrealistic to use such a service as a virtual extension of your hard drive. Travellers especially will find this storage option a godsend as it reduces the number of discs or CDs that you need to carry, but be warned – access times are not great and are certainly not as fast as having an external drive sitting next to your computer.

HOW TO CHOOSE

With this amount of choice it is sometimes difficult to decide which product will best suit your needs. The best advice I can give is to think carefully about
- how many images you are going to be working with,
- how large those images will be,
- what access time you will consider adequate,
- whether you want to share them with others and, most importantly,
- how much money you have to spend.

The answers to these questions will help you narrow down the solutions to your storage needs.

WHEN A BIG HARD DRIVE IS JUST NOT BIG ENOUGH

(fig 3)

It is the very nature of the digital-imaging beast that as quality increases so does the space needed to store it. I am still amazed by the pace at which manufacturers produce ever bigger hard drives to fill our storage appetite.

Even more fascinating, or perhaps frustrating, is the way in which a drive I bought six months ago, and swore I could never fill, manages to run out of usable space. It seems that my hard drive storage is a bit like my income – the more I have, the more I use.

If you are like me, then here are a few tips to help conserve your drive space (and in turn, your hard-earned income):

1. Use a file format that has compression built-in. Save your files using the TIFF format with compression turned on. This format does not use a compression technique that will degrade the quality of your images and it will save you space.

2. Be disciplined about how and where you store your images. By storing your images in an organized way you will quickly see and remove any duplicate and temporary files from your drive.

3. Make images that are the size that you need. Make decisions at the time that you are creating a digital file about what size you need that file to be. If you are only going to want to print a postage stamp-size version then there is no need to have a 20 MB file.

4. Be careful about using different colour modes. A RGB colour file is 25 per cent smaller than its CMYK equivalent. Only use the CMYK mode if you have a definite reason for doing so.

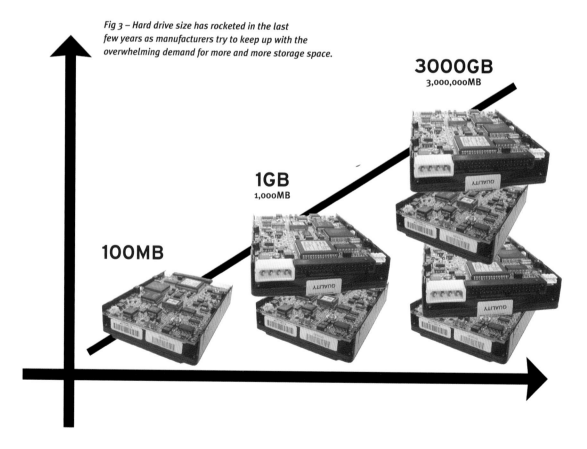

Fig 3 – Hard drive size has rocketed in the last few years as manufacturers try to keep up with the overwhelming demand for more and more storage space.

3000GB
3,000,000MB

1GB
1,000MB

100MB

WHERE DOES MY IMAGE FILE GO WHEN I SAVE IT? (fig 4)

One of the most difficult concepts for new computer users is the fact that so much of the process seems to happen inside an obscure little box. Unlike traditional photography, where you can handle the product at every stage – film, negative and print – the digital production cycle can seem a little unreal. Where your image actually goes when you store it is one of its mysteries.

PC

The devices that are used to store digital information are usually called drives. In PC terms they are labelled with letters – "A" drive is for your floppy disk drive and "C" drive your hard disk. It is possible to have a different drive for every letter of the alphabet but in reality you will generally only have a few options on your machine. If, for instance, you have a zip and a CD drive then these might be called "D" and "E" drives.

Mac

If your platform of choice is the Macintosh system then you need not concern yourself about the letter names above. Each drive area is still labelled but a strict code is not used.

Within each drive space you can have directories (PC) or folders (Mac). These act as an extra way to organize your files. To help you understand, think of the drives as drawers within a filing cabinet and the directories as folders within the drawers. Your digital files go into these folders.

Fig 4 – How you organize your images on your drives will affect how efficiently you will use the space that is available to you.

DRIVES

FOLDERS
(DIRECTORIES)

FILES

FILE FORMATS – THE STORAGE STORY CONTINUES

The storage of your digital masterpieces is really a two-step exercise. Firstly you need to decide where the image should be saved. Secondly you have to select the file format which will be used to save the image. Having now discussed the "where" of the process, we shall dedicate some time to looking at "how" our images can be stored.

Digital imaging files can be complex things. In their simplest form they are a description of each picture element, its colour and

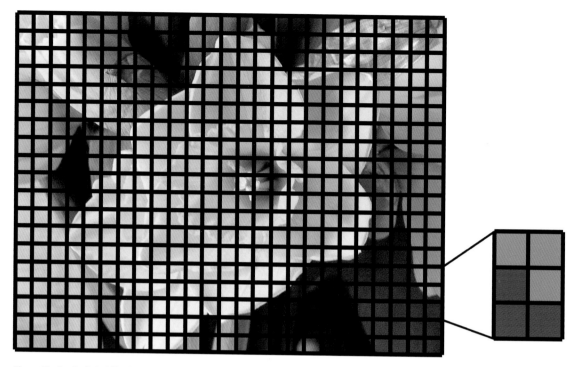

Fig 5 – The basic digital file defines the colour, brightness and position of each pixel that makes up the image.

brightness and its physical whereabouts within the image (see fig 5). With the increased sophistication of image-editing programs and our demand for complex graphics has come a range of purpose-built file formats that encompass a host of "value added" features that are beyond this basic file.

Layers vs Flat Files

The original image-editing programs performed all their manipulations on the basic file. At the time this didn't seen too much of a problem as we were just happy (and amazed) that we could actually change sections of an image digitally. But as designers and photographers increased their understanding of the new medium they also increased the complexity of the manipulations they wished to perform.

Working with a flat file became more and more restricting. Eventually the software developers incorporated the way that graphic designers had been working for years into image-editing programs. They took the idea that if you separate parts of an image onto transparent layers then you can manipulate each part without affecting the rest of the image. If

the image is then viewed from the front, all the layers appear merged and the picture looks flat – just as if it were a basic file (see fig 6).

As the image files of the time were all flat, the software developers also developed formats that would allow the storage of the separate layers. With the integrity of each layer intact it was then possible to return to work on a specific element of an image at a later date.

The Photoshop file format, or PSD, is an example of a format that will save editable layers separately. Each layer can be manipulated individually. Groups of layers can be linked and moved or merged to form a new single layer with all the elements of the group. Text layers remain editable even when saved and in the latest version of the software, special effects, such as drop shadows, can be applied to each layer automatically (see fig 7).

This extra flexibility does come at a cost. Layered files are bigger than their flat equivalents. With the size of modern hard drives this is not really something to be worried about. A second consideration is that formats like PSD are proprietary, that is they only work

with the programs that they originated from. This only becomes a problem if you want to share files with another piece of software and maintain the layers. No common layer formats have emerged yet, each software manufacturer preferring to stick with their own file types.

Compression

Imaging files are huge. This is especially noticeable when you compare them with other digital files such as word processing files. A document that may be a hundred pages long could easily be less than one per cent of the size of a single 10 x 8 inch (255 x 213mm) digital photograph. With files this large it soon became

obvious to the industry that some form of compression was needed to help alleviate the need for us photographers to be continually buying bigger and bigger hard drives.

A couple of different ways to compress your images have emerged over the last few years. Each enables you to squeeze large image files into smaller spaces but one system does this with no loss of picture quality – lossless compression – whereas the other enables greater space saving at the price of losing some of your image's detail – lossy compression.

Initially you might think that any system that degrades your image is not worth using and, in most circumstances, I would have to agree with you. But

LAYER 1 LAYER 2 LAYER 3

Fig 6 – A layered file appears to be similar to a flat file except that parts of the image are separated on individual layers. Each layer can be edited and changed separately from the other parts of the image.

Fig 7 – Photoshop uses a Layers dialog box to control the positioning and features of each layer in the image.

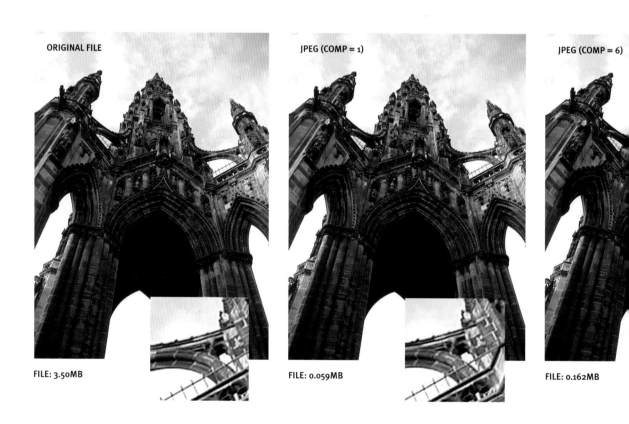

ORIGINAL FILE

JPEG (COMP = 1)

JPEG (COMP = 6)

FILE: 3.50MB

FILE: 0.059MB

FILE: 0.162MB

sometimes the image quality and the file size have to be balanced. In the case of images on the web they need to be incredibly small so that they can be transmitted quickly over slow telephone lines. Here some loss in quality is preferable to images that take four or five minutes to appear on the page. This said, I always store images in a lossless format on my own computer and only use a lossy format when it is absolutely crucial to do so.

The main compression formats that are used the world over are JPEG (Joint Photographic Experts Group) and TIFF (Tagged Image File Format) (see fig 8). JPEG uses a lossy algorithm to attain high compression ratios. By using a sliding scale from one to twelve you can control the amount of compression used to save your image. The more compression you use the more noticeable the effects (artefacts) of the process will be (see fig 9). TIFF on the other hand uses a totally different system, which results in no loss of image quality after compression.

For these reasons TIFF is a format used for archiving or sharing of work of the highest quality. Most press houses use TIFF as their preferred format. JPEG is used almost exclusively in the world of image transmission and the web. In this realm file size is critical and the loss of quality is more acceptable. This is especially true if the image is to be viewed on screen where some artefacts are less noticeable than when printed.

Web Features
The Internet in its original form was text based. Now the web is very definitely a visual, some might say a multimedia, medium. When you view a web page for the first time all the information on that page has to be transported from the computer where it is stored down the phone line to your machine. The pictures, animations and text that make up the page might be coming from almost anywhere in the world. It's a simple fact that the larger the file sizes of these components, the

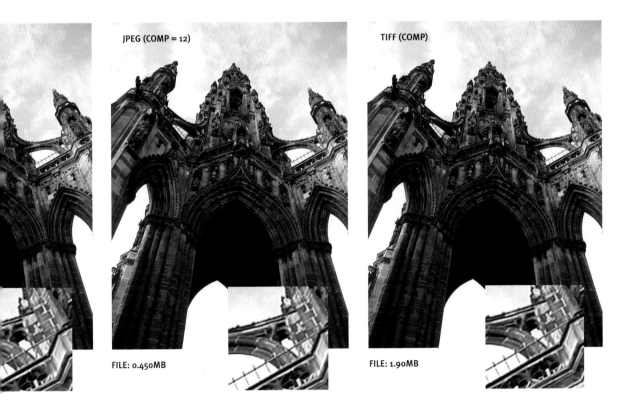

JPEG (COMP = 12)

TIFF (COMP)

FILE: 0.450MB

FILE: 1.90MB

Fig 8 – TIFF and JPEG both have inbuilt compression schemes for reducing the space taken up by your images when saved to disk.

FUZZINESS

BLOCKS
OF COLOUR

GENERAL
BLUR

EDGE
HALOS

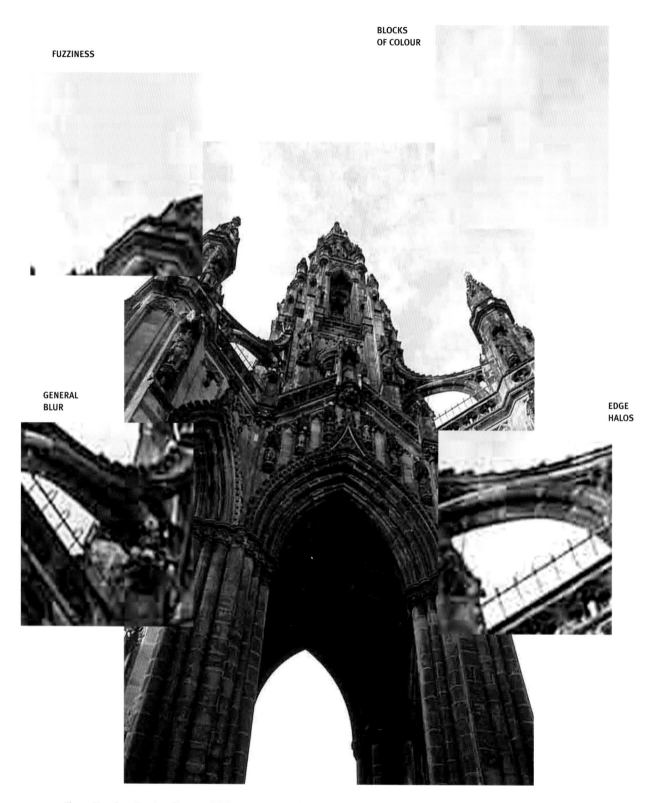

Fig 9 – To reduce the size of images, JPEG uses a compression system that loses detail from your image. High levels of this type of compression will cause your image to degrade and display a variety of artefacts.

longer it will take to download and display the page on your machine.

For this reason there are several file formats of choice for web work. Each (see page 176) is suited to specific types of image files. There is no one format that can be used for all the visual parts of your pages.

JPEG is best used for continuous tone photographs. GIF is designed for images with a limited number of flat colours and works best with logos and animated banner ads. PNG is a fairly new file format which has a wider colour range than GIF and better handling of transparency as well. This is a great format for users of IE (Internet Explorer) Version 4 browsers or higher.

SVG and JPEG 2000 are two relatively new formats that offer improvements over the web formats previously used. SVG is a vector-based system that provides not only smaller file sizes but also sharp images at any screen size. JPEG 2000 is a complete tune-up for the twenty-first century of the old compression system. It features user-controlled flexibility, less apparent artefacts and better compression to boot.

Customizing images for the web is so important these days that all the major image editing packages have sophisticated functions or wizards that will help you squeeze your images down to size without losing too much quality (see "Save for Web Option in Photoshop" page 177).

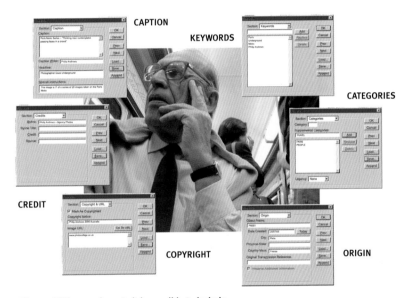

Fig 10 – With some formats it is possible to include some text along with the image data in one file.

Cross-platform concerns

The two major computer systems used by photographers the world over are the Macintosh and the IBM clone. Each system has its advantages and drawbacks and I'm not prepared to debate those here and now. I use both on a regular basis and there is no gain in trying to promote one over the other.

What is important to understand, though, is the basic fact that not all the people you will want to share images with will be using the same hardware as you. If you know this to be the case then you must

select a file format that can be used by both systems equally. I stick to TIFF, JPEG and PSD, as these formats are usable on both platforms (see "Top Tips for Cross-platform Saving" page 177).

Annotations

Some file types allow the user to attach text information to the main image file. This feature allows press agencies and picture libraries the chance to store captions, bylines, dates and background information all in the one format. This extra information is hidden from view when you first open the file in an image-editing program, but can usually be read and edited via an information window somewhere in the program.

Photoshop gives such access through highlighting the File----›File Info selection. Here you can view and edit entries for captions, keywords, categories, credits and origins. Some third-party image browsers can also search the captions and keyword entries. These categories are part of an information standard developed by the Newspaper Association of America (NAA) and the International Press Telecommunications Council (IPTC) to identify transmitted text and images. File information can be added in the following formats: PSD, TIFF, JPEG, EPS and PDF (see fig 10).

"BUT WHAT FORMAT SHOULD I USE?"

It's great to have such a choice of image file formats but the big question is what format you should use. There is no simple answer to this. The best way to decide is to be clear about what you intend to use the image for. Knowing the "end use" will help determine what file format is best for your purposes (see fig 11).

At scanning or image-capture stage I tend to favour keeping my files in a TIFF format. This way I don't have to be concerned about loss of image quality but I still get the advantage of good compression and I can use the files on both Mac and IBM platforms.

When manipulating or adjusting images I always use the PSD or Photoshop format, as this allows me the most flexibility. I can use, and maintain, a load of different layers which can be edited and saved separately. Even when I share my work, I regularly supply the original PSD file so that last-minute editing or fine-tuning can continue right up to going to press. If, on the other hand, I don't want my work to be easily edited, I supply the final image in an IBM TIFF format with all the layers flattened.

If the final image is to be used for the web, I save it as a GIF, PNG or JPEG file, depending on the number of colours in the original and whether any parts of the image contain transparency. There is no firm rule here. Size is what is important so I will try each format and see which provides the best mix of image quality and small file.

Fig 12 – Raster and Vector files are completely different ways of describing a digital image. All photographic images are stored in Raster or Bitmapped format.

VECTOR VS RASTER (fig 12)

The digital graphics world uses two main ways to describe images – one is Raster or Bitmapped and the other is Vector.

Raster images are made up of a grid system that breaks the image down into tiny parts or picture elements (pixels). At each point on the grid, the position, colour and brightness of each pixel is recorded. All digital photographs are stored in this format. Programs like Photoshop and Paint Shop Pro work exclusively with this type of image.

File Type	Compression	Layers	Metadata	Uses
Photoshop (.psd)	✗	✔	✔	Desktop publishing, internet, publishing, photography
GIF (.gif)	✔	✗	✗	Internet
JPEG (.jpg)	✔	✗	✔	Desktop publishing, internet, publishing, photography
TIFF (.tif)	✔	✔	✔	Desktop publishing, internet, publishing, photography
PNG (.png)	✔	✗	✗	Internet
Digital Negative (.dng)	✔	✗	✔	Archival storage of Raw files
Acrobat (.pdf)	✔	✔	✔	Desktop publishing, internet, publishing, photography
Raw (various)	✗	✗	✔	Primary camera capture format
Photoshop Large Document (.psb)	✗	✔	✔	Photoshop format for files larger than 2GB in size
High Dynamic Range (.psb; .psd; .hdr; .tif)	✗	✗	✔	A file type that can contain up to 32bits/channel of tone and colourdata

Fig 11 – Different file formats are suitable for different applications and have a variety of inbuilt features.

Vector images are very different. They work by mathematically describing the shape of flatly coloured objects within a space. Logos, sophisticated text manipulations and CAD drawings are all examples of vector graphics. Programs like Illustrator, Corel Draw and Freehand create images that are stored as vector graphics.

THE MAJOR RASTER FORMATS

JPEG – Joint Photographic Experts Group (fig 13)

This format provides the most dramatic compression option for photographic images. A 20 MB digital file which is quite capable of producing a 10 x 8 inch (225 x 213mm) high-quality print can be compressed as a JPEG file so that it will fit onto a standard floppy

Fig 13 – The JPEG dialog box in Photoshop allows the user to choose the level of compression that the image will be saved with.

disk. To achieve this the format uses a lossy compression system, which means that some of the image information is lost during the compression process.

The amount of compression is governed by a slider control in the dialog box. The lower the number, the smaller the file and the higher the compression and more of the image will be lost in the process.

You can also choose to save the image as a standard baseline or progressive image. This selection determines how the image will be drawn to screen when it is requested as part of a web page. The baseline image will draw one pixel line at a time, from top to bottom. The progressive image will show a fuzzy image to start with and then progressively sharpen this image as more information about the image comes down the line.

This is a great format to use when space is at a premium or when you need very small file sizes.

TIFF – Tagged Image File Format (fig 14)

This is one of the most common and useful file fomats. Images in this format can be saved uncompressed or using a compression algorithm called LZW, which is lossless. In other words, the image that you "put into" the compression process is the same as the one you "get out". There is no degradation of quality.

When you save you can choose to include a preview thumbnail of the image, turn compression on and off and select which platform you are working with. Most agencies and bureaus accept this format but nearly all stipulate that you supply work in an uncompressed state. Opening a compressed image takes a lot longer than opening one that is saved without compression.

Use this format when you want to maintain the highest possible quality.

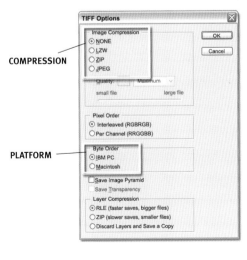

Fig 14 – The TIFF dialog box in Photoshop gives the user the choice of which platform to save for and whether compression is used.

GIF – Graphics Interchange Format

This format is used for logos and images with a small number of colours and is very popular with web professionals. It is capable of storing up to 256 colours, animation and areas of transparency. It is not generally used for photographic images.

PNG – Portable Network Graphics

A comparatively new web graphics format that has a lot of great features that will see it used more and more on websites the world over. Like TIFF and GIF the format uses a lossless compression algorithm that ensures what you put in is what you get out. It also supports partial transparency (unlike GIF's transparency off/on system) and colour depths up to 64bit. Add to this the built-in colour and gamma correction features and you start to see why this format will be used more often.

The only drawback is that it only works with IE browsers that are Version 4 or newer. As time goes by this will become less and less of a problem and you should see PNG emerge as a major file format.

PSD – Photoshop's native format

This file type is capable of supporting layers, editable text and millions of colours. You should choose this format for all manipulation of your photographic images. The format contains no compression features but should still be used to archive complex images with multiple layers and sophisticated selections or paths. The extra space needed for storage is compensated for by the ease of future editing tasks.

EPS – Encapsulate PostScript

Originally designed for complex desktop publishing work, EPS is still the format of choice for page layout professionals. It is not generally used for storing photographic images but is worth knowing about.

THE FUTURE IS HERE

As our imaging needs increase, so too does the format technology used to store our pictures. In the last few years two new formats have been developed, both particularly suited for web production. By the time you read this, you will be seeing, and hopefully using, commercial versions of software that use these formats.

ORIGINAL

STANDARD JPG 40:1

JPG2000 100:1

JPG2000 40:1

Fig 15 – JPEG2000 is a new improved version of the JPEG compression system. It is capable of much higher compression ratios and more user control.

JPEG2000 (fig 15)

The original JPEG format is over a decade old now and, despite its continued popularity, it is beginning to show its age. So a group of dedicated imaging professionals (the Digital Imaging Group – DIG) developed a new version of the format. Dubbed JPEG2000, it provides 20 per cent better compression, less image degradation than JPEG, full colour management profile support and the ability to save the file with no compression at all.

JPEG2000 is well placed to support the ever-increasing demand for transmittable high-quality images and for this reason it may well become the new default standard for web and press work.

COMPRESSION SETTINGS

Fig 16 – The "Save for Web" dialog in Photoshop allows users to compare settings and file types quickly and easily.

SVG – Scalable Vector Graphics

Unlike the two most popular web formats today – JPEG and GIF – SVG is a vector-based file format. In addition to faster download speeds, SVG also comes with many other benefits such as high-resolution printing, high-performance zooming and panning inside of graphics and animation.

This format will challenge the current dominant position of GIF as the premier format for flat graphic images on the web.

Save for Web Option in Photoshop (fig 16)

The latest version of Photoshop has a "Save for Web" function that enables direct comparison of an image being saved in a range of different web formats. This gives web professionals a quick and easy way to test particular compression settings and to balance file size with image quality. GIF, JPEG and PNG formats can all be selected and the compressed results compared to the original image.

TOP TIPS FOR CROSS-PLATFORM SAVING

1. Make sure that you always append your file names. This means add the three letter abbreviation of the file format you are using after the name. So if you were saving a file named "Image 1" as a TIFF, the saved file would be "Image1.tif", a JPEG version would be "Image1.jpg" and a Photoshop file would be "Image1.psd". Photoshop users can force the program to "Always Append" by selecting this option in the "Saving Files" section of preferences.

2. Mac users: save TIFF files in the IBM version. When saving TIFF files you are prompted to choose which platform you prefer to work with – choose IBM if you want to share files. Mac machines can generally read IBM tiffs but the same is not true the other way around.

3. Mac users: save images to be shared on IBM formatted disks. If you are sharing images on a portable storage disk, such as a Zip, always use media that is formatted for IBM. Mac drives can usually read the IBM disk but IBM machines can't read the Mac versions.

4. Try to keep file names to eight characters or less. Older IBM machines have difficulty reading file names longer than eight characters. So, just in case you happen to be trying to share with a cantankerous old machine, get into the habit of using short names… and always appended, of course.

INTO THE
::.FUTUR

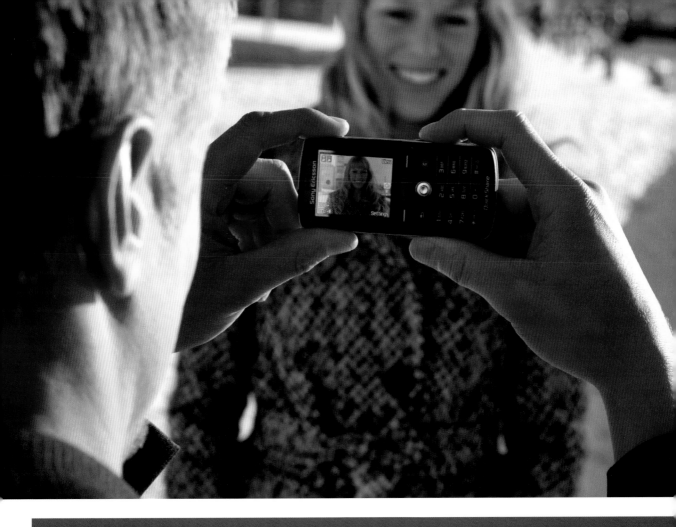

INTO THE FUTURE

INTO THE FUTURE FUTURE

It seemed that it was only yesterday that a phone was a large device that was permanently connected to the wall with a coiled cord. Nowadays not only are phones mobile but they can also play music, be used as a radio or voice recorder, display your emails, surf the net and occupy the kids with a range of action games. In the last few years most of the major manufacturers have added a camera function to the growing list of their phone capabilities.

PHONE CAMERAS VERSUS STILL CAMERAS

Like traditional digital cameras, the phone varieties comprise a sensor chip lens and memory card. The phone is switched into camera mode and the user can then compose the scene with the aid of a preview screen and capture the photograph with a click of a button. Once captured the photos can be sent via MMS (MultiMedia Messaging Service) to your friends and family, used as wallpaper for your phone or computer or printed (see fig 1).

Unlike other cameras, most phone cameras have a fixed focus lens (no auto-focus mechanism) and no zoom function (some models do contain a digital zoom feature). This hybrid or combined technology is still quite new and most camera functions are at about the level that you would expect to find on an entry level camera.

Early models used very low resolution chips which in turn produced small files suitable for mobile phone transmission. On the whole photographers were a little disappointed with the low-quality photos that these phone cameras produced, but more recent releases have addressed these issues by including larger sensors. Now many phones contain digital chips larger than three megapixels with one company producing an eight-megapixel camera capable of capturing photos with 3264 x 2448 pixel dimensions.

Choosing a Phone Camera

In addition to the digital camera features that we outlined in the Buying Your First Digital Camera guide on page 50 you should also consider the following phone camera features.

Connection Type – Many of the advanced features of phone cameras only really become evident when you connect your phone to a suitable computer. For some models you can make this link with a supplied cable, but more and more phones are linked with a wireless connection. To ensure that you can take advantage of your phone's features check that your computer has the required connection type before purchasing (see fig 2).

Fig 1 – As well as keeping us in touch many modern mobile phones can also take great pictures. Though not quite as advanced as all but the most basic digital camera, picture quality and image resolution are improving all the time.

Fig 2 – Camera phones connect easily to your computer via cable (USB) or wireless (Bluetooth or Infrared) technology. Once established, photos can be downloaded from the phone to your computer for editing and enhancing.

Service Provider and Plan Support – It is great to have the latest phone packed full of features and options but unless your service provider (phone company) and plan supports these advanced features you may not be able to use them. Enquire about the type of support that your current plan provides and how you can upgrade if necessary.

One way of ensuring a great match between provider and plan support and phone features is to purchase the phone from the company you are currently using. The consultants will have done all the hard work matching the network options they provide with the best of the features supported by various phone models.

Image Quality – If you are upgrading your phone and expect to make use of the inbuilt camera then make sure that you test drive the camera option by getting your dealer to "shoot and print" example images on the shop floor. This way you can check the photo quality and ease of use before handing over your hard-earned cash.

PHONE TO COMPUTER CONNECTIONS	
CONNECTION TYPE	MERITS
USB	Some phones are supplied with a USB cable to connect computer and phone. This wired connect is both easy to use and reliable and generally doesn't require any extra set up steps on either phone or computer.
Infrared	Infrared is a form of wireless connection designed to link phone and computer, but unlike Bluetooth your phone needs to be placed close to the infrared port of your computer to ensure a good connection. The transfer speed of most infrared connections is slower than both USB cable or Bluetooth wireless connections but this feature does provide another option for those users who don't have a cable handy or a Bluetooth-enabled laptop.
Bluetooth	Bluetooth is a form of wireless connection that can link your computer and phone, making cordless transfer of pictures (sounds, messages and contacts) possible. Some printers are also Bluetooth compatible allowing you to print your phone photos directly without the need for a computer. Bluetooth adapter cards can be purchased to install in computers that don't have this function built-in.

Fig 3 – Much of the software supplied with camera phones is designed to optimize pictures for on-phone use as screen savers or inclusion in multimedia messages.

Included Software – The software included with your phone plays a large part in the ease with which you can perform many of the camera's functions. Ask your phone dealer to demonstrate the programs that are bundled with your phone so that you can check out their features and ease of use (see fig 3).

Phone Features – It is easy to get carried away with the imaging potential of new phones but keep in mind their original purpose – to communicate with others! Make sure that you review the model's phone features as well.

CAMERA PHONE SHOOTING

The same approach that you use when shooting with

WHAT CAN YOU DO WITH A PHONE CAMERA?

- Send holiday photos from your holiday destination.
- Create personalized wallpaper or backgrounds for your phone or computer.
- Take pictures of a prospective house to show your partner if they can't view the property.
- Keep taking photos even when you don't have your regular camera handy.

your normal digital camera can be adopted for use when making pictures with a camera phone. Most models are totally automatic "point and shoot" affairs providing little ability to manipulate camera settings like focus, aperture or shutter speed.

Step 1: Choose the Camera Mode

After switching your phone on navigate your way through the menu system until you reach the imaging options. Select the Photo mode. Some models will also contain a Video option giving you the ability to shoot short video clips with the camera as well.

Step 2: Set Picture Size

Select the image size to suit your purpose. All phones designed to receive pictures support a minimum picture size of 160 x 120 pixels, but some models can also work with higher resolutions such as 600 x 800. When transmitting photos, stick with the lowest resolution unless you know the capabilities of the phone that you are sending to. If your phone is capable of capturing bigger picture sizes then these images are best kept for viewing on screen or outputting to print.

Step 3: Choose Picture Quality

Along with resolution, picture quality (the amount of compression used when creating the photo) also

contributes to the size of the file. Select normal or standard (or even low) quality for photos you intend to send to other phones to speed up transmission. For images destined for computer screens or print select the highest quality possible.

Step 4: Compose the Scene

Using the preview monitor on the rear of the camera, compose the picture and then squeeze the shutter button. Self portraits can be taken by reversing your hold on the phone and releasing the shutter.

Step 5: Store the Photo

Some camera models display a "Keep this photo?" immediately after capturing a scene. This gives you the option of saving the picture or deleting the photo and reshooting the scene.

TRANSFERRING PHOTOS

As well as sending your pictures to other photo enabled phones you can download the files to your computer and then edit and enhance them like any other image. Transferring the pictures requires you to connect your phone with a computer or laptop. Most new models have several different methods for making the connection including using a USB cable or a wireless connection such as Bluetooth or Infrared.

Once the connection is established the download process is very much like that used for transferring pictures from a digital camera to a computer.

Step 1: Set Link on Phone and Computer

For wireless connection both your phone and computer must have the same type of connection installed. Next make sure that the connection is switched on on both devices. If necessary add the phone to the list of devices available for connection and place the phone near the computer.

Step 2: Make the Connection

Once the connection is established between the two devices navigate through the phone's menus to locate and select the option to send or transfer pictures to a computer. You computer will respond by requesting permission to accept the file. Click Yes.

Step 3: Transfer Files

The pictures will automatically start to download to your computer where they can be edited and enhanced just like any other photos.

EDITING PHONE PHOTOS

It is no surprise that given the rise in popularity and technical specifications of modern mobile phone cameras that Adobe has seen fit to include a new "Get Photos···>From Mobile Phone" option in Elements 3.0. The new feature is found in the Photo Browser work space of the Windows version of the program and does not link your computer directly to your mobile phone – you will need the software that came with the unit for that – but rather watches the default folder where your phone pictures are downloaded. When new pictures are added to the folder, Elements either adds them to your catalogue automatically or notifies you of the new files and asks permission to add them.

To make sure that you can import your mobile phone pictures directly into Elements add the default download folder to the watch list first before selecting the File···>Get Photos···>From Mobile Phone option. Simply select File···>Watch Folders and use the Add button to browse for the folder that you use to store your mobile phone pictures. At the bottom of the window you can also choose whether Elements notifies you of new files added to the watched folders or automatically imports them into the Photo Browser (see fig 4).

Fig 4 – Photo editing packages like Photoshop Elements are now including camera phone photo download and upload options as standard.

JARGON BUSTER

A

ADC or Analogue to Digital Converter: Part of every digital camera and scanner that converts analogue or continuous tone images to digital information.

Aliasing: The jaggy edges that appear in bitmap images with curves or lines at 45 degrees. There are anti-aliasing functions in most image-editing packages that use softening around the edges of images to help make the problem less noticeable.

Aspect Ratio: The relationship between the width and height of a picture. The maintaining of an image's aspect ratio means that this relationship will remain the same even when the image is enlarged or reduced. The aspect ratio can usually found in dialog boxes concerned with changes of image size.

B

Background Printing: A printing method that allows the user to continue working while an image or document is being printed.

Batch Processing: The application of a function or a series of commands to several files at one time. This function is useful for making the same changes to a folder full of images.

Bit or Binary Digit: the smallest part of information that makes up a digital file. It has only a value of 0 or 1. Eight of these bits makes up one byte of data.

Bitmap: The form in which digital images are stored, made up of a matrix of pixels.

Brightness Range: The range of brightnesses between shadow and highlight areas of an image.

Byte: The standard unit of digital storage. One byte is made up of 8 bits and can have any value between 0 and 255. 1024 bytes is equal to 1 kilobyte. 1024 kilobytes is equal to 1 megabyte. 1024 megabytes is equal to 1 gigabyte.

C

CCD or Charge Coupled Device: The device which, placed in a large quantity in a grid format, comprises the sensor of most modern digital cameras.

Colour mode: The way that an image represents the colours that it contains. Different colour modes include RGB, CMYK and greyscale.

CMYK: A colour mode in which all the colours in an image are made up of a mixture of Cyan, Magenta, Yellow and Black (K). CMYK is the most common mode in the printing industry and is used by most high-quality digital printers.

Compression: The process in which digital files are made smaller to save on storage space or transmission time. Compression is available in two types – lossy, where parts of the original image are lost at the compression stage, and lossless, where the integrity of the file is maintained during the compression process.

D

Digitization: This is the process by which analogue images or signals are sampled and changed into digital form.

DPI: Dots per inch, a term used to indicate the resolution of a scanner or printer.

Duotone: A greyscale base image with the addition of another single colour other than black. Based on a printing method in which two plates, one black and one a second colour, were prepared to print a single image.

Dynamic Range: The measure of the range of brightness levels that can be recorded by a sensor.

E

Enhancement: Changes in brightness, colour and contrast designed to improve the overall look of an image.

F

File Format: The way in which a digital image is stored. Different formats have different characteristics. Some are cross-platform, others have inbuilt compression capabilities. (See Chapter Eight for more details.)

Filter: In digital terms, a filter is a way of applying a set of image characteristics to the whole or part of an image. Most image-editing programs contain a range of filters that can be used for creating special effects.

G

Gamma: The contrast of the midtone areas of a digital image.

Greyscale: A monochrome image containing 256 tones ranging from white through a range of greys to black.

Gaussian Blur: A filter which, applied to an image or a selection, softens or blurs the image.

Gamut: The range of colours or hues that can be printed or displayed by particular devices.

H

Histogram: A graph that represents the spread of pixels within a digital image.

Hue: The colour of the light as distinct from how light or dark it is.

I

Interpolation: The process used by image-editing programs to increase the resolution of a digital image. Using fuzzy logic, the program makes up the extra pixels that are placed between those generated at the time of scanning.

Image Layers: Images in both Photoshop and Paint Shop Pro can be made up of many layers. Each layer will contain part of the image. When viewed together, the layers appear to make up a single image. Special effects and filters can be applied to layers individually.

J

JPEG: A file format designed by the Joint Photographic Experts Group that has in-built lossy compression, enabling a massive reduction in file sizes for digital images. Used extensively on the web and by press professionals for transmitting images back to newsdesks worldwide.

JPEG2000: The latest, more flexible, release of the JPEG format.

L

Layer Opacity: The opacity or transparency of each layer of a layered image. Depending on the level of opacity of the layer, parts of the layer beneath will be more or less visible. You can change the opacity of each layer individually by moving the opacity slider in the Layers palette.

LCD or Liquid Crystal Display: A type of display screen used in preview screens on the back of digital cameras and in most laptop computers.

M

Megapixel: One million pixels. Used to describe the resolution of digital camera sensors.

O

Optical Resolution: The resolution at which a scanner actually samples the original image. This is often different from the highest resolution quoted for the scanner as this is scaled up by interpolating the optically scanned file.

P

Palette: A type of menu within image-editing programs that allows the user to select changes in colour or brightness.

Pixel: The smallest image part of a digital photograph, short for picture element.

Q

Quantization: The allocation of a numerical value to a sample of an analogue image. Part of the digitizing process.

R

RGB: A colour mode in which all the colours in the image are made up of a mixture of Red, Green and Blue. This is the typical mode used for desktop scanners, bitmap programs and digital cameras.

S

Stock: A printing term referring to the type of paper or card that the image or text is to be printed on.

T

Thumbnail: A low resolution preview version of a larger image file used to check before opening the full version.

TIFF or Tagged Image File Format: A file format that is widely used by imaging professionals. The format can be used across both Macintosh and PC platforms and has a lossless compression system built in.

INDEX

PICTURE CREDITS

Tim Daly

UK-based illustrative photographer, author of countless digital imaging articles and co-director of the online photography and imaging college – Photocollege.co.uk.
Email: tim@photocollege.co.uk
Web: www.photocollege.co.uk

Patrick Hamilton

A press and sports photographer based in Australia, currently working for for *The Australian* newspaper.

Stephen McAlpine

Wedding and portrait photographer based in Australia.
Email: sbmcalpine@bigpond.com.au

Martin Evening

UK fashion photographer, undisputed champion of digital photography and author of *Photoshop 6 for Photographers*, Focal press.
Email: martin@evening.demon.co.uk

The publishers would like to thank the following sources for their kind permission to reproduce the pictures in this book:

All images copyright Philip Andrews unless otherwise stated.

Key: page no. (fig. no.)

Adobe: 66 (9, 10), 72 (15, 16), 78 (21, 22); AMD: 80 (23); Karen Andrews: 35 (5), 174 (12), 21 (4), 93 (11), 105 (27), 130 (27, 28, 29), 132 (30, 31); Apple: 83 (26, 27, 28, 29), 164 (1); Earl Bridger: 14 (8), 13 (6); Canon: 17 (12), 28 (16), 29 (17), 49 (30), 50 (32); Corel: 74 (17, 18); Tim Daly: 58 (41,42); Epson: 59 (44); Martin Evening: 147 (53, 54); Fuji: 43 (21); Google: 68 (11, 12); Patrick Hamilton: 31, 45 (24), 46 (25); Iomega: 163 (2); Kodak: 12(4), 26 (13), 27 (14); La Cie: 24 (11); Stephen McAlpine: 14 (7), 133 (32), 134 (101); Microtek: 59 (43); Nikon: 13 (5), 25 (12), 49 (31); PictureWorks: 139 (39); Queensland School of Printing and Graphic Arts: 16 (10); Israel Rivera: 90 (7, 8); ROXIO: 76 (19), 77 (20); Ulead: 70 (13, 14); Wacom: 81 (24); Wellbeing.com: 59 (45)

Every effort has been made to acknowledge correctly and contact the source and/or copyright holder of each picture, and Carlton Books Limited apologises for any unintentional errors or omissions which will be corrected in future editions of this book.